The Arts Compared

The Arts Compared

An Aspect of Eighteenth-Century British Aesthetics

by James S. Malek

University of Idaho

Wayne State University Press
Detroit 1974

Published simultaneously in Canada
by the Copp Clark Publishing Company
517 Wellington Street, West
Toronto 2B, Canada.

Library of Congress Cataloging in Publication Data
Malek, James S
 The arts compared.
 Includes bibliographical references.
 1. Aesthetics, British. I. Title.
BH221.G73M33 700'.1 74–11088
ISBN 0–8143–1519–4

Publication of this book was assisted by the American Council
of Learned Societies under a grant from the Andrew W.
Mellon Foundation.

For my mother and father

Contents

Preface

My primary purposes in this book are to define, evaluate individual works in, and trace the history of one branch of eighteenth-century aesthetics—comparative discussions of the arts. There exists no extensive account of comparative discussions in previous studies of the century's "philosophical criticism," although a number of books and articles touch upon some of the individual works with which I am concerned. My work can perhaps be considered supplementary to R. S. Crane's "English Neoclassical Criticism: An Outline Sketch," first published in *The Dictionary of World Literature* (1943), Walter J. Hipple's *The Beautiful, the Sublime, and the Picturesque in Eighteenth-Century British Aesthetic Theory* (1957), and Robert Marsh's *Four Dialectical Theories of Poetry: An Aspect of Neoclassical Criticism* (1965). Crane was the first to recognize what I call comparative discussions as a characteristic and distinct kind of neoclassical criticism. The methodological approaches to eighteenth-century aesthetics of Hipple and Marsh are similar to mine; however, neither is centrally concerned with comparative discussions. In the preliminary phases of documentation, I have used the terms defined by Marsh in the first chapter of *Four Dialectical Theories of Poetry*. Marsh's distinctions among the various forms of neoclassical theory are valuable for any historian of eighteenth-century critical discourse because they provide lucid and important frameworks within which the significance of individual theories can be elucidated. His book is of course concerned specifically with four examples of a dialectical form of theory; most works examined here exemplify causal or rhetorical theories.

The most recent book in the general area of eighteenth-century British philosophical criticism, Lawrence Lipking, *The Ordering of the Arts in Eighteenth-Century England* (1970), differs from mine both in subject matter and methodology. The latter is self-evident, but the former involves a basic dissimilarity which may not be immediately apparent to all readers. Lipking investigates those works on painting, music, and poetry which first attempted, through combinations of history, aesthetic theory, biography, criticism, and so forth, to order an entire, separate art. I examine works in which the major problem was

9

finding bases for making intelligible the fundamental similarities and differences among the various arts. Lipking is concerned with works which first sought to describe the entire practice of a single art; I am concerned with those which first tried to systematize the interrelations of the arts.

I wish to express my gratitude to the National Endowment for the Humanities for a Younger Humanist Fellowship which enabled me to finish this study, and to the University of Idaho for a summer research grant which provided aid at an earlier time. Professors Robert Marsh and Wayne C. Booth of the University of Chicago read parts of the manuscript at various stages of its development and made valuable suggestions, for which I am grateful.

Parts of the book have appeared, in somewhat different form, in the following articles: "Charles Lamotte's *An Essay upon Poetry and Painting* and Eighteenth-Century British Aesthetics," *The Journal of Aesthetics and Art Criticism* 29 (Summer 1971): 467–73; "Art as Mind Shaped by Medium: The Significance of James Harris' 'A Discourse on Music, Painting and Poetry' in Eighteenth-Century Aesthetics," *Texas Studies in Literature and Language* 12 (Summer 1970): 231–39; "The Influence of Empirical Psychology on Aesthetic Discourse: Two Eighteenth Century Theories of Art," *Enlightenment Essays* 1 (Spring 1970): 1–16; "Physiology and Art: Daniel Webb's Aesthetics," *Neuphilologische Mitteilungen* 71 (1970): 691–99; "Thomas Twining's Analysis of Poetry and Music as Imitative Arts," *Modern Philology* 68 (February 1971): 260–68; and "Adam Smith's Contribution to Eighteenth-Century British Aesthetics," *The Journal of Aesthetics and Art Criticism* 31 (Fall 1972): 49–54. I wish to thank the publishers of those journals for permission to include copyrighted material.

Introduction

Although critics in all ages have compared poetry with other arts, the eighteenth century was the first to produce numerous essays in which the major problem was finding bases for distinguishing the fundamental similarities and differences among the various arts. In the years between John Dryden's translation (1695) of Charles Alphonse Dufresnoy's poem *De arte graphica*, prefaced by Dryden's "Parallel betwixt Poetry and Painting," and the first decade of the nineteenth century, comparative discussions of the arts assumed increasing importance in British criticism. This book is a detailed study of such works; it might best be classified as an essay in the history of ideas and in intellectual analysis: in the history of ideas insofar as its subject matter consists of a historically definable and significantly interrelated body of material (essays, dialogues, dissertations, letters); and in intellectual analysis in that each work is treated as complete in itself and in its own terms.

Comparisons among the arts were not uncommon from antiquity to the eighteenth century, but usually such comparisons were made incidentally while authors were addressing other primary considerations. In the eighteenth century, theorists recognized the search for universal bases of all the arts as a legitimate branch of "philosophical criticism." Such comparisons were effected through analyses of the mind, actual works of art, human nature, and qualities or properties of physical nature; some were primarily concerned with conventional precepts or rules for achieving various artistic effects, others with explanations of effects in terms of various "natural" causes or with "qualities" common to all the arts.[1] The fact that many writers in the period were concerned with comparisons does not imply that there is an essential set of doctrines and critical principles which all shared or which could be predicated of the entire age and still retain any precise meaning. Critics who compared the arts attempted to solve a variety of problems, employed various critical principles, and utilized several critical methods which each judged to be appropriate to his objectives.

A fundamental task in studying these writers is to distinguish the

various forms of theory through which common terms and formulas are given validity and meaning. A writer's statements lose meaning outside their contexts; what may serve as a premise of conclusions in a writer who treats the arts in terms of natural causes may be a conclusion of other premises in one who discusses the arts as means of obtaining ends which are predetermined by the conventional nature of the art in question. *Ut pictura poesis,* for example, does not mean the same thing for every theorist in the eighteenth century, and it is more useful to recognize the manner in which it receives value and the uses to which it is put by each author than to assume that its presence in numerous writers lends a doctrinal unity to the age.[2]

R. S. Crane has suggested that it is impossible to talk understandingly and fairly about any critical "pronouncement" without defining the questions which the critic was trying to solve, the assumptions about criticism which underlay the asking of the question and the determination of the answer, and the reasoning devices employed in answering the question.[3] Each of the works I discuss is analyzed in terms of this threefold context of critical principles involved, kinds of questions asked, and reasoning methods employed.

By way of clarification, it might be useful to designate modes of literary history which I consciously avoid. Faced with the enormous amount of theorizing about the arts and with the diversity of doctrines, terms, problems, and procedures in the eighteenth century, historians have sometimes used a comparative approach in which an author's comments on a given "subject" are lifted from their contexts and matched with the "opinions" of his contemporaries, predecessors, and successors.[4] The difficulty with such an approach is that terms need not have the same meaning in varying contexts, nor do seemingly identical doctrines necessarily imply similar meanings or methods. In such treatments, any critic can be made to look dogmatic and simple-minded when his "opinions" are abstracted from supporting arguments. The cataloguing of authors resulting from such analyses is seldom enlightening.

Similar difficulties are encountered in dialectical histories.[5] In this mode of intellectual history, the historian supplies broad organizing ideas which might encompass doctrines "common" to an entire period. Often principles or doctrines are interpreted under general dialectical contraries, such as romantic and classical, imitation and expression, or emotion and reason, which may or may not have been meaningful terms for the critic in question. Each critic is then analyzed under the auspices of this central scheme without much attention to the context in

which statements are made and through which terms receive precise meaning.[6] Such studies frequently obscure distinctions of method, force the historian either to ignore or to distort data which do not conform to his scheme, and tell us little about the intellectual causes which governed an author's formulation of problems and principles.

In selecting the writers included here, I have employed several criteria. I have made no attempt to include all authors who made use of comparisons of the arts, choosing instead to focus on works which are centrally concerned with establishing basic principles for analyzing relationships among the arts.[7] Hurd and Reynolds, to name two of many examples, draw comparisons among the arts, but they are by way of illustration and are never of primary interest to their authors.

I have also tried to indicate the variety of critical systems employed in comparative discussions in eighteenth-century Britain. All too often scholars have assumed a uniformity of method and purpose in these comparisons, thereby obscuring vital differences among them.[8] The essays of Dryden and Charles Lamotte are examples of a rhetorical form of criticism.[9] Dryden's essay is of historical importance in popularizing the speculations of such Continental writers as Dufresnoy, Roger de Piles, and Giovanni Bellori. Lamotte's work is at least partially intended as a supplement to Dryden's "Parallel," but differs from it in the manner in which *decorum* is applied as a means of delimiting the provinces of poetry and painting and defining artistic value. James Harris is one of the few authors who distinguish among the arts in terms of their various media; the limitations and strengths of the arts are investigated in terms of their imitative abilities and the intrinsic merit of subject matter, determined by the nature of their respective media. In *The Polite Arts*, a concept of imitation of an ideal nature abstracted from natural particulars serves as the basis for comparing the "polite" arts; differences among the arts and among poetic species are explained in terms of historically defined conventions and concepts of ideal artistic form synthesized from the particular beauties of individual works by active principles of taste. The works of James Beattie, Sir William Jones, and Daniel Webb utilize a causal method in which aesthetic responses are analyzed in terms of natural causes, principles deriving from investigations of psychological or physiological phenomena. They do not attempt to answer identical questions, however, and their uses of terms vary sufficiently that they would appear to be much less similar than they are if one were to construct a history solely based on doctrinal content. Thomas Twining's work is a close analysis of the manner in which music and poetry can be classed as imitative arts. He attempts to

correct much of the confusion which resulted from what he considers inexact or constricting uses of the term in earlier theories. Adam Smith's essay is of considerable intrinsic interest; the significance of his investigation of the limits and powers of instrumental music alone would recommend his inclusion. His essay, and those of Harris and Twining, are among the most perceptive in eighteenth-century British criticism. In terms of inherent worth, influence, or comprehensiveness, these works constitute Britain's major comparative discussions of the arts during the eighteenth century.

Many minor works addressed to the same problem, or to specialized aspects of it, were also produced, particularly toward the end of the century. A number of these essays and letters are important sources for defining the various methodological kinds and wide differences in scope which works in this branch of aesthetics present. The second half of the eighteenth century also saw the rise to prominence of works which combine comparisons with scholarly histories of the arts, thus contributing to both aesthetics and art history. By examining minor works and combinations of comparisons with history, I attempt to provide some notion of the increasingly prominent role played by comparative discussions in the critical discourse of the period.

In order to avoid distorting and unfairly judging the views of their authors, I have described and judged these works in the context of the specific questions and methods which give meaning to their doctrines. The process of examining each work more or less independently, however, does not preclude the possibility of tracing lines of development within comparative discussions of the arts, and I attempt to fulfill that objective by identifying some of the major conceptual and procedural shifts of emphasis which took place in this branch of "philosophical criticism" during the eighteenth century.

Chapter One

Rhetorical Theories

John Dryden: The Initiation of Comparative Discussions

In 1695, Dryden took two months off from translating Vergil's *Aeneid* to translate Charles Alphonse Dufresnoy's Latin poem *De arte graphica* into English prose and to compose his "Parallel betwixt Poetry and Painting," which he prefixed to the translation.[1] Translations of and commentaries on Dufresnoy's poem exerted considerable influence on eighteenth-century discussions of painting; *De arte graphica* became "one of those works which set the terms in which men wrote about the arts."[2] Dryden's translation was the first English version, but was followed by numerous others during the century—such as those of Defoe (1720), James Wills (1754), William Mason (1783; to which Reynolds added notes), and W. Churchey (1789). The poem was known and admired, through the original or in translation, by many later critics of note, including Pope and Johnson.[3] Dryden claims that he undertook the translation at the insistence of painters and other artists who recommended Dufresnoy as one "who perfectly understood the rules of painting" and "who gave the best and most concise instructions for performance, and the surest to inform the judgment of all who loved this noble art."[4] By making such a work generally available to the public, Dryden hoped to provide a set of rules which would enable those who "blindly" valued painting to "defend their inclination by their reason" and to "know when nature was well imitated by the most able masters" (2: 115).

In addition to translating Dufresnoy, Dryden says that he was "importuned to say something farther of this art, and to make some observations on it, in relation to the likeness and agreement which it has with poetry, its sister" (2: 117). His "Parallel," in terms of specific doctrines, is largely unoriginal; its chief doctrinal significance lies in popularizing the speculations of such Continental writers as Dufresnoy, Roger de Piles, and Giovanni Bellori. Its lasting importance is found elsewhere. Plato, Aristotle, and Horace in antiquity, and numerous

Italian and French theorists in the sixteenth and seventeenth centuries compare poetry with other arts incidentally; in the "Parallel," the *major* problem is finding a basis for distinguishing the fundamental similarities and differences among the arts. If it is not accurate to claim that Dryden originated this branch of aesthetics, his essay is at least a prompter of such discussions in the eighteenth century. His work is primarily a series of precise parallels serving to lend the weight of classical rules to certain types of contemporary painting and poetry, but the kinds of problems implicitly raised by the "Parallel" are central to systematic aesthetic discourse. Moreover, the essay's significance for this branch of aesthetic theory resides not only in its role as an initiator of discussions of the comparative powers of the arts (evidenced by the many references of later writers to the specific arguments of the "Parallel") but also in the kind of methodology Dryden employs in attempting comparisons among the arts. He uses a "rhetorical" form of theory in which poetic and pictorial kinds are viewed as conventional means of producing predetermined effects. The major terms of his discourse derive from the tradition of Roman rhetoric, and interest focuses on questions of artistry, construction, and established styles and species (as in Horace), rather than on general qualities or values which distinguish one artist from another regardless of medium or genre (as in Longinus). With Dryden as one of its chief practitioners, this "rhetorical" method became the major mode of criticism in the first half of the eighteenth century.

Since Dryden's "observations" on "the likeness and agreement" of poetry and painting are largely a commentary on Dufresnoy's poem,[5] a brief examination of *De arte graphica* will be useful. Composed in Rome between 1633 and 1653, *De arte graphica* attempts to instruct native genius by codifying rules which are appropriate to the art of painting.[6] Dufresnoy does not intend to "tie the hands of artists" or "stifle genius"; rather, he means to provide a basis for "choosing judiciously what is true" and for "distinguishing betwixt the beauties of nature and that which is low and mean in her."[7]

The poem begins by quoting Horace (*ut pictura poesis*)[8] and Simonides (*pictura loquens*),[9] linking poetry and painting as sister arts.

> Ut pictura poesis erit; similisque poesi
> Sit pictura; refert par aemula quaeque sororem,
> Alternantque vices et nomina; muta poesis
> Cicitur haec, pictura loquens solet illa vocari.

Dryden translates these four lines as "Painting and Poesy are two sisters, which are so like in all things, that they mutually lend to each other, both their name and office. One is called a dumb poesy, and the other a speaking picture" (17: 339). Hagstrum points out that Dryden's free translation glosses the dogmatism of Dufresnoy's text, which, literally interpreted, suggests that not only should painting resemble poetry but poetry should also strive to be like painting (*The Sister Arts*, pp. 174–75); here, they are alike insofar as both treat the same "noble" subjects. *Ut pictura poesis* in the seventeenth and eighteenth centuries was most frequently interpreted to mean that poetry and painting should resemble each other. In what sense this should be so was a matter of debate, much of which was fruitless. Fifty years after Dryden's "Parallel" was published, James Harris argued that the respective media of the arts necessarily determine their subject matters, limitations, and strengths, thereby anticipating Lessing's final refutation of the narrowest applications of the *ut pictura poesis* doctrine in his *Laokoön* (1766). But early in the eighteenth century, when distinctions among the subject matters of the arts were made, they were seldom based on the recognition of fundamental differences between spatial and temporal art forms.

The most important aspect of painting for Dufresnoy is learning what nature has made most beautiful and proper to the art. Such knowledge derives from studying the taste and manner of the ancients. But reason and example must cultivate the artist's natural disposition in order to avoid extremes (the good and beautiful residing in a mean between fancy and servile copying). In order to achieve perfection, the speculative genius which combines with reason to determine *what* is beautiful must have the assistance of precepts concerning "manual operation" if the artist is to know *how* to achieve it. The painter is to "follow the order of nature" (17: 359) in all matters, but not be "so strictly tied to nature that you allow nothing to study and the best of your own genius" (17: 355). For Dufresnoy, then, the individual artist and work are subordinated to considerations of the art. The art of painting is distinct from nature insofar as it provides a set of rules by which nature is to be imitated and improved upon; at the same time, knowledge of nature is the basis for the rules of painting.

Dufresnoy treats painting as a conventional means of achieving predetermined effects. All of his technical rules ultimately derive from the special demands of subject matter represented and from past practice. He organizes these rules under the common rhetorical headings of invention, design, and coloring. Invention, which concerns

the conception of a proper subject, is the product of inspiration and not to be acquired by study. Rules for design involve such diverse subjects as adornment and the expression of passion. Coloring rules are technical, dealing with the use of light and dark, reflection, union of colors, and so forth. He remarks that a looking glass is useful for instructing the painter, but he is not advocating a literal transcription of nature. At this point (ll. 385–88), he is discussing the manner in which a picture may achieve harmony. A looking glass is instructive in the same manner in which a panorama viewed in the evening is: both maximize the effects of distance, contributing a sense of uniformity by lessening details. Dryden does not use the concluding section, containing advice for young painters, making it irrelevant for our purposes.

Although Dufresnoy links poetry and painting as sister arts at the beginning of his poem, he is not primarily interested in drawing parallels between them. His basic concern is to provide precepts deduced from the established norms of painting and from the special demands of the subject matter involved; parallels are infrequent and refer only to dramatic poetry. In the matter of excluding whatever is trivial, he says that painting should imitate tragedy, "which employs the whole forces of her art in the main action" (17: 347); similarly, "as a play is seldom very good in which there are too many actors" (17: 353), paintings which have a large number of figures are seldom perfect. Howard says that Dufresnoy's use of comparisons with drama "is obviously of great importance; for the drama is in a real sense visible poetry; dramatic scenes lend themselves to fixation and perpetuation on canvas in a far higher degree than the less distinct moments of an epic action" ("Ut Pictura Poesis," p. 85). There is nothing, however, in Dufresnoy's definition of the proper subject matter of painting which makes tragedy a more appropriate source of "parallels" than epic poetry. Painting can represent only a single moment in an action and is to treat subjects which deserve to be "consecrated to eternity" by virtue of their nobleness. Dryden contends, in the "Parallel," that epic poetry, in fact, provides a more exact parallel with painting than tragedy when the subject matter of the two arts is discussed in terms of certain conceptions of idealized nature.

Dryden, to justify drawing parallels between the technical rules of painting and those of poetry, must first establish that the two arts strive for similar effects based on similar principles. He does so by positing a concept of imitation applicable to both arts. He quotes Giovanni Bellori and Philostratus to define ideal beauty, to show that it comprises the

subject matter of both arts, and to argue that the proper imitation of such beauty produces the greatest effects in each.

In the "Idea del pittore," which served as a preface to *Le vite de' pittori, scultori et architetti moderni* (Rome, 1672), Bellori regards imitation as a process through which the artist apprehends ideas (or first forms) behind objects or being and produces his work by expressing the ideal beauty appropriate to the form he wishes to represent (a creative act comparable to God's creation of first forms). Bellori's concept of the ends of art directly opposes the notion that painting should copy nature literally. Ideal form[10] resides in "that perfect and excellent example of the mind, by imitation of which imagined form all things are represented" (2: 118). The artist is to look inward, away from nature, to the immaterial world of the mind, wherein ideas underlying visual form may be apprehended; similarly, the intellect is to be the judge of the performing hand.

Dryden uses the quotation from Philostratus to suggest an affinity between poetry and painting based (1) on a similarity of means in achieving effects (both impose on the imagination by creating the illusion of reality) and (2) on the need for identical knowledge of human nature for the practitioners of both arts. For Philostratus, the painter must understand all that pertains to the mind and thought in order to express the "motions" of the mind through signs exhibiting a concurrent harmony. Pleasure results from inducing the spectator to believe that "objects" which have no "real being" in nature are real. The same effect occurs in poetry since the two spring from a common imagination and have the same subject matter.

The quotations from Bellori[11] and Philostratus are used to initiate Dryden's discussion of concepts of imitation which are useful in drawing parallels. Questions relating to the imitative nature of the arts are of central importance for eighteenth-century comparative discussions; virtually all theorists after Dryden discuss the "imitative" nature of each art, although few writers mean precisely the same thing by mimesis. Pictorialists are quick to judge painting and poetry as imitative, but find music troublesome. Although such late-century theorists as Twining and Smith clear up much of the confusion resulting from indiscriminate uses of mimesis, writers often give the term whatever meaning best suits their immediate arguments in the years immediately following the publication of Dryden's "Parallel."

Dryden recognizes several concepts of imitation. Whether a concept such as *perfect nature* is of use in the "Parallel" depends on the

literary genre or type of painting being discussed. Dryden treats genres and types as conventional modes through which prescribed effects are to be achieved, distinguishing them in terms of the special demands of subject matter and audiences. It is assumed, for example, that comedy and tragedy are directed to different audiences, that they strive for different effects, and that the characters which are appropriate for one may not be appropriate for the other. Since the basic consideration is how prescribed effects can best be achieved, the problem of defining concepts of imitation on which rules appropriate to each literary genre or type of painting can be established becomes relevant.

The fact that Dryden regards species as products of conventionally approved subject matter and specific audience demands explains his claim that the idea of perfect nature is of little value for comedy, tragedy, or portraiture. The portrait painter is to create an exact or slightly flattering likeness of a particular person; similarly, comedy and tragedy represent characters who are in some manner less than perfect. There is a better likeness (tragedy) and a worse (comedy), but in either case the perfection of such characters consists "in their likeness to the deficient faulty nature" (2: 123) rather than to ideal nature. On the other hand, the concept of perfect ideas is relevant for the history painter and the epic poet, whose subjects approximate divine nature.

Since Dryden's discrimination of literary genres and types of painting does not allow the idea of perfect nature to serve as a universal foundation for parallels, he must establish an alternative basis for rules. He does so by analyzing those ends of the two arts which are similar enough to admit of comparison. Considerations of specific subject matter enter only after it is shown that the arts strive for similar effects through comparable means. Dryden's definition of the ends of poetry and painting modifies Dufresnoy's statement that the chief end of painting is to please the eyes and that a major concern of poetry is to please the mind by way of the ears (17: 339). Dryden agrees with the substance of the parallel, but claims that while the primary end of painting is to please, the ultimate end of poetry is to instruct. He applies this distinction to the ends of poetry and painting considered as arts (apart from the immediate purpose of the artist). If one considers the artists themselves rather than the art, their aims are identical, for both must prefer pleasing to instructing. Moreover, for Dryden, the means of pleasure in both arts is deceit;[12] painting "imposes" on the sight by representing bodies, actions, and things which are not real, and poetry

imposes on the imagination through the resemblance of an actual story by fiction.

There is ambiguity in Dryden's treatment of the problem of pleasure and instruction in the arts. He says that "the chief design of Poetry is to instruct" (2: 128) and later states that "one main end of Poetry and Painting is to please" (2: 133). The ultimate end of painting is to please (instruction may enhance that pleasure). If poetry's "chief design" is instruction, it would seem that pleasure is to be regarded as a *means* of instructing. But if "one main *end*" of poetry is pleasure, and if the artist must always make sure of pleasing in preference to instructing, pleasure is not simply a means but an integral part of poetry's ultimate purpose. Pleasure is thus treated as both means and end; this results in some confusion in Dryden's presentation because the sense in which poetic pleasure is to be regarded is not always clear. Discussing the "aims of artists" and those of poetry as an art separately does not resolve the problem since it is not clear wherein they differ. The ambiguity is not fundamentally damaging to the essay since Dryden establishes that pleasurable effects, whether considered as means or ends, are necessary in poetry. Hence there is a parallel with painting. The question of the relative status of pleasure and instruction in the two arts is important for Dryden's purposes, however, since it partially determines the nature of technical rules for each. Aside from necessary differences resulting from media, if one strives to *please* "the eyes" while the other ultimately seeks to *instruct* "the mind," their rules must differ significantly enough to discourage exact parallels.

Pleasure is conveyed through deceit in both arts, but the nature of the fiction represented varies among literary species and types of painting. Hence the question of appropriate subject matter for conventionally established kinds becomes relevant for Dryden's comparison of the effects and rules of painting and poetry. Tragedy and epic poetry, for example, "ought to have nothing of immoral, low or filthy in them" (2: 129); their subjects, like those of history painting, must be the action of an illustrious hero. The parallel with painting is "more complete in tragedy than in an epic poem" because "tragedy and picture are more narrowly circumscribed by the mechanic rules of time and place than the epic poem" (2: 130).

Dryden bases this comparison on a general probability concerning the natural sources of pleasure. He assumes that viewing a single action in a relatively short span of time or as a single impression will necessarily have the strongest possible effect on the minds of men. On

the strength of this assumption, he concludes: "I must say this to the advantage of painting, even above tragedy, that what the last represents in the space of many hours, the former shows us in one moment" (2: 131). If the mind were capable of comprehending an entire picture in a single moment, the imitation would achieve its desired effects at once, whereas tragedy cannot convey a similar single impression.

In making this judgment, Dryden is not primarily interested in the psychological causes of aesthetic effects; instead, he makes assumptions about universal human traits on which generic rules of art can be based. Comparative discussions in which explanations of aesthetic effects in terms of natural causes play a significant role did not appear in England before the publication of such Continental works as Jean Baptiste Du Bos's *Réflexions critique sur la poésie et sur la peinture* (1719), but Dryden's discussion of the impressions of time and place in poetry and painting contains the germs of causal explanations of aesthetic effects.

If the ends of the arts are similar and if their species are comparable, seeking parallel rules is justifiable. For Dryden, the sources of rules are previous critical systems based on past practices. He treats species and rules in the same manner; as the various species are conventionally defined, so are their precepts. Since art is conceived in this manner, it is not surprising that he compares poetry and painting with medicine. The principles of all three are founded in nature and have been codified in the course of time. Hence all that is undiscovered can be found by further inquiries by men who are versed in ancient precepts.

The appeal to authority is an appeal to nature for Dryden and writers with a similar orientation to criticism. The rules of the ancients are based on artistic practices; these works pleased then and are still capable of pleasing; hence rules based on them are founded on a knowledge of what naturally pleases and how. Nature remains constant in all ages; thus the appeal to ancient rules is an appeal to nature methodized because nature, practice, and the rules based on practice are the same thing. Such "neoclassical pronouncements" as Dryden's statement that Italian and French critics derived rules of modern tragedy by "studying the precepts of Aristotle and Horace and having the example of the Grecian poets before their eyes" (2: 134) become wholly intelligible only if we recognize the assumptions and reasoning processes underlying them.

When Dryden argues that tragedy is more beautiful than comedy, he uses Dufresnoy's claim that knowledge of beauty determines a painting's worth, but his application of this "rule" is influenced by his

22

requirement for instruction in poetry. He argues that since the most noble subject must be the most beautiful, and since the most beneficial form of instruction depends on the worth of the audience to which it is addressed, tragedy is more beautiful than comedy.

Dryden's account uses imitation as the basis of artistic effects not simply because it affords the pleasure of comparing likenesses but because it allows for the perception of truth. If a true knowledge of nature gives pleasure, artistic imitations of it will necessarily produce more since the arts imitate the "best nature." By "best nature," Dryden means a synthesis of the scattered beauties of nature presented in "images more perfect than the life in any individual" (2: 137). Hence truth does not refer to literal transcriptions of material nature or to innate ideas of moral perfection, but to "generalized" nature.

Dryden does not attempt to draw parallels between all of Dufresnoy's rules and those of poetry. Some are technical rules applicable to paintings as objects, but irrelevant for poetry. He adapts others to accord with differences in media and with the greater role of instruction in poetry. Although neither author gives rules for invention, since "happy genius" is the gift of nature, Dryden does suggest rules to improve invention, which pertain to following precepts of the ancients and are based on the assumption that nature remains unchanged despite its various trappings.

Of the many rather mechanically drawn parallel rules relating to design, some are not justified by Dryden's definition of poetry and painting as imitative arts. Dufresnoy says, for example, that a withered hand should not belong to a young face; Dryden's parallel rule is that "he who entered in the first act a young man . . . must not be in danger, in the fifth act, of committing incest with his daughter" (2: 142). The rule of consistency involved in the first half of the comparison refers only to visual form, whereas the second refers to time; the means through which the conditions presented in Dryden's dramatic example could be made probable (inherent in the plot itself and quite independent of sensory images) involve principles which are irrelevant for questions concerning the probability of a withered hand belonging to a young face. Similarly, there does not seem to be sufficient ground for an analogy between too careful detail in drapery at the expense of the face in painting and the unfortunate consequences which result from introducing similes in a scene which strives for the expression of passion. Too minute attention to the details of drapery is distracting in the sense of minor visual details interfering with the primary visual object; the introduction of a simile in a passionate scene is destructive

of passion because it intrudes a verbal image whose natural effect is more directly related to the intellect than to passion.

Dryden concludes the "Parallel" by equating coloring in painting with expression in poetry,[13] both of which perform exactly the same function: as the selection of appropriate and appealing color and the use of light and shadow make the design pleasing to the eye, so versification, diction, tropes, and "all other elegancies of sound" beautify the design, "which is only the outlines of the fable." Coloring and expression act as bawds for the design, making beautiful what would otherwise appear passable (2: 147–48). Dryden's parallel assumes an analogous final stage in the creative process in the two arts; as color is applied to a sketch, poetic expression is applied after the properties of invention and design. He thus restricts expression to verbal phenomena.[14] He does not, however, draw elaborate parallels between color and expression; the principal rule he advances concerns training the artist to recognize the mean which constitutes beauty. His precepts presuppose that the mean is determined by subject matter and the accepted norms of literary species rather than by an independent ideal of beautiful expression.

In the "Parallel," Dryden states that he is not "loaded with a full cargo"; others can easily "add more" (2: 124–25) because he has not attempted to exhaust the subject of parallels between poetry and painting. Theorists who followed him in this branch of aesthetics did "add more" in steadily increasing volumes, refining Dryden's arguments, altering his methodology, and expanding the subject to include other arts. The value of the "Parallel" is not that of a fully developed, original, or systematic treatment of poetic and pictorial aesthetic theory; but if the essays of some of Dryden's successors in the eighteenth century surpass it in philosophical sophistication, the "Parallel" remains of signal importance as an initiator of theoretical discussions of the arts.

Charles Lamotte: Poetry, Painting, and Artistic License

Dryden's invitation to other theorists to expand his "cargo" was accepted by Charles Lamotte in An Essay upon Poetry and Painting, with Relation to the Sacred and Profane History (1730). Lamotte says that he is not attempting a complete parallel of poetry and painting since others, including Dryden,[15] have attempted "just and exact" comparisons; instead, he contributes "some few Observations which may perhaps have escaped those Writers or which have not been so

fully insisted upon by them." [16] His "few Observations" focus on those aspects of comparisons which he judges to be most relevant for questions of pictorial and poetic license. They comprise the first half of his essay (fifty-five pages); the second half, with which I am not concerned here, consists of a somewhat dreary list of examples of paintings and poetic works which take "inexcusable liberties" with religious and historical subjects (inexcusable because they violate rules of decorum which Lamotte establishes in the first half of the essay). Although Lamotte's essay is not of great intrinsic merit, it is of considerable interest in the history of eighteenth-century aesthetics. Lamotte employs a rhetorical critical method similar to Dryden's, but as a result of reading such works as Du Bos's *Réflexions critique sur la poésie et sur la peinture,* he is also interested in explanations of artistic effects in terms of natural causes. Moreover, although many of his specific arguments are unoriginal, some are unusual (particularly those deriving from the ascendant position he accords to historical and religious "truth" as a basis for judging artistic license).

An *Essay upon Poetry and Painting* is Lamotte's only treatise on aesthetics. His concern with religious and historical truth in art reflects what were probably the two greatest interests in his life—theology and antiquarian studies. Lamotte was a clergyman, fellow of the Royal Society, member of the Society of Antiquaries, and chaplain to the Duke of Montagu. These interests are manifested in the other two of his three published works—*An Essay upon the State and Condition of Physicians among the Antients* (London, 1728) and *The Greatness of God's Works in the Vegetable World* (Stamford [1740]).

Lamotte's *Essay* and Dryden's "Parallel" may be compared profitably because (1) both men are concerned with similar questions and use a similar form of theory in answering them; (2) Lamotte consciously builds on the edifice erected by predecessors such as Dryden; and (3) analyzing the differences between theories which are as similar as those of Dryden and Lamotte effectively defines the unique aspects of Lamotte's position in eighteenth-century aesthetics.

In terms of method, Lamotte is like Dryden insofar as both treat the two arts as means of achieving predetermined ends. But although they share a common critical vocabulary, terms assume different meanings and are used in distinctions of radically different significance. Dryden's primary interest is in drawing exact parallels between the rules of painting and poetry; Lamotte, although concerned with fundamental similarities between the two arts, is equally interested in their "peculiar advantages." For Lamotte, the "truth" of an imitative

work is to be judged ultimately not in terms of ideal nature, as in the "Parallel," but with reference to particulars in nature and historical accuracy. Both arts strive for pictorial effects; at the same time, Lamotte stresses the differences in effects which necessarily result from creating a single visual image (painting) rather than depicting images which change or progress in time (poetry) as well as differences resulting from demands of the various subject matters of the two arts.

Lamotte's primary interest in the *Essay* is apparent from the manner in which he initiates the subject of artistic parallels. Before discussing the similar beauties of painting and poetry and the differences between them, he introduces literary and pictorial examples designed to prove that the two arts partake of identical defects. But before producing specific examples of "bold and inexcusable" licenses, he must indicate the grounds on which these examples are to be judged. Poetry and painting are entitled to a certain amount of license, he says, by their very nature, but Horace (*Ars poetica* 1–13) would not have poets or painters "join Things together that are repugnant and contradictory to each other, that are entirely inconsistent and incompatible" (p. 3). Additional licenses to be condemned, according to Lamotte, are those which pertain to accuracy in chronology (Alexander and Caesar should not appear in the same scene) or to manners and customs.

The extent of Lamotte's indebtedness to traditions of Roman rhetoric is evident. The concept of imitation implicit in his strictures is identical with that found in Horace, Cicero, and other rhetoricians—the mirroring of actual conditions or customs, accurate depiction of objects as they exist in nature, and copying literary models. Similarly, truth refers not to "being and appearance" but to the precise likeness of the imitated object and the imitation, and to whether such events in the work actually transpired.[17]

Lamotte's examples of licenses which "break in upon the age or time" indicate the dominant role accorded to historical and literal accuracy in his conception of art. For instance, faithfulness to historical accuracy is more important than considerations of demands made by specific audiences. Discussing a "blemish" in one of Raphael's paintings, he says that although critics such as Jonathan Richardson (*Essay on the Theory of Painting* [London, 1715]) have said that "faults" often result from the demands of those for whom a picture is painted and ought not to be imputed to the painter, this excuse is not valid since the artist should not "sacrifice his Glory and Reputation to the wrong Taste and Vanity of others" and should have the "same Love of Truth as an impartial Historian" (p. 10).

26

Most of Lamotte's criticisms are objections which Aristotle classifies as accidentally connected with the poetic art (*Poetics* 25. 1460b. 6–32). In Lamotte's essay, rules of decorum are absolute and are not derived from an inductive investigation of principles of artistic construction; rather, they are deemed necessary a priori to the two arts. He assumes that licenses are fundamentally opposed to the manner in which the arts achieve their ends (because such violations necessarily destroy pleasurable effects in a right-minded audience), and, therefore, cannot ask, with Aristotle, whether such licenses are justifiable if they serve the end of art itself.

For Lamotte, the qualities and training of the artist partially determine the effects of the arts. The initial segment of his comparison of the general similarities of the two arts is predicated on the idea that similarity of requirements for the poet and painter necessarily produces identical effects in their works. The idea is a non sequitur. He argues that since the same spirit, universal knowledge of nature, and "Elevation and Sublimity of Genius" are required in the poet and painter, "so these, when they meet together, must of necessity produce the same Effects" (p. 15). He thus ignores questions relating to the nature of different media in his initial comparison.

The remainder of his comparison refers to the ends of art. Lamotte suggests three, taken from "the Learned F[ranciscus] Junius." Both arts seek "to move and affect the Passions, to teach and instruct, and lastly to please and divert Mankind" (p. 15). The confirmation of Junius's claim, he says, lies in experience. He offers a number of examples to prove that poetry and painting instruct and please, urging the reader to consult Junius (*De pictura veterum* [Amsterdam, 1637]) for proof that they move the passions. Lamotte uses *instruct* simply in the sense of providing facts about various practical matters and examples of desirable social and religious behavior. His concept of artistic truth as literal and historical accuracy and his interest in religious topics influence his discussion of instruction in art. It becomes apparent from his definition of artistic ends that artistic worth is judged in terms of a Christian moral outlook. He says that painters are to instruct the "vulgar"; because their works are the pages from which the vulgar learn proper religious and moral behavior, the painter must "have the utmost regard to Truth" (p. 19). But this "truth," for Lamotte, is Christian (more specifically, Anglican); thus, a pagan painter, though he might move the passions, could not instruct or please a Christian audience as effectively as a Christian painter (in Lamotte's system, it would follow that he might move, instruct, and please a pagan audience). Lamotte

does not make such a general appraisal, but it is a valid extension of the principles on which he judges poetry and painting.

Horace's phrase *ut pictura poesis* is quoted on the title page of the *Essay*; it signifies to Lamotte that poetry ought to resemble painting and painting ought to resemble poetry. He treats both as imitative arts which present visual images to the mind. The poet must consider what effect his poem would have if it were a picture; similarly, what appears unnatural on canvas must necessarily have the same effect on paper. There are differences too that result from what Lamotte calls the "nature" of each profession. Hagstrum points out that pictorialists noted the differences between the two arts because they cannot be instructed to resemble each other if they are virtually indistinguishable (*The Sister Arts*, p. 152). Resemblances are necessary for purposes of comparison, but nothing is to be gained from comparing identical substances. Lamotte's distinctions among the arts and among species, however, are made within the framework of the assumption that all imitate by creating visual images; differences relate to objects and manners of imitation, not to a variety of ends dictated by means. Consequently, he establishes a pictorial standard for an essentially visual, spatial art and for a temporal art which is not essentially visual. Of course poetry may convey precise visual images; but, as Burke points out, it need not do so to be affecting (*A Philosophical Enquiry into the Origin of Our Ideas of the Sublime and Beautiful*, 2d ed. [London, 1759], pt. 5).

Lamotte is aware of differences of effects resulting from the use of dissimilar media. His discrimination of the unique strengths of each art is based on the differing "essential characteristics" of each. He does not fully realize the implications of his distinction between simultaneous and progressive effects, however; the standard remains the same for both. Poetry has certain advantages because painting can present only a single visual image whereas poetry can supply them successively. Unlike the painter, the poet is not confined to a single action "which, in its utmost Extent can only answer an Episode in a Poem" (p. 25). Action, as Lamotte uses it, means nothing more than a succession of physical activities. Dryden makes a similar comparison, but he uses it to argue that in this respect there is a more exact parallel of history painting with tragedy than with epic poetry. Lamotte would agree; it is evident that he has epic poetry in mind since he uses Vergil as an example of the range of action possible in poetry. Similarly, he says that poetry can vary its scenes and can depict all the various passions of an individual, whereas painting can show only one. Underlying these judgments is the

assumption that variety necessarily pleases; without variety of scene, the pleasure derived from viewing a picture eventually languishes and finally surfeits the viewer, but poetry, capable of greater variety, can please for a longer time.

The third advantage (that of depicting numerous passions) is not that poetry can represent passions which are impossible in painting (because certain passions are not accompanied by "proper motions" in the countenance and thus afford no material for painting) [18] but simply that painting can depict only a single passion in each figure. Some passions, that is, are mixed, and poetry can better portray the various elements of such a temper. The ideal implied here is still that of exact description and simultaneity of effect; the poet's advantage is that he can create a more detailed and therefore more accurate portrait.

Of the advantages of poetry resulting from the "nature of the art," the last one mentioned by Lamotte directly concerns one of the three essential qualities Junius enumerates—moving the passions. Lamotte claims that poetry is a greater mover of the passions, adding that "in this I foresee I shall have a whole Body of Vertuosi and learned Men against me, as Junius, Felibien; and the ingenious Reflectionist . . . who pronounces in Favour of Painting, declares against me, and brings several strong Proofs to support his Opinion; which I shall not insert here" (pp. 28–29). Du Bos (the "ingenious Reflectionist") argues that painting produces greater effects than poetry because it operates by the sense of seeing and employs natural rather than artificial signs. The sight has a greater influence on the soul than the other senses; words, as artificial signs, depend on education whereas the signs of painting elicit their force directly from the natural relation between the organs of sight and external objects. Poems can only affect by degrees, by first exciting ideas of which they are signs, and these ideas must in turn be digested by the imagination, which forms visual images for the mind. Only then do words affect us. The natural signs of painting operate directly in forming such images; hence their effects are produced more quickly and are stronger (*Critical Reflections*, 1: 321–23).

Du Bos and Lamotte both regard the arts as similar in achieving their effects by presenting visual images to the mind. Du Bos's argument depends on his analysis of the mechanism of causation; he says that the multiplicity of steps involved in converting the signs of poetry into affecting images debilitates the "energy" (or force) of the effect. Lamotte's analysis of poetry contradicts this argument. He bases his belief, he says, on experience. Every day we see that a moving poem or tragedy elicits tears "which we do not, or at least very rarely see done,

by the Sight of the finest Painting" (p. 30). Granting that sight (and therefore visual images) has a greater influence over the soul than the other senses, and assuming that there is a direct natural relation between effect and cause (sight of the external object), Lamotte would disagree with Du Bos's contention that multiple steps between artificial signs and effects debilitate effects because it is not upheld by experience. Lamotte's opinion assumes that tears are the measure of profundity of effects.

He further states that "men will be more apt to weep at a Poem well workt up, though they are sure before-hand it is all fabulous and fictitious, than at the Sight of a Picture whose Action they know to have been real and undoubted Matter of Fact" (p. 30). Although Lamotte uses this argument to prove the power of one *art* over another, the principles invoked challenge his fundamental assumption about the relationship of truth and effects in art. If the art of poetry enables a work which is not historically accurate to achieve greater effects than one which is, are there considerations within an art which would allow licenses in favor of certain effects? He would probably argue that this example of the effect of art has efficacy only when poetry and painting are compared; within a given art, the work which is true to manners, chronology, and natural objects will have greater effects than one which is not. Even assuming that they could have different but equal effects, he might argue in terms of greater goods. The best poems are those which instruct and move the passions; if instruction is impossible when poetic licenses abound, that work which is not guilty of licenses is preferable to one which is, since the former can partake of both essential qualities of the art.

In addition to the advantages of poetry over painting resulting from the "nature of the art," Lamotte enumerates three which are "casual and accidental." One[19] is that poetry "is sure to have more true Admirers" than painting. A "true" admirer is defined as a competent judge. Painting has more admirers because its language (what Du Bos calls natural signs) is understood by all men, but the majority are not judicious, for they may simply be affected by bright colors (pp. 31–32). The argument is similar to Dryden's explanation of the pleasurable effects of imitation. For both writers, art is subordinated to the audience in the double sense that it owes its existence to man's instinctive pleasure in viewing imitations (pleasure in apprehending truth) and that its worth is ultimately determined by a discerning public. For both, verification of artistic value does not rely on the experience of all audiences; as Dryden states, it is not what pleases but "what ought to

please" that determines merit (2: 136). The competent judge, versed in the rules of art and the practice of the ancients, determines the standard of taste. If art is dependent on nature for its objects of imitation and for the source of pleasure in imitation, it is also independent of nature insofar as it provides rules and criteria for correcting and imitating nature.

The advantages which Lamotte attributes to painting result from its ability to achieve simultaneity of effect and from its capacity for creating precise visual images of things which words describe with difficulty. His observations that painting is quicker in its operation and that it discloses an entire scene at once had been made by Dryden, Du Bos, and Richardson.[20]

Of the advantages of painting over poetry, the one which Lamotte considers most significant is based on considerations of subject matter and derives from his conception of the manner in which instruction is possible in the arts. He argues that there are numerous "useful Notions, that serve to enrich and improve the Mind, which can never be expressed by Words, and can only be conveyed by Painting and Drawing" (p. 39). Lamotte assumes that knowledge is conveyed by sensible images; but words present obscure images of certain subjects, whereas painting is more precise. He argues that images pertaining to geographical description, mathematics, gardening, and architecture are better suited to painting than to poetry, concluding that "if the Excellency of an Art is not to be determined by the Pleasure, but by the Benefit and Usefulness it brings along with it, I dare pronounce in behalf of Painting, and assert that it is as much superiour to Poetry, as the Utile is preferable to the Dulce, and the enriching and improving the Mind to the moving and affecting the Passions" (p. 41). For Dryden, instruction concerns imitating the best nature, while Lamotte restricts it to conveying accurate visual images of useful subjects; hence the two men draw radically different conclusions about the instructional value of the two arts.

One could challenge Lamotte's argument by objecting to the pictorial standard he sets for instruction in poetry, but even if we accept his assumptions about the ends and means of the two arts, his conclusion is not justified (at least, the manner in which it is expressed appears excessive). In discussing the advantages of poetry, he remarks that painting can show only one passion in a single figure, but poetry can describe the complexity of mixed tempers (pp. 26–28). If so, it follows that there are subjects (such as character) about which poetry can better instruct than painting even when the ideal remains that of

precise accuracy. Nor is it clear that painting can better instruct in matters relating to abstract ideas. In terms of all of his critical principles, Lamotte's conclusion that painting is superior to poetry if excellency in art is determined by usefulness might more consistently be qualified to a statement that "relating to instruction, some subjects are better suited to painting while others are more appropriate to poetry."

Lamotte's *Essay* and Dryden's "Parallel" are alike in that both seek rules and governing principles of poetry and painting in the conventional precepts of the arts and the actual practices of poets and painters. Dryden's major concern is the comparison of rules which are deduced from the examples of painters and poets and from critical systems which are based on artistic models. Lamotte's assumptions about the arts are similar and his principles are derived in a like manner. However, he has read Du Bos's *Réflexions critique sur la poésie et sur la peinture* and has been impressed by it; his discussions of poetry's superior ability to move the passions and of the "quickness" of effects in painting manifest some interest in explaining artistic effects in terms of natural causes. Such analyses are of primary importance in Du Bos's essay; Lamotte does not analyze natural mechanisms of cause and effect, but he does have some acquaintance with the results possible from these analyses.

Lamotte stresses differences between the two arts to a greater extent than Dryden, partly because he is more interested in artistic "faults" and advantages which raise questions about variations of simultaneous and successive effects, and partly because establishing similarities is more important for Dryden's immediate purposes. Lamotte is aware of problems relating to differences between spatial and temporal forms of art, but they are colored by and ultimately subordinated to his central concern with licenses in the two arts.

Chapter Two

Mid-Century Pluralism

James Harris: Art as Mind Shaped by Medium

Among eighteenth-century comparisons of the arts, James Harris's
"A Discourse on Music, Painting and Poetry" [1] is distinct from those
(such as Dryden's "Parallel" and Lamotte's *Essay*) in which the arts are
regarded as conventionally established modes striving for similar effects
and sharing similar rules which form the basis of parallels. It also differs
from those (such as Daniel Webb's *Observations on the Correspondence
Between Poetry and Music* [1769] and Sir William Jones's "On the Arts
Commonly Called Imitative" [1772]) in which the primary problem is
the discovery of natural psychological causes which account for the
effects common to the arts. [2] Unlike Lamotte, who assumes that
similarity of requirements (genius, experience, judgment) for the poet
and painter leads to similarity of effects in their works, Harris
discriminates among the arts in terms of their different media; and
unlike Jones, who assesses artistic effects in relation to the communica-
tion of passion through the universal psychological phenomenon of
"sympathy," Harris evaluates the arts (1) in regard to their respective
ability to imitate accurately and (2) in terms of the inherent worth of
subject matter to which each art is restricted as a consequence of its
media.

In the essay "Concerning Art, a Dialogue," which precedes the
"Discourse," Harris discusses art in general in terms of Aristotle's four
causes. A brief examination of Harris's equation of art with mind in the
"Dialogue" may help elucidate his final judgment in the "Discourse"
that the subject matter of poetry is superior to that of music and
painting because it contributes to a "master-knowledge," to that "which
constitutes to each of us his true and real Self" (p. 89).

The "Dialogue" is an attempt to discover that which is common
to all the arts. Harris's account of the efficient cause serves as his
definition of the idea of art in general: "an habitual Power in Man of
becoming the Cause of some Effect, according to a System of various

33

and well-approved Precepts" (p. 17). All art is a cause of some effect, but since not all cause is art, art implies volition and consciousness. Furthermore, consciousness must be founded in experience or practice (that is, habit) to distinguish it from instinct. Thus, for Harris, art is distinct from the "unconscious causes" of the natural and animal world and from divine power which is originally perfect and cannot admit of learning. Finally, to distinguish art from "the meanest Trick of a common Juggler," consciousness must be regulated by numerous rational, historically approved precepts (pp. 6–17).

In his discussion of the material cause of art, Harris distinguishes between "contingent" and "necessary" nature. Contingent being is that which is subject to change and motion, whereas that which is necessary is not; art is concerned with contingent being because art is a cause and causes operate by motion or change. Thus truth, knowledge, and the intellectual essences of things are not proper subjects of art. Not all contingent natures are reducible to art, either; the higher contingents (planetary systems, seasons) which proceed without disturbance are exempt. Hence the material cause of art is defined as "all those contingent Natures, which lie within the reach of the Human Powers to influence" (p. 22).

That from which art has its beginning, the reason for which it comes into being (that is, the final cause) is "the Want or Absence of something appearing Good; relative to Human Life, and attainable by Man, but superior to his natural and uninstructed Faculties" (p. 29). As Harris uses it, "good" includes that which contributes to enjoyment as well as that pertaining to physical comfort. The formal cause of art is either "work" or "energy"; that is, art terminates in productions, the parts of which are coexistent (a work) or successive (an energy). A painting or a statue is a work, whereas music, sailing, and life are energies since their natures exist in succession or transition (pp. 32–36).

Having defined the causes of art, Harris concludes the "Dialogue" with the "fragment of an essay" praising the power and dominion of art. Art is addressed as the highest form of human life, that which teaches man to "assume that Empire, for which Providence intended us" (p. 38). The "wide and extensive" domain of art embraces inanimate and animate subjects of the material world. These subjects, however, are inferior, "at best irrational" (p. 41). It is when art "choosest a Subject more noble, and settest to the cultivating of Mind itself" that it becomes truly "amiable and divine." The moral quality of instructing mind is the highest form of art; the source of these subjects is the mind as efficient power. The active principle of mind shapes the material of the rational

mind to create the highest form of art. Considered as the source of sublime beauty, "by what Name shall I address Thee? Shall I call Thee Ornament of Mind; or art Thou more truly Mind itself? 'Tis Mind Thou art, most perfect Mind; . . . of such Thou art the Form" (p. 42).

Harris is not contradicting his earlier statement that necessary subjects such as truth and intellectual essences are beyond the reach of art. The analogy is with divine power; necessary subjects contain their own principle of perfection and their own causes in permanent union. In art, the efficient power does not inhere in its subject matter; the works or energies of human art exist as a result of the operation of efficient cause on material cause.

Harris's description of the power of art as the noblest form of mind clarifies his appraisal of the relative merits of the subject matters of the arts in the "Discourse." The ideal of moral perfection inheres in the mind of man and can best be approached not through sensory forms or through "irrational subjects," but through the representation of forms which approximate the true intellectual concept of perfection. In the moral world, knowledge depends not only on sense but on the "express Consciousness of something similar within; of something homogeneous in the Recesses of our Minds" (p. 89). In other words, Harris is arguing that the forms of the highest art correspond to innate ideas of perfection, the apprehension of which enables man to achieve "his true and real Self." The efficient power of art is the form of the most perfect, rational mind. The master knowledge without which "all other Knowledge will prove of little or no Utility" (p. 87) can only be acquired through subject matter which corresponds to prior mental ideas. If we combine this criterion for the highest art with a consideration of poetry's "artificial" media, it is not difficult to see why Harris argues that poetry is a higher art than painting or music. Poetry can best imitate those subject matters which are most affecting, most improving, and admit of the strongest comprehension. Expressed in the conceptual terms of the "Dialogue," the efficient power or form of mind shapes the matter of mind to produce the greatest possible effects in human art.

As the "Dialogue" defines that which is common to all arts and suggests a criterion for evaluating the subject matter of art by identifying the efficient power of art with the highest form of mind, the "Discourse" attempts "to treat of Music, Painting, and Poetry; to consider in what they agree, and in what they differ; and which upon the whole, is more excellent than the other two" (p. 55). Harris distinguishes between arts relating to necessity (medicine, agriculture)

and to elegance (music, painting, poetry), arguing that if "well-being" is preferable to "mere-being," the elegant arts have some claim to superiority. If we are to avoid misreading Harris, it is essential to note that he is not establishing a simplistic "utile-dulce" distinction, such as that in Lamotte's essay. Well-being does not connote amoral pleasure; Harris's preference for poetry is a judgment concerning moral worth. In one sense, the most elegant is the most "useful."

Although the mind is made aware of the natural world and its affections through all the senses, these three arts use only two (seeing and hearing) in imitating "either Parts or Affections of this natural World, or else the Passions, Energies, and other Affections of Minds" (pp. 55–56). Thus they can imitate only in media appropriate to these senses: motion, sound, color, and figure. But if Harris is to account for the full range of possible subjects in any art, he must discriminate the difference in relationship between subject and sense and media and sense. If media must be relative to the apprehending sense, the subject matter imitated need not; it may be "foreign to that Sense, and beyond the Power of its Perception" (p. 56n). Harris means that a painting, for example, can imitate an action, which is not a color and figure.

The arts are alike in that all are imitative, and differ by utilizing different media. As painting uses color and figure, music is restricted to sound and motion. When words are considered as mere sounds, poetry is also restricted to sound and motion. However, when words are considered not merely as sounds but as having meaning by "compact," it can imitate all that "language can express" (p. 58). Music and painting use media which are natural, whereas the medium of poetry is primarily artificial. The distinction is of central importance because it provides the basis on which the subject matter of poetry is later judged to be of greater value. Moreover, it distinguishes Harris's essay from earlier treatises in which standards of visual accuracy are posited for pictorial *and* verbal arts. Harris rejects the *ut pictura poesis* doctrine of Dufresnoy. Painting may achieve greater visual effects than poetry in regard to some subjects, but Harris's argument clearly implies that poetic effects are not to be judged in terms of single or successive visual images since poetry's artificial medium extends its dominion to subjects (such as the "internal constitution" of man) which are not suited to painting.

The subject matter of each art is determined by its medium. To understand Harris's evaluation of each art, it is important to see that his judgment of their respective abilities to imitate accurately also results directly from his analysis of the various media. Moreover, *accurate*

imitation, though a means of ranking, is not the ultimate criterion, as it is in Lamotte, for assigning artistic value. The subjects most properly suited to the media of painting (figure and color) include all objects, motions, and sounds which are apprehended by obvious visual effects, "energies" [3] and passions of the soul which are intense enough to produce visual physical changes, and actions which (1) are sufficiently short and self-contained to be represented visually in a single moment, (2) have incidents similar enough to allow the viewer to infer the whole from a part, (3) have many parts occurring in the same moment of time, or (4) are universally known (pp. 61–64). In regard to universally known actions, Harris quite justly remarks that it is questionable whether the favorite subjects of history painting (those regarded by Dufresnoy, Dryden, and Lamotte as the most noble) would have been intelligible through the media of painting alone. Harris uses the argument to illustrate the limitations of various media. Other writers in the first half of the eighteenth century make similar observations but fail to recognize the resulting implications for aesthetic theory. For example, Lamotte also notes the unintelligibility of pictorial subject matter, but he uses this recognition simply to argue that, although painting and poetry strive for similar effects in representing such subjects, the painter must be especially careful to observe rules of decorum in avoiding errors that vitiate the office of instruction (*An Essay upon Poetry and Painting*, pp. 50–51).

Since motion "may be either slow or swift, even or uneven, broken or continuous" and sound "may be either soft or loud, high or low," the proper subjects of music are those in which any of these species of sound exist "in an eminent (not a moderate or mean) degree." These range from roaring water in the inanimate world to the shouts of a crowd in the animate world.

In terms of their imitative abilities, painting is judged superior to music since painting can precisely imitate those colors and figures which distinguish individuals (as well as species) and most of the passions and energies of each individual, whereas music can imperfectly imitate only classes of sounds and motions. Moreover, in respect to subject matter, while painting "is equal to the noblest Part of Imitation, the Imitating [of] regular Actions consisting of a Whole and Parts" (p. 69), music is not. It is not surprising that Harris, acknowledging music's undeniable affective power after having shown that its media preclude imitating many subjects, turns to a concept other than imitation to define musical effects. Later in the "Discourse," he states that music's efficacy lies in "the raising [of] Affections, to which Ideas may correspond" (p. 99). In

comparative discussions throughout the period, one of the most troublesome problems is defining the value of "pure" music. Harris evades the problem by discussing the "greatest power" of music in terms of its strength when joined with poetry. There is no reason to fault him for doing so because his primary concern is with the imitative aspects of art. He has already shown that music does imitate, but that its greatest power is non-imitative; hence his concern here is merely to suggest additional sources of musical effects.

In doing so, he assumes a special, direct connection between certain sounds and sentiments (some sounds automatically make us sad, others cheerful, and so forth). There is also "a reciprocal Operation between our Affections, and our Ideas; so that, by a sort of natural Sympathy, certain Ideas necessarily tend to raise in us certain Affections; and those Affections, by a sort of Counter-Operation, to raise the same Ideas" (p. 96). Hence ideas derived from external causes may produce different effects in individuals depending on what affection prevails. If the ideas raised are in sympathy with the prevailing affection, the resulting impression is stronger than if they conflict. When the two arts cooperate, the power of poetry is enhanced if the ideas it raises complement the affection which music has already raised. Harris argues that the heightening of effects resulting from such a union amply atones for the breach of natural probability involved when a poem is sung (as in opera or oratorio).

Despite the brevity of his analysis of music, Harris raises questions that recur later in the century. His "Discourse" is frequently referred to, often by men of some influence: Charles Avison, in his investigation of musical expression, relies heavily on Harris's conclusions concerning the imitative powers of music. Although he does not attempt a detailed analysis of the relationship between "sound and sentiment," the idea that there is a special connection is a persistent one after Harris in the eighteenth century; later writers, particularly those interested in psychological or physiological explanations of aesthetic responses, were eager to investigate the mechanisms through which music is consecrated to the passions.

After enumerating the proper subject matters of painting and music and judging painting superior to music as an imitative art, Harris contrasts the imitative nature of the natural medium of poetry (words as mere sounds) with those of painting and music. In its natural medium, poetry is inferior to painting, which is more precise, and approximately equal to music. But when poetry is considered in its artificial medium (words as significant sounds), its power is much greater; it can find

sounds to express every idea and may thus present all pictorial and musical subjects. Poetry is inferior to painting in regard to those subjects which are "principally and eminently characterised by certain Colours, Figures, and Postures of Figures—whose Comprehension depends not on a Succession of Events" (pp. 76–77). Painting is a superior means of imitation (more similar, immediate, and intelligible) in those subjects in which its powers can be exerted fully because (1) it appeals directly to the mind through natural media, which are necessarily more affecting than artificial ones; (2) it can supplement mental ideas with ideas of its own, whereas poetry can only raise ideas with which the mind is already furnished; and (3) it relates all details in a single moment of time in the same manner in which natural objects are presented to the mind, whereas poetry must provide details that risk tediousness or obscurity. But even in subjects in which music can exert its greatest efforts, poetry is superior as an imitative art because music, though employing natural media, can raise ideas that are only similar to the subject imitated, whereas poetry can reproduce the idea definitely (pp. 77–91).

There remain, however, subjects that poetry is better adapted to imitate than the other arts. There are successive actions so lengthy that painting cannot indicate the nature of the whole by presenting any single "point of time," and "all Subjects so framed, as to lay open the internal Constitution of Man, and give us an Insight into Characters, Manners, Passions, and Sentiments" (pp. 83–84). Poetry can more accurately imitate such subjects, but imitative accuracy is not the source of Harris's preference for poetry. Rather, it is a factor in evaluation only insofar as poetry's artificial medium allows poetry to imitate subjects beyond the scope of other artistic media. There is no doubt that for Harris the ultimate preference of poetry to painting and music results from the intrinsic worth of these subjects. They are necessarily the most affecting because we are most closely concerned with their subjects (human actions) and most improving because the just representation of the sentiments and manners of men enables the spectator to acquire knowledge by contemplating the true internal moral order. Since the rational mind has "strong Ideas" of that which pertains to the moral world, it clearly comprehends such subjects. Earlier in the "Discourse" Harris states that poetry raises ideas with which "every Mind is furnished . . . before" (pp. 77–78); we have seen that his equation of art with the highest form of mind at the end of the "Dialogue" allows the judgment that the highest art is that in which the most affecting, instructive, and strongly comprehended matter is

"imitated" by the efficient cause. Poetry provides the opportunity for the reader to attain knowledge of the moral world by representing that which corresponds to the reader's "true and real Self." As Marsh observes (*Four Dialectical Theories of Poetry*, p. 144), Harris's conception of the "universal forms" of poetry is not Aristotelian. Gordon McKenzie errs in stating that Harris's writing "consistently presents an undiscerning Aristotelianism" and "even suggests the phrasing of the *Poetics*." [4] For Aristotle, universality of form refers to principles of probability and necessity residing in the work rather than to true, preexistent ideas inherent in the minds of rational men.

For Harris, then, painting is superior to poetry only in imitating those subjects for which its media are best adapted, but poetry can present certain subjects that are beyond the power of the other arts. These subjects are uniquely suited to provide knowledge of man's moral nature; it is upon this basis that poetry may lay claim to superiority: "Poetry is therefore, on the whole much superior to either of the other Mimetic Arts; it having been shewn to be equally excellent in the Accuracy of its Imitation; and to imitate Subjects, which far surpass, as well in Utility, as in Dignity" (p. 94).

Harris's conclusion stands in marked contrast to Lamotte's statement that painting is "as much superiour to Poetry, as . . . the enriching and improving the Mind to the moving and affecting the Passions" (*Essay*, p. 41). For Lamotte, successful artistic "instruction" depends on visual accuracy, and the truth of an imitation depends on the confirmation of sensory experience. Both men consider painting and poetry imitative arts; but for Lamotte, poetry, like painting, imitates not innate moral ideas but natural objects and historically verifiable manners. To equate the arguments of Harris and Lamotte, as Atkins has done (*English Literary Criticism*, p. 345), is to emphasize superficial similarity of statement while ignoring fundamental differences of critical assumptions and methods. In context, similar "points" lead to radically different conclusions about the value of poetry. And surely Atkins does not mean to include Harris when he says that beyond "discriminating between the functions of the arts—description being that of painting, action that of poetry—English critics did not go. It was left for Lessing to point to the significance of the facts, namely, that the difference of function was necessarily determined by the difference of medium." [5] It is precisely upon the "significance of the facts" that Harris bases his argument; poetry is superior to the other arts because its subject matter is of greater worth, and the subject matter of each art is in turn determined by the natural powers and limitations of its

respective media. Atkins's statement does provide some measure of Harris's achievement. Drawing "parallels" that overlook essential differences in media can easily lead to the requirement that one art do what another art is better suited to accomplish. It is to Harris's credit that he recognizes the most fundamental implication of differences in artistic media—that evaluative principles must take into account the unique properties of each art.

"The Polite Arts": Platonism and the Anglicization of Batteux

The Polite Arts, or a Dissertation on Poetry, Painting, Musick, Architecture, and Eloquence was published anonymously in London in 1749, five years after the appearance of Harris's *Three Treatises*, and has a peculiar status among eighteenth-century comparative discussions of the arts. Although part of it is apparently original, more than three-fourths consists of a direct translation of sections of Charles Batteux's *Les Beaux Arts réduits à un même principe*, first published in Paris in 1746.

It is not surprising that *The Polite Arts* has been credited with an originality that it does not possess. In the first (and only) edition there is no acknowledgement that it is primarily a translation, nor has it been listed as such in standard bibliographies of eighteenth-century British works.[6] Indeed, several aspects conspire to conceal its source. For example, the author/translator substitutes British for French literary examples in support of theoretical arguments, drops all material (such as Batteux's analysis of the harmony of the French language) which gives *Les Beaux Arts* a peculiarly French flavor, refers to current British actors and actresses, carefully makes the original sections militantly British (through such means as discussing specific British buildings in detail in the chapter on architecture), and uses such phrases as "our British Orators" (p. 56) and "our English songs" (p. 124). Moreover, the Dedication creates the impression of originality ("I had determined from the Time of beginning this Dissertation . . ." [p. vii]); ironically, phrases which attempt to portray the author as a humble man cautiously seeking public approval have a quite different effect when viewed in the context of literary thievery ("The World, 'tis true, will think me very daring thus to offer my Work to so eminent a Gentleman. . . . I confess I am very daring" [p. vi]).[7]

Only three whole chapters (18, "Rules and Uses of Comedy"; 23,

"Of Eloquence"; and 24, "Of Architecture") and part of another (16, "Of Tragedy") are not taken from *Les Beaux Arts*.[8] The translated material frequently omits or compresses sentences, paragraphs, or whole sections from the original, and rearranges the parts of *Les Beaux Arts*; moreover, the author/translator attempts to anglicize this material by making a number of additions and substitutions of examples familiar to British audiences. If changes, additions, and omissions serve to anglicize *Les Beaux Arts*, they also diminish its worth and occasionally obscure its meaning. The coherence which Batteux gains through systematic organization, for example, is partially replaced by a disjointedness resulting from the author/translator's shuffling of sections. Similarly, the material found in chapter 12 of *The Polite Arts* (which constitutes part of Batteux's introduction to part 1 of *Les Beaux Arts*) is presented as a serious statement of poetry's relationship to the other arts, whereas Batteux uses it as a characteristic example of inadequate arguments which he will refute; by omitting part of Batteux's introduction, the author/translator inverts the sense of this passage.

We have, then, both more and less than a translation, whose chief historical importance lies in introducing Batteux's ideas to British audiences without acknowledging the source of those ideas. *The Polite Arts* can be analyzed in its own terms and in the context of the continuing dialogue in this branch of British aesthetics without constant reference to *Les Beaux Arts* as long as we are aware that virtually all descriptive and evaluative comments regarding the primary arguments and significance of *The Polite Arts* also apply to *Les Beaux Arts*. To avoid confusion in the ensuing discussion, the man responsible for *The Polite Arts* is simply referred to as "the author," [9] with the understanding that "the author's conception of x or y" may, except where noted, be read "Batteux's conception of x or y."

Herbert M. Schueller notes that *The Polite Arts* "reflects a Platonism fairly uncommon in the middle part of the 18th century in Britain." [10] Platonism of any kind is unusual in mid-eighteenth-century British or Continental aesthetics; the "Platonism" manifested here consists of the borrowing of Platonic terms and concepts largely divorced from Platonic methodology. Interest lies primarily in the manner in which Platonic doctrines, problems, and terminology are given meaning in what is essentially a non-Platonic system.

The basic concern of *The Polite Arts* is to define an "ideal imitation" of nature common to all the polite arts and by which individual works can be judged. Of the various aspects of artistic creation—the artist, the subject matter, the work itself, and the effect

on the audience—the most important single element in *The Polite Arts* is the knowledge of what is to be imitated. The author's treatment of the artist, work, and audience is determined by and subordinated to the central principle that it is through the imitation of an ideal beauty that the arts achieve their greatest effects.

Harris's "Discourse" and *The Polite Arts* have numerous similarities of general interest and doctrinal statement:[11] both are concerned with the imitative nature of the arts, both distinguish between arts relating to necessity and those primarily concerned with "elegance" or pleasure, and both analyze the expressive nature of musical sounds. Similarity of statement in the two occurs because both are concerned with terms and doctrines derived from Plato, but the similarity is not one of principles and method. The differences in principles and method between the two works are fundamental. The author of *The Polite Arts* formulates the principal problems of his essay in a less Platonic manner than Harris. Artistic value, for example, is judged not in terms of the moral or instructional merit of subject matter but as a means of communicating pleasurable qualities, and ideal form refers not to permanent, immaterial, informing ideas but to ideas of beauty collected from the scattered beauties of material nature.

The author's conception of the ends of the arts differs radically from Harris's (or those of Dryden and Lamotte). He distinguishes among three "kinds" of arts: those which relate to physical comforts and necessities, those which have pleasure as their object, and those which combine usefulness and pleasure. The first category includes mechanic arts, the second the polite arts (music, dancing, painting, poetry, and sculpture), and the third the arts of eloquence and architecture. If the artist strives merely to please, the author's rules will necessarily differ from Dryden's or Lamotte's, even though all seek to improve taste. And by classifying poetry as an art which has pleasure as its primary end, the author's departure from both Plato and Harris is immediately evident. If the arts are to be judged solely on their ability to produce pleasure, the author cannot prefer poetry to the other arts, as Harris does, on moral grounds. His position is closer to that of Horace, for whom the birth of poetry is to delight the mind (*Ars poetica* 377). In *The Polite Arts*, the entire problem of instruction in the arts is made irrelevant by the basic assumption that the arts are to please, unless it is found that the way to please is to instruct. But it is evident that moral instruction is not considered essential to pleasure. Mankind, "unsatisfied with too scanty an Enjoyment of those Objects which simple Nature offered . . . had Recourse to their Genius, to procure

themselves a new Order of Ideas and Sentiments" (pp. 7–8) to amuse their wits, thereby enlivening their taste. Hence the essay's chief question becomes: How can the polite arts best please?

Given this objective, the author could conceivably locate the source of a "new order of ideas and sentiments" either in unfettered, inspired genius or in the natural world experienced by the senses and ordered by the rules of nature. However, his assumption that genius is necessarily confined to the natural sensory world precludes the possibility of divine inspiration. But if man cannot transcend nature either in his productions or his perception, he can improve upon nature's individual productions. The polite arts are based upon the principle that the artist is "to make choice of the most beautiful Parts of Nature, to form one exquisite whole which should be more perfect than mere Nature, without ceasing however, to be natural." Since artistic practice has been based on this principle, he concludes: "First, That Genius which is the Father of Arts, ought to imitate Nature. Secondly, That Nature should not be imitated, such as she is. Thirdly, That Taste, for which Arts are made, and which is their Judge, ought to be satisfied, if Nature is well chosen and well imitated by the Arts. Thus all our Rules should tend to establish the Imitation of (what we may call) *beautiful Nature*" (pp. 8–9).

This definition of ideal form differs from both Plato's and Harris's conceptions of first or highest forms. In *The Polite Arts*, perfect forms do not refer to innate ideas existing in all rational minds, nor do they afford moral instruction; instead, they are means of affording pleasure, result from the active synthesizing faculty of the artist, and exist only in his mind. This concept of ideal form does, however, bear similarity to the "perfect state of Nature" described by Sir Joshua Reynolds twenty-one years later in the third (1770) of his fifteen *Discourses on Art*. In the *Discourses* and in *The Polite Arts*, the ideal is earthly even though the accomplished artist is freed from particular objects of the natural world. The source of ideal beauty for Reynolds is subject matter as constructed by the imagination. The imagination functioning as a separate faculty, rather than perception, is responsible for revealing abstract beauty. "Enthusiasm" in *The Polite Arts* plays a somewhat analogous role, although the author does not clearly distinguish it from sensory perception.

In Harris's "Discourse," the poet is not dependent on the single impressions of material nature for the highest subject matter. The relationship between art and nature in *The Polite Arts* is complex, a complexity resulting from the author's conceptions of the end and

subject matter of art. If art is distinct from and superior to nature in providing a set of rules by which ideal forms can be apprehended and imitated, it is also dependent on nature as the prototype of the arts; nature provides the subject matter of art and the principle which determines pleasure insofar as it "contains all the Plans of regular Works, and the Designs of every Ornament that can please us" (p. 10). Moreover, the function of the arts is to present natural beauties in "objects to which they are not natural," which, in turn, is the source of the author's contention that the arts represent "not the true, but the probable"—an important distinction because it helps define the province of each art. Unfortunately for later arguments, the "truth/probability" dichotomy confuses means with objects of imitation. The painter's canvas and the sculptor's marble statue are "artificial" when compared with the individual productions of nature, which do not derive their form from an external principle of art; but it does not follow that the subject matter imitated in art is "probable" rather than "true." Obscured is the distinction between the work as an object and the work as an imitation. The author limits "truth" to natural reality, to individual objects and occurrences in nature, and "probability" refers to ideal art forms.

Despite a reference to chapter nine of the *Poetics*, this concept of probability is entirely unlike that of Aristotle, for whom rules of probability inhere in the individual work and vary according to the nature of the material presented. The author of *The Polite Arts*, however, assumes that probability is the basis of all artistic works because they are of a similar kind, in which all seek the same end by representing identical matter. Considerations of probability do not vary from work to work or from genre to genre because the universal forms presented in art operate on the principle that pleasure is derived from the probable. For Aristotle, there is no single rule of probability which applies to all poetic works regardless of subject matter and ends; but in *The Polite Arts*, the author's definition of artistic subject matter and ends makes identical considerations of probability relevant for all works.

This universal principle of probability distinguishes the author on the most fundamental level from pictorial theorists like Lamotte, for whom probability refers to the precise imitation of natural particulars and to historical accuracy. For the author of *The Polite Arts*, poetry and sculpture cannot justify bad performances by claiming verisimilitude "because it is not the True but the Beautiful that we expect from them" (p. 36). The polite arts are to produce pleasure; the means of producing

pleasure is through the representation of ideal forms; the ideal forms of art depend on probability rather than truth; thus a just copy of a particular (truth, reality) is not the measure of artistic worth, as it is for Lamotte, because it does not necessarily relate to the source of artistic pleasure (the recognition of ideal form). Hence the type of painting which allows Lamotte to classify painting as a more instructive art than poetry because it can precisely reproduce natural particulars cannot receive the same evaluation in *The Polite Arts*. The difference in judgment is not one of taste; it results from the use of principles based on dissimilar assumptions about the sources of pleasure derived from nature and art.

As the author's use of "probability" is not Aristotelian, neither is his conception of fiction as the matter of the arts Platonic. In the *Republic* the imitations of painting and poetry are "fictitious" in that they are twice removed from true ideas; they produce only the appearance of that which is in turn a copy of ideal form. But in *The Polite Arts*, poetry and painting are fictitious because they present ideal forms which are abstracted from the reality of particular natural objects. Thus a painting or poem is "untrue" in the sense that it presents forms which are not found in the reality of the material world, not because it is removed from the essential ideas which inform the material world.

The author of *The Polite Arts* initially defines art in terms of subject matter. His treatment of the artist is determined by the central principle of general ideas and at the same time adds another element to the governing principle of the essay. The concept of general ideas is evolved in this manner throughout the essay. "Ideal beauty" is first discussed as subject matter, then in relation to the artist, and finally with respect to the audience; only then is a final definition of artistic value offered. Since the artist's role is discussed in relation to ideal beauty, the primary requirement is that the artist study nature to derive those generalized forms appropriate to each subject. In addition, however, synthesized subject matter must be infused with life by "enthusiasm."

The introduction of this term *enthusiasm*[12] allows the author to complete his definition of the proper subject matter of art and to introduce questions involving taste, the ultimate judge of art. The proper subject matter of art is ideal nature represented to the mind through enthusiasm. It is through an analogous process of synthesis (which in its highest development recognizes and is affected by enthusiasm) that taste operates. A corollary unstated assumption is that

46

works which are not wholly successful fail either because they appeal to the senses rather than to the mind by copying particulars, or because the artist's synthesis does not approximate the spectator's idea of perfect nature or of perfect artistic form. The introduction of considerations of the audience thus allows for the final ingredient in the definition of artistic value: the apprehension of ideal "natural" beauty in an ideal art form.

The controlling device through which terms are defined and values established in *The Polite Arts* is a process of generalization from particulars to ideas. The process of opposing the individual to the general forms the basis of the author's discussion of artist, work, and audience, as well as subject matter. As the subject matter is generalized nature, the artist must study individual natural beauties and synthesize them, benefiting from a knowledge of various perfections of past artists. Similarly, the work itself creates a new "Order of Elements" by the operation of the artist's enthusiasm on his materials. Finally, the faculty of taste abstracts an idea of perfection from individual works of a given kind; the highest taste is that which is based on the breadth of experience and strength of mind (emotions, imagination) necessary for a highly developed concept of ideal beauty. To arrive at perfection of taste in poetry, for example, the best works of each kind are to be read, their individual qualities abstracted, and an idea of perfection conceived. With regard to this aspect of methodology, the author and Reynolds are very similar. The major terms of Reynolds's *Discourses* are defined through a nearly identical process of opposing the general to the particular, thereby establishing a set of values for determining both the grand style and taste (excellence in the work and sensitivity in aesthetic response).

Of the various generalized elements in artistic creation in *The Polite Arts*, the most important—because it serves as the basis for comparisons among the arts—is the concept of subject matter as ideal nature. Like Harris, the author claims that painting, poetry, and music imitate; but unlike Harris, he assumes that the arts share a common subject matter. Hence his consideration of the various media necessarily differs from Harris's. The author concurs with Harris in designating the senses of seeing and hearing as those to which the arts are limited. Painting, sculpture, and "gesture" (dancing) appeal to sight, while music and poetry are confined to sound.[13] Thus "Painting imitates Nature by Colours, Sculpture by Relievos, Dancing by the Motions and Attitudes of the Body, Musick imitates it by inarticulate Sounds, and Poetry by Words in Measure" (p. 30).

Since the various media through which ideal nature is imitated do not produce identical pleasurable effects, the author's treatment of each art and of the various poetic "kinds" attempts to determine the effects appropriate to each media and to analyze the principles of pleasure on which various effects are based. More accurately, he makes such efforts in his discussions of music and poetic kinds. Of painting, he simply remarks that design and coloring are exactly parallel to fable and versification in poetry (pp. 46–48). Although he recognizes differences in the media of painting and poetry (pp. 29–30), he does not try to define the peculiar pleasures of painting. Apparently he assumes that its effects are identical to those of poetry, thus failing to profit from Harris's perception that differences of subject matter and possible effects necessarily follow from differences in media.

His account of music and dancing, however, does seek to establish principles which explain the unique pleasures of these arts and serve as a basis for rules. He argues that there are three means through which man expresses ideas and sentiments—words (poetry), tone of voice (music), and gesture (dance). The latter two have several unique advantages: they are more natural and universally understood, and, more significantly, "they are consecrated in an especial manner to our Sentiments" (p. 50). As speech "convinces" the reason, tone and gesture "move" the heart: "Speech expresses Passion only by means of Ideas, to which Sentiments are affixed, and as if by Reflection. The Tone and Gesture go directly to the Heart. Speech expresses Passions by naming them: if we say, I love you or I hate you, and don't join some Gesture and Tone to the Words, we rather express an Idea than a Sentiment" (p. 51). The distinction between idea and sentiment serves as the basis for the author's discrimination of musical from poetic effects.[14] The end of music is to "move the Soul"; tone is peculiarly suited directly to achieve this end; thus the rules of music must pertain to the ordering of tones for the purpose of obtaining the maximum pleasurable effects possible from moving the sentiments.

Despite the use of Platonic terms and doctrines, the author treats poetry rhetorically, much like Dryden and Lamotte, as a means of achieving predetermined effects through prescribed modes. As in music, the design of poetry is "to please in stirring the passions" (p. 63), although poetry's domain is greater than that of the other arts. Poetry pleases in a number of kinds; hence each poetic "species" is discussed individually. In *The Polite Arts*, these species are not treated as products of natural psychological causes (as in Beattie or Jones) or defined in terms of peculiar intrinsic principles of artistic construction (as in

48

Aristotle or Fielding's prefaces); rather, they are viewed, much as in the *Ars poetica* of Horace, "according to the common Signification . . . established by Custom" (p. 82) (that is, as kinds conventionally restricted to certain subject matters and effects). Individual works within each species are judged in accordance with their ability to imitate ideal nature. However, there is a unique ideal nature appropriate to each species, the imitation of which produces distinctive effects based on rules prescribed for each kind.

The poetic kinds (and their respective rules) discussed by the author are epic, tragedy, comedy, pastoral, apologue, and lyric poetry. Epic poetry is defined as a "Recital in Verse of a probable, heroic, and wonderful Action" (pp. 82–83). Of the various rules (relating primarily to probability and the "Oraculous Tone" of epic poetry) enumerated, that concerning "the wonderful" is the most interesting because the author reduces the problem of divine inspiration to a question of convention. The creative act of the poet apparently is not actually analogous to that of God, but the ruse of divine inspiration is regarded as a useful convention for conveying the "wonderful" in epic poetry. The author argues that "all men are naturally convinced that there is a Divinity which rules their Fates," but men are not aware of "the secret Causes of Things" until they are manifested in occurrences in the natural world. If the epic poet declares that he is inspired by a genius which is conversant with the principles and ideas of God ("secret causes"), and relates such "wonderful" ideas "with an Air of Authority and Revelation," the audience will accept the wonderful as probable.

Tragedy like epic poetry presents action of "Grandure and Importance," their essential difference being that of manner (dramatic as opposed to narrative). Like Dufresnoy, the author draws parallels between dramatic poetry and painting: "It is a Representation of great Men, a Painting, a Picture; so that its Beauty consists of its Resemblance with the Truth. In short, to find out all the Rules of Tragedy is to place your self in the Pit, and fancy that all you are going to see is to be absolutely true" (p. 93). The author is not contradicting his earlier statement that "the Matter of the polite Arts is not the true, but only the probable" (p. 11). Truth in the earlier statement refers to subject matter, to the distinction between ideal nature and particular nature; truth here refers to dramatic manner, to the relationship between the audience and the dramatic production. Although the subject matter does not bear an exact likeness to natural truth, the manner of imitation must create the illusion of natural truth. The conventions of tragedy are unlike those of epic poetry because the audience bears a different

relationship to the work. Hence "the Imitation is bad" if unity of place is violated or if "the Action lasts a Year, a Month, several Days whilst I know that I saw it begin and end in about three Hours" (p. 93). The difficulty with such an argument results from the author's assumption that a dramatic work by its very nature must approximate the temporal truth of the material world. Given such an assumption, he does not raise the question of whether the violation of unities of time and place are justifiable if they serve the ends of art by achieving more important effects based on other principles. He does not discriminate among the species inductively on the basis of an investigation of their constitutive principles; rather, he assumes that individual works must have certain characteristics because they belong to historically defined species. Hence he dismisses a priori certain problems relating to possible variations of construction.

The various rules of comedy, pastoral, apologue, and lyric poetry, like those of tragedy, are determined by the prescribed conventions of each species, by the special demands of subject matter deemed appropriate to each, and by the taste of specific audiences. Thus, although all comedy "imitates the ridiculous" (p. 98), the author distinguishes three separate types on the basis of subject matter and audience appeal. And the pleasures of pastoral poetry, for example, whose "essential Object is a Country Life, represented with all its possible Charms," derive from man's natural love for the country (pp. 114–17).

The author's analysis of the rules and effects of the poetic species is inadequate. His particular conceptions of their prescribed natures do not account for the possible effects of any given species; that is, there are relevant problems of literary construction and special effects for which his principles cannot provide solutions. Such a criticism is valid insofar as he does attempt to provide rules for construction and definitions accounting for effects. Nor is there consistency in his discrimination of poetic species; the difference between epic and tragedy, for example, is one of manner, whereas that between epic and pastoral is one of subject matter.

There are further inconsistencies within the author's system. The principal argument of *The Polite Arts* is that the polite arts are alike in imitating ideal nature. The matter of the polite arts is the probable, whereas that of the useful arts is the true (material nature); the polite are distinct from the useful arts in that the primary end of the former is pleasure. On the basis of these principles, there is no reason to exclude all prose works from the polite arts. As the author seems to realize (p.

40), a "romance," for example, may imitate ideal nature for purely pleasurable effects. His argument is that prose regards the true, but poetry concerns the probable because speaking in verse is not natural. Overlooking the failure to distinguish between matter and meter, it can be argued that a romance composed in prose is as "unnatural" a means of discourse as a poem in verse. The contention that poetry is essentially different from eloquence because the latter is designed primarily for use, as a means of persuading or purveying factual truth, however embellished, cannot be applied to romance; thus, on the basis of the author's principles, two works in prose, a political oration and a romance, are essentially less similar than a comedy in verse and a romance or a "pastoral" poem and a romance. Similar arguments would apply in urging the inclusion of prose comedies and tragedies as polite arts.

Perhaps the most notable weakness of *The Polite Arts* is an incompleteness of method which is responsible for many of the differences in specific arguments between it and Harris's "Discourse." The author recognizes that differences of means allow for differences of effects in music and some poetic species; music raises passions through sounds which bear special relations to certain sentiments (p. 50), whereas poetry raises passions through the office of ideas. And, although the author does not draw the analogy, it is clear that the poetic species which is most nearly parallel to music in his system is lyric poetry since it, unlike other species, communicates sentiments directly to the heart. Like Harris, the author also notes differences of means between painting and poetry, but unlike Harris, he does not remark a resultant dissimilarity of subject matter and effects. If the means of music produce effects unlike those of poetry, it is unclear why a similar consideration does not obtain, as it does in Harris's "Discourse," in analyses of the visual effects of painting and the verbal ideas of poetry.

Although neither *The Polite Arts* nor *Les Beaux Arts* has the intrinsic merit of Harris's *Three Treatises*, they occupy a unique position in the history of eighteenth-century aesthetics. Neither manifests any single or consistent methodology; perhaps the term which best describes them is *eclectic*. If the Platonic terminology of *The Polite Arts* and *Les Beaux Arts* is striking, we must recognize that those terms are translated into what is in large part a rhetorical system; at the same time, some aspects of the methodology of the two works resemble the dialectical form of Reynolds's *Discourses* later in the century. *The Polite Arts* and *Les Beaux Arts* may be taken as signs of the increasingly pluralistic nature of mid-eighteenth-century aesthetics.

Charles Avison: The Primacy of Musical Expression

Charles Avison's *An Essay on Musical Expression*[15] is not directed primarily to the problem of finding bases for clarifying similarities and/or differences among the arts, but it deserves mention in any history of eighteenth-century comparative discussions of the arts for several reasons. First, Avison devotes an entire chapter to drawing analogies between music and painting. Schueller has drawn attention to Avison's importance, noting that he "made a major contribution to theoretical speculation by drawing parallels between painting and music"; by doing so, Avison "practically [opened] up a new subject for thought and analysis." [16] Detailed "parallels" between poetry and painting were frequent by the 1750s, but music had proved to be much more troublesome; moreover, the occasional parallels involving music usually compared it with poetry. It is not accurate to claim that Avison originated this branch of analysis, since Harris's "Discourse," for example, treats music in relation to the other arts, including painting, but his contribution is fundamentally unlike Harris's. Avison is the first British writer to focus on numerous specific parallels between music and painting; his role with respect to these two arts is similar to Dryden's with respect to poetry and painting. Neither Dryden's "Parallel" nor Avison's *Essay* is a highly developed, systematic aesthetic treatise, but each initiates discussion by making comparisons which emphasize similarities between the arts in question.

Second, Avison's *Essay* plays a directly influential role in the century's comparative discussions. Several recent studies have recognized the significance of his work in paving the way for a new music criticism in the eighteenth century;[17] Avison apparently wished, and did not altogether fail, to become the father of British music criticism by establishing and applying critical principles drawn from "the School of Nature and Good Sense," [18] thereby educating the general public. His influence on eighteenth-century comparative discussions is not as great as it is on the period's music criticism, but it is extensive. Many later comparative theorists refer to his work; whether it is praised, qualified, clarified, or castigated, the *Essay* was at least seen as something to be reckoned with.

Third, if only one whole chapter and scattered passages throughout the rest of the *Essay* are explicitly addressed to the matter of discovering fundamental likenesses among the arts, the entire *Essay* is related to a concern which steadily gained importance in comparative discussions after Avison. As we have seen, theorists before him generally

agree that poetry and painting are mimetic arts, even if there is disagreement about how or what they imitate, but these writers find it much more difficult to regard music as a mimetic art. Lipking states that by "substituting expression for imitation as the principle underlying musical effects, the *Essay* helped to alter the terms of a major debate" (*The Ordering of the Arts*, p. 218). Avison was not the first to seek a concept other than imitation in explaining musical effects; as we have seen, Harris had already argued that although music can imitate, its greatest power is non-mimetic (raising affections to which ideas may correspond). Avison's discussion of musical imitation is heavily indebted to Harris; he bases his analysis of musical imitation on Harris's conclusions, provides the term *expression* to describe the musical effect Harris had partially defined, and translates the rudiments of Harris's arguments into general theoretical and technical precepts which he then applies to specific composers and compositions. Although Avison consciously avoids providing a univocal definition of musical expression ("the energy and grace of musical expression is of too delicate a nature to be fixed by words: it is a matter of taste, rather than of reasoning" [p. 71]), his discussion of it proved provocative. Virtually all later theorists in this branch of aesthetics evaluate music's expressive or affective qualities, frequently mentioning Avison's specific remarks on the subject in the process. Much of the ensuing debate was unprofitable (as Avison's use of *expression* is equivocal, so later analyses are often imprecise); the problem of defining precisely the imitative and expressive powers of music was not satisfactorily resolved until the publication of Smith's and Twining's essays on imitation in art.

In order to comprehend fully Avison's analogies between music and painting (in part 1, section 2 of the *Essay*), it is necessary to understand the function of this section within the context of the entire work. The *Essay* analyzes musical effects within a three-fold context of audience, composer, and performer. The first and most theoretical part attempts to define musical effects (and music's "meaning") by relating responses to melody, harmony, and expression to psychological causes. Later sections treat musical expression in relation to composer and performer. Within this framework, Avison's intentions are manifold; his primary objective is the improvement of taste (1) through the definition of musical terms and effects in language which could be comprehended by a general public lacking specialized knowledge of music, and (2) by providing yardsticks (general rules concerning harmony, melody, and expression) by which the worth of any musical composition or performance could be measured. If the mainstream of literary and

pictorial criticism in the mid-eighteenth century was comprehensible to the unspecialized reader, music criticism was not.[19] In attempting to make music criticism accessible for public consumption, Avison faced the problem of providing a nontechnical vocabulary for explaining music's principles and effects; the section containing analogies between music and painting is designed to further this objective. Since painting "is an art much more obvious in its principles" and more widely comprehended, and "as there are several resemblances" between the two arts, "it may not be amiss to draw out some of the most striking of these analogies" in order to illustrate the principles of musical composition (pp. 18–19).

The first section of the *Essay*, immediately preceding the analogies, discusses music's affective power in relation to melody, harmony, and expression. Avison assumes a direct connection, inherent in all men, between sounds and man's imagination and passions; man is so constituted that melody and harmony, considered simply, are "no less ravishing to the ear, than just symmetry or exquisite colours to the eye" (p. 2). Like Harris, he does not attempt a detailed analysis of the mechanisms through which music is consecrated to the imagination or passions; he simply remarks that this "internal sense" is more refined than our external senses since prior contrasting "uneasiness" is unnecessary for experiencing maximum pleasure. He adds that when the force of musical expression is added to melody and harmony, music has "the power of exciting all the most agreeable passions of the soul." In evoking passion, expression operates either by imitating those sounds which are inherently affective or by "any other method of association" of ideas which enables the imagination to specify the objects of passion.[20]

If Avison's *Essay* is similar to Dryden's "Parallel" in drawing specific parallels between two arts, the preceding discussion of the first section of the work should make it clear that the forms of theory employed by the two men are dissimilar. Avison is less centrally concerned with questions relating to obtaining predetermined effects in prescribed artistic modes and through established techniques than Dryden, and more importantly concerned with explaining the qualities or effects of art in terms of natural human behavior. With respect to formal method, Avison's *Essay* is more closely related to the fully developed later causal theories of Beattie, Jones, and Webb than to Dryden's rhetorical criticism.

Avison's parallels are similar to Dryden's, however, insofar as both men emphasize similarities rather than differences and use comparisons

as a means of broadening critical vocabularies in the interest of improving taste. Viewing Avison's analogies as perhaps more calculating than illustrative, Lipking states that they are "an exploitation of whatever resemblances glorify music" (*The Ordering of the Arts*, p. 223). In this respect, they are also like Dryden's parallels, which "glorify" poetry; but Dryden's glorification of poetry is often at the expense of painting, whereas Avison's analogies do not notably victimize painting (although he selects chiefly the "noblest" aspects of painting to compare with music).

The eight analogies Avison enumerates in the second section of the *Essay* relate to subject matter, sources of excellence, formal components, execution, audience comprehension, and distinctions based on style. Although the analogies are intended to be illustrative, several are so imprecise and/or facile that they contribute confusion rather than clarity to aesthetic discourse. The first states that music and painting are founded in geometry, and have proportion for their subject. His explanation of this analogy confuses objects with means of imitation. He says that the vibrations of musical strings, which cause sound, are as measurable as the "visible objects" of painting; the analogy is inexact since painting's subject matter is compared with music's means (instruments producing sound) rather than with music's subject matter (presumably the patterned interrelationship of musical notes, since "subject" here refers to geometrical proportion).

Avison does not confine his analogies to considerations of audience responses or material properties of art; the efficacy of the second analogy, for example, depends on assumptions about the artist's creative process. He says that as excellence in painting derives from design, coloring, and expression, its source in music is melody, harmony, and expression. Melody is analogous to design insofar as both serve as foundations for the work of art, whereas harmony and coloring support or give life to the work. The analogy does not rest on a comparison of the material properties of the two arts, but on an equation of the order of the creative acts of the painter and the composer. Later in the *Essay*, Avison associates melody with "genius" and harmony with "art" (pp. 42–43); melody is "the first principle which engages the composer's attention," much as design comes first to the painter's mind. Harmony or coloring is then added by the composer or painter. In both arts, expression "is no more than a strong and proper application of [the other two ingredients] to the intended subject" (p. 20). Avison's definition of three elements of music (melody, harmony, expression) and painting (design, coloring, expression) in the *Essay* and Dryden's

adaptation of the Ciceronian concepts of invention, disposition, and expression in the "Parallel" serve similar purposes of organization, but the two men mean quite different things by apparently analogous or identical terms. Dryden uses *expression* in a far more restricted sense than Avison. For Dryden, expression in poetry is analogous to coloring in painting, acting as a bawd for design; it plays a subordinate role in enhancing any given work, but does not operate directly to evoke primary aesthetic responses. In Avison's *Essay*, the term is given greater importance; although he uses it in different senses in different contexts, it is clear that it signifies the ability to evoke aesthetic effects and is directly linked with passion. This shift in meaning of the term is important (for later writers as well as for the specific arguments of the *Essay*); for Avison, music derives meaning from its ability to evoke passion (that is, from its expressive qualities). His treatment of expression is both indicative and a contributing cause of a fundamental and steadily accelerating shift of emphasis in eighteenth-century aesthetics; as artistic meaning increasingly came to be sought in art's affective qualities, analyses of natural human behavior tended to supplant analyses of the formal properties and techniques of given species as a basis for providing principles for comparisons among the arts.

An author's concern with the affective qualities of art, however, need not imply lack of interest in the material components of art; indeed, Avison's third, fourth, and fifth analogies deal with the materials of art. The third compares light and shade in painting with concords and discords in music (and gradations with preparations and resolutions of discords), while the fourth compares "the foreground, the intermediate part, and the off-skip" of painting with bass, tenor, and treble in music. Of these analogies, the fifth is the most troublesome; in it, Avison says that the subject or leading succession of notes in a musical composition resembles the principal figures in a history painting, to which all else in the work is to be subordinated. The analogy is confusing because earlier in the *Essay* he uses the term *subject* in senses which are inconsistent with its signification here. In the first analogy, he defines the subjects of painting and music as geometrical proportion; in this analogy, a *figure* (that is, one of the ingredients constituting "proportion" in a painting) is either being compared with proportion or musical "subject" is being used in a far more limited sense (as an element of proportion [its "real" subject?]). To cloud the issue further, in the Advertisement Avison defines subject as connoting "what the word Subject likewise implies in writing" (p. v); but surely this is not

geometrical proportion. He adds that the "term Air, in some cases, includes the manner of handling or carrying on the subject." But we have seen that that is the province of *expression;* and how can a portion (air or melody) of the subject be so defined as to encompass the whole, unless subject does not here refer to geometrical proportion? The difficulty is that Avison uses the term in a technical sense (as in the first analogy) to refer to something inherent in the composition *and* (as is implicit in the Advertisement and the discussion of expression through imitation and association in section 1) to refer to something external to the work.

Of the three remaining analogies, the sixth involves a compositional rule for ordering material ("fulness" is achieved in both arts through the support of minor for major subjects), and the seventh concerns the viewer or auditor (just proportion is perceived in either art only with the proper positioning of the viewer or auditor). The final parallel asserts that the various styles of painting (grand, terrible, and so forth) have analogies in music. In attempting to explain and draw conclusions from this analogy, Avison obscures and invalidates it. He says that "as the manner of handling differs in Painting, according as the subject varies; so, in Music, there are various instruments suited to the different kinds of musical compositions" (p. 24). The use of "subject" in painting here implies that it is something other than proportion (that is, material from nature to which certain styles are uniquely suited). Moreover, technique in painting (manner of handling rather than brushes or canvases) is compared with instruments in music (rather than treatment of score).

In addition to these analogies, comparisons of music with the other arts are scattered throughout the *Essay.* As Lipking observes, "by far the most frequent of Avison's critical methods . . . is the argument from analogy. Once he had forgone those technical terms that had enveloped music in dark dialect, he had no alternative but to borrow terms from the common language of the other arts" (*The Ordering of the Arts*, p. 225). In addition to providing critical terms and illustrative examples which would be widely understood by his audience, these comparisons serve to celebrate the power of music by associating it with acknowledged masterpieces from the other arts, and to defend his judgments concerning individual composers and/or compositions by linking them with specific examples from music's sister arts. Most of these comparisons, particularly those which serve to defend his evaluations of specific men and works, are not contributions to aesthetic discourse. They are, however, extremely far ranging; for example, he

draws parallels between the histories of music and architecture (pp. 40–42), the powers of music and eloquence (both arts must succeed without a self-conscious indulgence in "art") (p. 61), and the imitative powers of music and poetry (pp. 59–60).[21]

Perhaps the most interesting of these comparisons is one between fugues and "history-painting"; both "not only contain the chief excellencies of all the other species, but [are] likewise capable of admitting many other beauties of a superior nature" (p. 66). Noting that Avison is one of few eighteenth-century critics who admire fugues, Schueller remarks that it "is hard to see that Avison was approving of these forms for any reasons other than taste or convention. Both were forms which had been generally approved of in the past" ("Correspondences," p. 339). It *is* difficult to see any basis of comparison beyond the desire to glorify fugues by associating them with history painting. Schueller adds that "certainly he was not comparing them in terms of imitation and expression"; indirectly, however, the basis of the comparison appears to be the fugue's expressive and imitative power. Avison uses *fugue* in a very broad sense to include any composition which admits of "a variety of subjects . . . and which, with their imitations, reverses, and other relative passages" are "productive of all the grandeur, beauty, and propriety, that can be expected from the most extensive plan in the whole range of musical composition" (p. 66). He commends fugues for their range of subject matter and, since different subjects relate to different passions, for their superior expressive power. The judgment is not unlike Harris's preference for poetry above the other arts for its ability to imitate subjects beyond the reach of the other arts; the difference is that Harris's approval is of certain kinds of moral subjects, whereas Avison's simply rests on the fugue's ability to evoke a wide range of passion. Moreover, Avison has in mind works "particularly [suited] for voices and instruments united," which he earlier identifies as particularly affective. He also praises fugues for their "fulness of harmony"; when fullness of harmony, "the highest excellence of every musical work" (p. 20), combines with a wide range of subject matter, the resulting work is expressive of numerous passions, for expression is simply the successful combination of harmony and melody (which is equated with subject in an earlier comparison with history painting [p. 22]). His fugue/history painting parallel, like many others, is inexact, but its basis does lie in the subject matter of the species under consideration; as history painting's effects are the noblest and/or broadest of the pictorial species because its subject matter is the noblest and/or broadest, so the fugue's affective power is the broadest

of the musical species because its subject matter is the most extensive.

Charles Avison's *Essay* has significance for the history of eighteenth-century music criticism partially because it marks, as Schueller observes, "a new tendency to give music the kind of *separate* attention which painting and poetry had long received" ("The Use and Decorum of Music," p. 74). But the *Essay* is important for the history of comparative discussions of the arts for the opposite reason; as Avison realizes, *expressiveness* is not limited to music. It is not surprising that later aestheticians seeking to define qualities and explain effects common to all the arts read the *Essay* with interest.

Chapter Three

Causal Theories

James Beattie's *An Essay on Poetry and Music, as They Affect the Mind* (1776), Sir William Jones's "On the Arts Commonly Called Imitative" (1772), and Daniel Webb's *Observations on the Correspondence Between Poetry and Music* (1769) like many earlier essays attempt to discover bases for clarifying likenesses and differences among the arts. The sources of critical principles underlying the formulation and determination of answers in these works differ, however, from those in the essays of Dryden, Lamotte, Harris, and the anonymous author of *The Polite Arts*; and the method of inquiry employed by the later group of critics is distinct from those used by the earlier theorists. In Dryden's "Parallel" and Lamotte's essay the various rules of painting and poetry are deduced from a consideration of art, from the practices of artists and precepts of past critics; effects are discussed in terms of the demands of particular audiences and subject matters. Principles derived from analyses of art form the groundwork for comparisons. In Harris's comparison of the arts, principles are based initially on an investigation of the arts' respective media; poetry, painting, and music are alike in being imitative, but their subject matters vary according to media. In *The Polite Arts*, the author postulates a concept of ideal nature which serves as the basis of comparisons, and an ideal form for each art or species.

In the essays of Beattie, Jones, and Webb, critical principles for discussing the arts are sought primarily in analyses of natural causes. The central concern is not with how effects can be achieved properly but with *explaining* the various causes of effects. The three writers focus attention not on subject matters but on the mind which apprehends artistic works and on the mind which shapes the properties of nature into artistic forms. In so doing, demands of specific audiences are deemphasized in favor of considerations of the natural responses of men in general. The prescribed rules of various arts and kinds are, moreover,

subordinated to examinations of human nature. As Dryden is concerned with rules which provide knowledge of what ought to please, the later writers attempt explanations of why the arts do please. For Dryden and Lamotte, questions relating to the powers and conduct of the artist are generally of less importance than problems involving art, whereas these men are more directly concerned with considerations of the qualities and habits of the artist's mind as causes of aesthetic effects. Consequently, the artist's role assumes increased prominence in these aesthetic theories.

All three men are concerned with the nature of aesthetic responses, with the objective causes of effects, and with the mechanisms through which causes produce effects. However, the principles on which they found their explanations are not identical. For Beattie, the effects of music result partially from a natural resemblance of musical sounds to the tones of passion, and partially from the association of certain passions and ideas with specific sounds; Webb, on the other hand, rejects the idea of association as an explanation of the "natural relation" between sound and sentiment, arguing that musical effects are based on nervous vibrations analogous to the "motions" of the passions. Webb's argument, that is, depends on a prior analysis of physiological rather than psychological phenomena.[1] Both Jones and Beattie posit *sympathy* as a universal basis of aesthetic responses, but the sympathetic faculty operates on different principles in their theories. For Beattie, sympathetic responses to poetry result from poetry's essential "imitativeness," whereas Jones assumes that all concepts of imitation are irrelevant for explaining "sympathetic" aesthetic effects. The similarity among these essays, then, is one of general interest and theoretical method rather than one of specific arguments, principles, or doctrines.

James Beattie: Psychology and Art

Beattie's *An Essay on Poetry and Music, as They Affect the Mind* was first published in Edinburgh in 1776 as part of a collection entitled *Essays*; in this volume, it serves as an appendix to a revised edition of *An Essay on the Nature and Immutability of Truth, in Opposition to Sophistry and Scepticism*.[2] Although it was "not originally designed for the press," [3] *An Essay on Poetry and Music* generated sufficient interest to warrant separate publication in 1778 and 1779. It was written in 1762 and "read in a private literary society" many years before

publication (Advertisement and p. 349), thus antedating the essays of Jones and Webb.

The principal task of Beattie's essay is to deduce rules of poetry and music from a consideration of universal human nature. He bases his investigation on principles of "reason and philosophy"; and as the full title of the essay indicates, these principles are derived from a prior analysis of the workings of the human mind. Beattie divides all rules of art into two classes: those which "are necessary to the accomplishment of the end proposed by the artist" and those which "have no better foundation than the practice of some great performer, whom it has become the fashion to imitate" (p. 349). The latter, which are termed "mechanical" or "ornamental" rules, can be deduced simply by studying past artistic works, whereas the former are amenable to philosophic investigation. It is apparent that the "mechanical" rules derived from simple observation are not essential to Beattie in explaining aesthetic effects. The issue at stake is the fundamental question of the adequacy, both for achieving artistic ends and for explaining effects, of rules which are solely based on past artistic practice.

The difference between Beattie's essay and those of Dryden and Lamotte in the source of first principles is largely one of shifting emphasis. Dryden and Lamotte derive rules from artistic models and precepts based on past practices; since they assume that what pleases in one age pleases in another, there is an indirect appeal to nature, but the primary emphasis is on the rules of art. Beattie, while not denying the validity of all precepts, turns directly to universal natural laws as a source of critical principles and artistic rules. Psychological principles underlying the "true laws of nature" are given greater emphasis than preestablished artistic laws in explaining aesthetic effects.

Beattie's argument is not that past models should never be imitated; the problem is distinguishing essential from ornamental rules. He says, for example, that whenever "the rules of Aristotle's *Poetics*, being founded in the practice of Sophocles and Homer," are "local and temporary," they "ought not to be applied to the poems of other ages and nations"; but those which are "founded in nature" are indispensable (p. 351). Music and poetry are perfectly "rational and regular," operating in accordance with various natural laws.

Because each art must have an end to be meaningful, and because essential rules relate to ends, Beattie defines poetry's end before explaining its effects. "True" poetry is "addressed to the heart, and intended to give pleasure by raising or soothing the passions" (p. 384).

Given this concept of poetry's function, the primary question in explaining poetic effects becomes how and why pleasing passions are raised. Ultimately, his answers derive from considerations of the universal mental traits which connect artistic material with aesthetic responses. With slight risk of oversimplification, it can be said that generally, for Beattie, poetic and musical effects result from the operations of sympathetic imagination and the mental process of association of ideas, and are founded on man's innate love of moral and natural truth.

Before examining Beattie's arguments concerning particular artistic effects, it will be helpful to clarify his use of *sympathy* and *association*, which are primary terms in his poetic and musical theories. Beattie, asserting that a "great part of the pleasure we derive from poetry" results from sympathetic feelings, devotes an entire chapter to outlining what he calls the "philosophy of Sympathy." Such analyses, he says, "ought always to form a part of the science of Criticism" (p. 489).[4] He argues that if we imagine ourselves in the situation of another person, particularly if that situation appears painful or pleasurable, "we are apt to fancy ourselves in the same condition, and to feel in some degree the pain or pleasure that we think we should feel if we were really in that condition" (p. 489). Hence the good or evil of an individual becomes a social good or evil in Beattie's concept of sympathy, and may prompt the observer to social action.

In order to avoid misreading his explanation of aesthetic effects, it is important to recognize that by *sympathy*, Beattie does not mean the same thing which we ordinarily mean by *empathy*. His concept of sympathetic responses preserves the conscious illusion of art. The observer does not forego his identity; he imagines himself in the situation of another without completely forgetting his own circumstances. Thus, in nature, a man might sympathize with a dead man confined in a grave even though the dead man is incapable of experiencing the emotions felt by the observer. From Beattie's definition, it would follow that in art the audience's response is sufficiently self-conscious to recognize the artificial aspects of poetic imitations.

Beattie's concept of sympathy allows for various degrees, depending on the similarity between our own condition and that of the man with whom we sympathize: we sympathize "not so much by our reflecting on what others really feel, as by a lively conception of what they would feel if their nature were exactly such as ours" (p. 490).[5] A corollary argument made explicit in his discussion of poetic character (pp. 398–416) is that certain characters, such as men with no faults, are

unsuited to poetry (1) because we cannot readily sympathize with them, and (2) because the pain resulting from witnessing pure virtue suffering is incompatible with tender passions of pleasurable sympathy.

Beattie says that we do not easily sympathize with "unnatural passions" (such as envy or violent anger), nor are all men equally capable of sympathetic feelings. Although he does not say so explicitly, this principle accounts for varieties of artistic taste. Beattie's analysis of artistic effects postulates a general human nature capable of sympathy, and assumes that the minds of most readers are not disfigured by "unnatural passions," so that it is possible to formulate laws of universal psychological responses in art. At the same time, there are variations which allow valid differences of opinion. `

If the pleasurable effects of imitation depend partly on the operation of sympathetic imagination, they also result from mental associations. Because Beattie's concept of the associative connection between ideas and sentiments forms a partial basis for all of his explanations of aesthetic responses, it is important to recognize that he applies the concept to several distinct processes involving both the artist and the audience. The raw matter of artistic creation is associated in the artist's mind with various ideas which mechanically arouse certain sentiments, and these ideas are colored by the prevailing passion in the poet's mind. Similarly, in the minds of the audience, the various images or sounds are associated with certain ideas which produce the different sentiments of aesthetic response.

In Beattie's account, the faculty which responds sympathetically is the same as that which associates ideas—the imagination. In an essay "On Memory and Imagination," Beattie defines imagination as "first, the power of apprehending or conceiving ideas, simply as they are in themselves, without any view to their reality; and secondly, the power of combining into new forms, or assemblages, those thoughts, ideas, or notions, which we have derived from experience." [6] Imagination is distinct from memory in that the latter reconstructs ideas to remember our past experience of them while the former considers present ideas as they are without reference to past experience. Memory may cooperate in determining aesthetic responses, but Beattie clearly regards the imagination as the primary responsive faculty.

In the same essay, "On Memory and Imagination," Beattie outlines five principles of association which account for our ideas of beauty. In *An Essay on Poetry and Music,* even though Beattie attributes all aesthetic responses to the association of ideas, he does not reduce them to a single principle. Instead, he multiplies the kinds of

association to coincide with various causes. We must recognize that although responses are traced to a single mechanism, causes are related to aesthetic effects in several manners. All five of the associative principles defined in "On Memory and Imagination" are employed, explicitly or implicitly, in his analysis of effects in *An Essay on Poetry and Music*. They are: resemblance, contrariety, nearness of situation (or contiguity), the relation of cause and effect, and custom (or habit) (1: 95–176).

Resemblance is the principle by which "Ideas that are similar, or supposed to be such, are attractive of each other in our minds" (1: 99). All poetic similes and metaphors fall under this principle. More significantly, "when the soul is occupied by any powerful passion, the thoughts that arise in it are generally similar to that passion" (1: 100). On the basis of this principle he argues, in *An Essay on Poetry and Music*, that an artist must feel the emotions that he wishes his audience to experience if his work is to succeed, and that the influence of a powerful emotion on the mind of the artist will combine seemingly disparate ideas more effectively than mechanical dexterity.

The principle of contrariety involves the contrast of present conditions with a possible good (if we are hungry or cold, we think of food or heat). In art, contrariety accounts for pleasure in artful variety and in contrasting characters.

Beattie defines the third principle of association (contiguity or nearness of situation) by providing examples: "To an architect the fragment of a column conveys a notion of the whole pillar; and the outline of the shadow of a face which we know, is found to give a lively idea of all the features" (1: 105). On a larger scale, the same principle accounts for differences of national character and love of country; particularly, Beattie uses it to account for the unique qualities of Scottish music and for varying responses to it.

The fourth and fifth principles of association—cause and effect, and custom—are frequently involved in explanations of aesthetic pleasure in *An Essay on Poetry and Music*. Cause and effect denotes associating ideas with causes which are or are supposed to be their cause, while custom denotes the accidental connection of ideas which bear no logical relation to one another. The association of ideas by custom is of paramount importance for art, especially in music, because it appeals to the passions in a more direct manner than poetry and lacks the precise intellectual meaning of the verbal images of poetry.

As all ideas of beauty and aesthetic effects can be explained in terms of the five principles of association and the functioning of

sympathetic imagination, all of the essential rules of art must be based on what is for Beattie a fundamental fact of human nature—man's innate love of virtue and truth. Poetry which raises emotions contrary to virtue cannot please the majority of mankind; those sentiments which betray "moral or intellectual perversity" offend unless "they appear to be introduced as examples for our improvement" (p. 356). Beattie does not mean that the poet should simply communicate "moral and physical" truth; he uses *instruction* to signify the raising of affections which induce virtue and repress contrary passions. Agreeable amoral affections are possible in poetry, but the moral sentiments of the mind assimilate them quickly, nor can a poem of any length be pleasing unless the sympathetic imagination is engaged. Instruction is an integral aspect of pleasurable effects in his poetic theories because he ultimately regards sympathy as a species of moral virtue which functions as an affecting agency in moral contexts.

The nature of Beattie's discussion of poetic invention is shaped by his interest in associative principles as the determining factors of artistic creation. He focuses attention on the powers and habits of the poet's mind rather than on his rhetorical circumstances. In Beattie's account, poetic imagination deduces beauty from the apprehension of causes in the material world, and from the habit of associating ideas derived from atomic impressions of natural beauty.

Problems relating to undisciplined genius and to possible beauties in works which violate natural laws do not occur to Beattie because he regards reason and invention as aspects of mind automatically governed by rational laws. And "it is not to be supposed, that what contradicts any one leading faculty should yield permanent delight to the rest" (p. 373). Inventive imagination associates ideas in accordance with reason, which implies natural plausibility. Since the same natural laws apply to the artist and to the audience, Beattie argues that we could not be pleased by a painting which violates the physical laws of nature. The inadequacy of his conception of the relation between emotional responses and their causes is immediately evident if we consider that his explanation denies the possibility of pleasurable responses to the works of Salvador Dali, for example, and forces us to consider him "mad." The principal weakness of his explanation is his failure to recognize essential differences between natural and artistic probability. The mind perceiving nature and that apprehending art are not governed by identical principles; what appears grotesque in nature need not have the same effect in art.

Beattie does recognize, however, that the "nature" which poetry

exhibits is "somewhat different from the reality of things." Again his explanation of this phenomenon is based on natural causes. The imagination combines experiential ideas into new forms; inasmuch as the same faculty of the audience responds to the ideas of the poet, it follows that the imagination will be more affected by an idealized form of nature than by the forms of material nature apprehended by the senses.

Subject matter imitated is not the most important factor in determining audience responses in Beattie's essay. Artistic ends are defined as the "sympathies that the poet means to awaken in the mind of his reader" (p. 384). The poet's material must be consistent with this end, but it is clear that Beattie regards the artist's prevailing emotion and general character as more important than specific subject matter in shaping the affecting nature of his work. This aspect of his theory can be clarified if we examine his discussion of inanimate objects as subjects for art. Presumably because the moral ideas influencing sympathy relate to human emotions, Beattie says that man is naturally affected by ideas relating to percipient beings. However, descriptions of inanimate objects may also be affecting. Beattie's explanation rests on the associative principle of resemblance. When the artist's mind is under the influence of any emotion, the ideas which arise are either consistent with it or tinctured by it; through association, indifferent objects become affecting subjects. The author's character functions in the same manner in determining the affective quality of art.

The assumption that universal moral sentiments have remained unchanged in all ages underlies all of Beattie's "essential rules." Hence he does not hesitate to borrow established rules or concepts from past critics; the function of his essay is not to advance new rules, but to discover the abiding natural causes behind them. For example, although Beattie attributes it to Aristotle, his concept of the ideal nature which poetry imitates is the familiar rhetorical notion of abstraction: "the ideas of Poetry are rather general than singular; rather collected from the examination of a species or class of things, than copied from an individual" (p. 391). His interest is in explaining this general "law" by analyzing the imaginative faculty of the poet's mind which associates ideas to create new affecting forms.

Like his "general rules," those relating to character and "arrangement" are based on natural causes. The associational principle of contrariety determines his explanation of the merit of Homeric characters.[7] Similarly, he says that poems must not be too long "because poetry is addressed to the imagination and passions, which cannot long

be kept in violent exercise, without working the mind into a disagreeable state, and even impairing the health of the body" (pp. 417–18), and that "poetical arrangement of events" (beginning in the middle of an action) is more "affecting to the fancy [or imagination] [8] and more alarming to the passions" (p. 423), since it excites curiosity about the causes of effects. He advances many other rules, but the method of argument is similar for all.

Beattie's explanation of the effects of music is of greater intrinsic interest than his account of poetic effects, mainly because aesthetic responses to music are not (and even in his system cannot be) traced to facile connections between emotions and moral causes. If the sympathetic imagination operates in a moral context in responding to poetry, it is not clear what role "natural morality" can play in responses to musical sounds.

Brewster Rogerson states that Beattie's consideration of music is an "elaboration" of the musical "opinions" of Harris and Avison, and that like most eighteenth-century critics, Beattie regards music as a form of affective expression.[9] The statement is accurate and useful only if we recognize that "affective expression" has quite different meanings for various eighteenth-century theorists. Certainly critics trace the effects of music to a wide range of sources. However, Rogerson is correct in noting the influence of Harris and Avison on Beattie; like many late-century music critics, Beattie refers to Avison's *An Essay on Musical Expression* with approbation, and directly borrows technical and theoretical ideas from it. We have seen that Avison in turn quotes the last chapter of Harris's "A Discourse on Music, Painting and Poetry" in arguing that imitation of natural sounds does not play a significant role in raising the passions. We have also seen that although Avison and Harris maintain that certain sounds automatically induce certain affections, neither attempts to analyze the connection between affections and sounds; Beattie's essay provides such an analysis.

Beattie, like Avison and Harris, believes that the greatest power of music is in raising the affections. His principal concern is with how it does so. Since almost every eighteenth-century discussion of the affective power of music involves a consideration of *imitation*, it is not surprising that Beattie begins his explanation of musical effects by asking if music is an imitative art. He argues that in addition to the gratification of a natural propensity, pleasure in imitation derives from several other principles governing the operation of the human mind: comparing a copy with the original, apprehending the agreeable

qualities of the "instrument" (medium) of imitation, and sympathizing with the moral sentiments of the artist (pp. 436–37).[10]

Since music does not have "meaning" in the sense that poetry and painting do, the artist's "moral sentiments" are obscure; and since it is difficult to see any precise resemblance between imitating and imitated objects, Beattie concludes that musical pleasure is not imitative in any important sense. As in his analysis of poetry, he does attempt to base music's essential rules on rational, natural laws; he uses identical principles, but applies them differently because the sympathetic faculty which responds to imitation in poetry does not have a similar role in music. Music may be imitative "when it readily puts one in mind of the thing imitated," as in the singing of birds and roar of thunder. These imitative sounds may be used to further the "genuine" end of music—"to introduce into the human mind certain affections, or susceptibilities of affection" (p. 443), but their effect is slight. Moreover, "illicit" imitations (such as expressing ideas of elevation by high notes) ought not to be used, since they distract the hearer's attention from the affective nature of the entire piece to particular ideas suggested by technical dexterity.

Beattie rejects the idea, advanced by Harris and Avison, that there is a fundamental natural relation between sounds and emotions, because such a connection is not sufficiently systematic to be traced to psychological laws. He argues that no clear resemblance exists between melodic tones and passions: if the "flat key, or minor mode" is adapted to melancholy subjects, "are there not melancholy airs in the sharp key, and chearful ones in the flat?" (p. 450). He later concedes that there is some relation between sounds and mental affections (p. 452), but he argues that musical effects more often result from the associational principle of custom (particular tones are associated with definite places, occasions, and sentiments).

In the course of his analysis, Beattie advances five distinct natural laws to explain musical effects. First, the idea that the composition of musical tones produces pleasing effects on the mind accounts for the affective nature of various inarticulate sounds. The second law involves naturally agreeable and disagreeable effects of concords and discords, and the third relates to engaging the affections through "expression." The latter explains Beattie's preference for vocal to instrumental music; instrumental music may "prepare" the mind generally, but the annexation of poetry fills the mind and heart with determinate ideas and emotions. The fourth law (that variety and simplicity of structure

necessarily please) implicitly appeals to the associational principle of cause and effect. Simplicity of rhythm and melody, that is, renders music intelligible by enabling the mind to associate what has gone before with what will probably follow, thus producing a pleasure founded on the natural love of order.

The fifth and most important principle is that of accidental association or custom. Beattie combines this principle with that of nearness of situation to argue that there is a strict union between passions and their outward signs; if "there be, in the circumstances of particular nations or persons, anything that gives a peculiarity to their passions and thoughts" (p. 476), there will be a corresponding peculiarity in their expressions. The same rule applies to audible signs of passions; peculiarities of sentiment produce unusual qualities in Highland music (the picturesque, melancholy environment results in wildly irregular compositions and "warlike," "terrible," "melancholy" expression). By shifting the source of first principles from established precepts to natural laws, Beattie is able to define and reevaluate the merits of works which might otherwise appear inferior for violating historically accepted standards.

Sir William Jones: The Rejection of Mimesis

Sir William Jones also attempts to account for the effects of poetry and music upon principles "which must be sought for in the deepest recesses of the human mind." [11] Jones is similar to Beattie insofar as he founds his explanation of poetic and musical effects on psychological principles, postulates sympathy as a primary means of aesthetic communication, and directs attention to the mind of the artist rather than to the established precepts of each art, but differs from Beattie in his assessment of poetry's power as an imitative art. "On the Arts Commonly Called Imitative" is of interest primarily for Jones's attempt to define a "natural artistic act," for the ascendant position accorded to lyric poetry, and because it denies, perhaps more adamantly than any other eighteenth-century essay, any artistic value to the "imitative" aspects of poetry and music.[12]

Such interest is largely historical rather than intrinsic, however, for the essay in its entirety is not distinguished. Jones offers no coherent account of the mechanism of sympathy; his essay suffers accordingly because he argues that sympathy is the basis of artistic effects. Moreover, the distinction he makes between imitation and the natural

expression of passion is of little value in explaining the source of aesthetic responses; he restricts imitation to copying literally natural objects and manners, and claims that imitation cannot be affecting because an artist must be genuinely moved by passion if he wishes to raise passion in his audience. Ultimately, Jones's argument equates art with nature, for it overlooks the essential artificiality of all poetic and musical works; Jones apparently finds no significant difference between man's response to the artistic expression of passion and the expression of passion in nature. Furthermore, his requirement that an artist must be sincerely moved to affect his audience (and thus cannot be said to imitate) is irrelevant in explaining aesthetic responses (1) because there is no way of knowing whether an artist was "moved" when he composed a certain song or poem, and (2) because no expression of passion can be wholly "natural" in these two arts, since the poet or musician translates "passions" into "unnatural" arrangements of words or sounds.

The fundamental task of "On the Arts Commonly Called Imitative" is to answer the question of why we are pleasantly affected by poetry and music. For Jones as well as for Beattie, the solution lies in empirical knowledge of psychology, and, additionally, in an analysis of the natural causes determining the origins of the two arts. Jones rejects the authority of past critics as an adequate source of critical principles: "It is the fate of those maxims, which have been thrown out by very eminent writers, to be received implicitly . . . for no other reason than because they once dropped from the pen of a superiour genius; one of these is the assertion of Aristotle that all poetry consists in imitation" (p. 201). Criticism should not simply be based on accepted precepts, particularly when those precepts conflict with the empirical evidence of psychology ("it must be clear to any one, who examines what passes in his own mind, that he is affected by the finest poems, pieces of musick, and pictures, upon a principle . . . entirely distinct from imitation") and with historical data concerning the origin and development of the arts ("whatever be said of painting, it is probable, that poetry and musick had a nobler origin" than imitation [p. 202]). Jones thus rejects those accounts which consider the arts "merely" imitative, claiming that the greatest effects result from "a very different principle," which he later identifies as "sympathy."

To grasp the precise import of his argument, several basic assumptions about poetry and music and the connotations of several key terms evident in Jones's formulation of his principal problem should be noted. Although he attributes it to Aristotle, the concept of imitation

71

which he attacks is decidedly non-Aristotelian. As Jones uses it, imitation refers to a one-to-one likeness between an artificial object and an original found in nature. This type of imitation is of natural particulars, whereas poetic imitation for Aristotle involves principles of necessity found in the individual work of art rather than in natural verisimilitude. Since imitation, for Jones, is not of action but of manners or specific objects, he is able to argue that only some painting and descriptive poetry can be the products of imitative artistic acts; such imitations bear a strict and immediate reference to particulars, whether located in the natural world or in the nature of men (manners). Jones does not use imitation to signify representation in matter differing from natural matter; rather, he opposes imitative acts to naturally expressive acts, both of which may utilize the same media. However useful such a disjunction is for his polemic purposes, it contributes little to the problem of defining the senses in which various arts can be called imitative, because this opposition refers to simple differences of subject matter and the author's "sincerity."

A fundamental assumption in Jones's argument is that the function of both music and poetry is to express passion. There are types of music and poetry which do not, but they are not the forms of art which produce the greatest effects; hence Jones is concerned more with lyric than with descriptive poetry. The latter achieves its effects through a principle ("substitution") which is analogous but inferior to the principle upon which the former and all passionately expressive works communicate—sympathy. A further assumption is that "true" music is designed to enforce poetry's expression through melody. Pleasurable music is not merely sensual but also affects the heart. Jones acknowledges, like Beattie, that musical sounds may imitate natural sounds; both argue, however, that music is most affecting when accompanying poetry. Finally, the central question of the essay (what, if not imitation, is the principle through which poetry and music render their greatest effects?) implies a related complex of questions: where is such a universal principle to be sought, how is its existence to be accounted for, and how does it function in determining responses to the various kinds of poetry and music?

As the explanation of artistic effects is to be founded on the "observation" of what transpires in the human mind, the reasons for the existence of a universal principle of artistic response may be deduced from an investigation of the original impulse to artistic expression. By discussing the origin of poetry and music, their differences, and their relation to one another, Jones evolves a definition of each art which lays

the groundwork for the discovery of a universal affective principle. He argues that inasmuch as the speech of a person agitated by strong passion approximates cadence and measure, poetry was originally the animated expression of human passion, variously mixed or pure. Jones thus supposes that the first poetry might have been simple praise of the deity for providing nature's plenitude.

Jones, by assigning the original source of poetry to the expression of passionate joy in natural beauty, bases the first segment of his argument on grounds with which there would be little disagreement, for the elements of natural beauty are widely experienced and less complex than those of art. And because this type of poetry is found in all nations, he argues that there is an emotional impulse common to the psychological makeup of all men—that toward the expression of passion. Moreover, since the dramatic poetry of Europe had the same source ("a song in praise of Bacchus"), the only species of poetry which he calls imitative (presumably because in the dramatic mode human figures strictly represent the activities of other human figures) evolved from a "natural emotion of the mind, in which imitation could not be at all concerned" (p. 204).

In addition to praise of a deity, Jones claims that there were probably four other sources of poetry: (1) love, or a natural inclination founded on personal beauty, which gave rise to odes and love songs; (2) grief, the source of dirges, later lengthened to elegies; (3) detestation of vice, leading to moral and epic poetry in which heroes and kings are introduced as examples of moral truth; and (4) hate, giving rise to satire (pp. 204–05).

Jones claims that music had the same sources as poetry, but before substantiating this claim, he analyzes the "nature of sound" in order to define his subject matter. His definitions of *common* and *musical* sounds provide a clear example of the extent to which distinctions between the realms of art and nature are obscured in his essay. A common sound is "simple and entire in itself like a point," whereas a musical sound is "accompanied with other sounds, without ceasing to be one" (p. 206). Obviously the former is not restricted to nature nor the latter to art, so that the distinction in itself cannot explain the unique effects of instrumental music. But Jones conceives of music chiefly as an accessory to poetry; "pure and original" music adds force to poetry and affects the heart not by imitating nature but by becoming "the voice of nature herself." Like Beattie, Jones subordinates instrumental music to that which accompanies poetry because the former, lacking meaning, cannot raise definite passions. Music, Jones believes, must resemble the

expressive variations of poetry as precisely as possible to achieve its greatest effects. Lacking intrinsic signification, the musical scale has meaning only as notes resemble the variations of passionate speech.

Jones's discussion of the various musical modes makes it clear that he concurs with Harris's and Avison's claim that many sounds bear a natural relation to various affections. He claims, however, that, although musical modes have some effect over the mind, no "series of mere sounds has a power of raising or soothing the passion" (p. 209) unless it is historically associated with a particular instrument and kind of poetry. Music by itself cannot raise passions, although certain modes are better adapted to some kinds of expression than others; but when joined with poetry, music enhances the pleasurable effects of passion. Hence Jones ultimately defines music as an embellishment of poetic expression: "We may define original and native poetry to be the language of the violent passions, expressed in exact measure, with strong accents and significant words; and true musick to be no more than poetry, delivered in a succession of harmonious sounds, so disposed as to please the ear" (p. 210).

In view of his definition of music, it is not surprising that Jones prefers "ancient" to eighteenth-century music. Ancient Greek music, united with poetry, was "wholly passionate or descriptive," so that its effect was to further poetry's influence over the passions, whereas modern "boasted harmony" paints and expresses nothing "to the heart." The latter has no affective power because its appeal is limited to sensory gratification. Consequently, he argues that the most useful distinction among types of music is that between music of "mere sounds" and that of the passions rather than the "old divisions" into celestial/earthly, divine/human, active/contemplative, and intellectual/oratorical. The latter are founded on "chimerical analogies" rather than on the natural distinction of fleeting sensory pleasure from sympathetic passion. Throughout Jones's essay, prior analyses of nature rather than formal considerations of art serve as the basis for distinctions and definitions.

Despite Jones's process of evolving what appear to be descriptive definitions through the use of historical "evidence," his definitions are prescriptive. They do not account for the possible pleasure derived from all types of poetry and music. His concern is with what he regards as ideal types, primarily lyric poetry and music designed to accompany poetry. The expression of passion through sympathy forms the basis for his comparison of the two arts (1) because the quality of passionate expression need not be restricted to any single art or genre, and (2)

because, in view of his definitions of poetry and music, sympathy can be postulated as the mechanism of response to either art. Although he refers to natural causes, his definitions actually reduce to a preference for certain genres and subject matter, since the ultimate distinction between true and inferior poetry (or music) is that one deals with materials which relate to the passions while the other does not. By defining poetry as the direct expression of passion and then defining imitation in such a manner that its very nature precludes the possibility of expression, it of course follows that some other principle must be discovered to account for poetic effects. The difficulty with such an exercise is that even if one accepts Jones's definition of the function of poetry, it does not follow that any principle of imitation must be irrelevant to the explanation of poetic effects, for his simplistic and restrictive concept of imitation is obviously not shared by all critics he attacks.

Nevertheless, by defining poetry and music in terms of the expression of passion operating on minds through sympathy, Jones hopes to avoid the confusion and inaccuracy which he apparently feels exists in discussions which analyze the imitative nature of art. He implies that the term *imitation* is inaccurate in describing the artistic act, since "a man, who is really joyful or afflicted, cannot be said to imitate joy or affliction" (p. 211). And the term is confusing presumably because "a fable in verse is no more an imitation than a fable in prose; and if every poetical narrative, which describes the manners, and relates the adventures of men, be called imitative, every romance, and even every history must be called so likewise" (p. 212). Jones is, of course, unfair to Aristotle, who neither equates meter with poetry (and in fact warns against such an error in the first chapter of the *Poetics*) nor claims that all narratives describing the manners and adventures of men are imitative. Apparently he is unaware that Aristotle distinguishes among the modes of artistic imitation in terms of means, objects, and manners of imitation.

If passion is the proper subject of poetry and music, how can the artist who is passionately moved engage in an artificial act such as imitation? Jones's answer is that he cannot; rather, nature acts through him. The definition of such a "natural artistic act" could lead to complex considerations of efficient causes, but Jones avoids them. He simply assumes, for example, that a poet must be genuinely moved by grief to write an affecting elegy (questions relating to the artist's sincerity are not irrelevant to Jones's explanation of artistic effects). Moreover, he claims that the passions, "which were given by nature,

never spoke in an unnatural form, and no man, truly affected with love or grief, ever expressed the one in an acrostick, or the other in a fugue" (p. 213). Thus an acrostic, fugue, or any other form of poetry or music which does not express passion through sympathy is either to be stricken from the canon of poetry and music or relegated to an inferior rank.

Jones anticipates and tries to dispel some of the objections which might be raised to his argument. "It is true," he says, "that some kinds of painting are strictly imitative, as that which is solely intended to represent the human figure and countenance," but the paintings which have the greatest effect on the mind represent some passion. The effects of such paintings prove "not that painting cannot be said to imitate, but that its most powerful influence over the mind arises, like that of the other arts, from sympathy" (p. 213). Jones uses *sympathy* in essentially the same manner as Beattie: it implies an emotional response of the audience's imagination to the naturally affecting passion of the artist (or the passion of nature acting through the artist). In answering those critics who call descriptive poetry and music strict imitations, he says that sounds and words have no resemblance to visible objects; he thus ignores what Harris calls the imitative power of poetry resulting from meaning by compact. As the finest parts of poetry, music, and painting (that is, those relating to the passions) achieve their effects through sympathy, those which are merely descriptive operate through "substitution." Jones means that they raise the same "affections" or "sentiments" in the audience's mind which would be called forth if the audience's senses were confronted with the same visual objects in nature. The painter, for example, is better able to describe visual objects precisely than the poet or musician, but he cannot "paint a thought or draw the shades of sentiment" (p. 215). Thus each artist, according to Jones, will achieve his purpose, not through imitation but by assuming the power of nature and "causing the same effect upon the imagination which her charms produce to the senses" (p. 216). Art, that is, appeals to the imagination in precisely the same manner in which nature confronts the senses, so that the beholder will "mistake art for nature" (p. 215). There is no reason to suppose that the audience, in terms of Jones's explanation of effects, would *not* mistake art for nature, since he effectually dismisses those considerations which distinguish an artificial work of poetry or music from a production of nature.

Daniel Webb: Physiology and Art

Daniel Webb in *Observations on the Correspondence Between Poetry and Music*[13] is concerned, like Beattie and Jones, with the nature of aesthetic responses, the objective causes of effects, and the mechanisms through which causes produce effects. For Beattie and Jones, the mechanism connecting the various properties of music and poetry with pleasurable sentiments is psychological; for Webb, however, it is largely physiological. His essay is the only one in this branch of eighteenth-century aesthetics which accords a dominant role to physiological causes in explaining aesthetic effects.[14] In the *Observations*, responses result from the functions of "nerves and spirits" rather than from mental processes of association or sympathy. Webb's explanation of poetic and musical effects depends on a prior analysis of the mechanical operations of these faculties; specifically, he is concerned with the "movements" impressed on the nerves and "animal spirits" by the passions, with similar motions produced by poetic and musical impressions, and with the natural connection or analogous nature of these two types of motion.

If the passions operate by conveying certain movements to the nerves, and if the properties of poetry and music (sound and motion) convey similar movements, the principle which explains the natural influence of these arts on the passions must be, Webb reasons, one of motion. Various passions operate by different kinds of movement, and various combinations of the properties of music and poetry also produce numerous (analogous) kinds of movement; hence Webb describes several modes of motion to explain the relationship between specific works or kinds and particular sentiments. The primary task of Webb's essay, then, is to explain the effects of poetry and music on the basis of the "natural relation" between the mechanical operation of the passions and the corresponding "movements" of the arts.

The potential obscurity of discussing natural connections between passion and the arts, particularly music, is evident to Webb. He says that although men know from the experience of their senses that music does influence the passions, and are willing to acknowledge such effects, "we find ourselves embarrassed in our attempts to reason on this subject, by the difficulty which attends the forming a clear idea of any natural relation between sound and sentiment" (p. 2). Webb dismisses principles derived wholly from considerations of mental operations as an attempt to elude this difficulty. The principle of the association of ideas, for example, is simply inadequate for the explanation of responses

to artistic phenomena because it does not accord with observed evidence: "I have observed a child to cry violently on hearing the sound of a trumpet, who, some minutes after, hath fallen asleep to the soft notes of a lute. Here we have evident marks of the spirits being thrown into opposite movements, independently of any possible association of ideas. This striking opposition in the effects of musical impressions seems to indicate the regular operation of a general and powerful principle" (p. 3).

This principle Webb seeks in a direct analysis of sound. All musical sounds, he argues, are either acute or grave, result from vibrations, and produce effects only by a succession of impressions; "should it appear, that our passions act in like manner by successive impressions" (p. 3), the principle explaining the relation of sound to sentiment can be discovered.

Having acknowledged that man does not have immediate knowledge of the structure or operations of the passions, Webb bases his concept on their visible signs and on the metaphorical expressions used to describe their effects (love "softens," anger "quickens," pride "expands," sorrow "relaxes"), concluding that "there is just reason to presume, that the passions, according to their several natures, do produce certain proper and distinctive motions" (p. 5) in the nerves and "animal spirits." Moreover, the spirits and nerves receive similar impressions from music; therefore, "if music owes its being to motion, and, if passion cannot well be conceived to exist without it, we have a right to conclude, that the agreement of music with passion can have no other origin than a coincidence of movements" (pp. 6–7). When a particular musical composition conveys sensations which are identical to those induced by a specific passion, the mind automatically recognizes their connection from the similarity of the sentiments which they raise.

Webb reduces all musical impressions to four basic kinds. He observes that "in music we are transported by sudden transitions, by an impetuous reiteration of impressions"; that "we are delighted by a placid succession of lengthened tones, which dwell on the sense, and insinuate themselves into our inmost feelings"; that "a growth or climax in sounds exalts and dilates the spirits, and is therefore a constant source of the sublime"; and that "if an ascent of notes be in accord with the sublime, then their descent must be in unison with those passions which depress the spirits" (pp. 8–9).[15] The first class produces movements resembling those of such passions as anger and courage; the second, love and benevolence; the third, pride and glory; and the fourth,

sorrow. Like Beattie and Jones, Webb argues that only when poetry is joined with music can the passion evoked become specific; the impressions of instrumental music can imitate only classes of passions.

The division of passion into fundamental types is used as the basis for a consideration, in an appendix, of the degree to which imagery may express passion. This brief analysis is not crucial to Webb's main argument, but it provides an illustration of the extent to which his discussion of natural causes often becomes obscure. He says that the impressions of the passions "extend to· the imagination"; under the influence of passions such as anger, love, or pride, the imagination may naturally "describe" feelings through images. For example, "as these passions [pride, wonder, emulation] and their movements tend naturally towards increase, it follows, that the images here employed may be enlarged and dilated" (p. 153). However, imagery cannot be the language of grief or dejection because "the vibrations of relaxed nerves can communicate nothing more than their own languor: accordingly, we shall always find, that, while we are under the influence of a dispiriting passion, our aim will be to express, not to describe, our feelings" (p. 154). Webb apparently assumes that the imagination communicates images to the nerves and animal spirits when literally raised, heated, or expanded, but cannot do so when nerves are relaxed under the influence of a "languishing" passion. Aside from the difficulty one has in accepting the analogy between nerves and the imagination in terms of physiological alterations, his conceptions of the causal connection between nervous condition and imaginative act (and the explanation of "passionate" imagery derived from them) are, at best, occult.

The affective pleasures of poetry are traced to the same source as those of music—similarity of movement. Webb assumes that poetry, like music, is an art of sound and motion because it employs verse; he also assumes that verse and musical sound are identical in their operations on the nerves and animal spirits, so that the laws which govern one also direct the other. Consequently, he conducts a lengthy examination of verse movements which correspond to the four primary movements of passion, and, since other passions are derived from various combinations of the four basic types, with numerous "secondary" movements.

Webb's investigation of the "natural connection" between sentiment and sound (or motion) is more systematic and hence less obviously flawed than, say, Jones's account of sympathetic responses to poetry and music; but it is based on a fundamental assumption which is untenable. It is essential that the movements of verse and those of musical sound

be exactly parallel if Webb's explanation of musical effects is to be accepted. Herein lies a primary weakness of the *Observations*. Musical sounds as such do not refer to anything beyond themselves; their "movements" are determined wholly by the relationship they bear to one another within a given composition. Movements of verse, on the other hand, depend in part on the intellectual sense of the ideas they convey; the modulations of the voice of a man reading a poem are at least partially determined by his interpretation of the poem's ideas. Webb is somewhat aware of this difficulty. He says that words or sounds which imitate particular ideas must be distinguished from words or sounds whose succession determines movement (p. 19); but his avowal that sounds in general, rather than particular words, must echo sense does not solve the difficulty because echoing the "sense in general" still implies ideation. Moreover, "movement of sound" provides a larger portion of the total pleasurable effects derived from music than from poetry. Webb does not question the validity of isolating one aspect of affective pleasure and discussing it in abstraction from the other components determining aesthetic feeling, although he is, of course, aware that the pleasures of poetry do not result entirely from the "movements" of verse.

Through various combinations of sounds and motions corresponding with the four primary kinds of passion, Webb argues, music and poetry can express almost any passion; however, there are some passions, readily conveyed by painting and sculpture, which musical sounds cannot express. At the basis of this argument lies a distinction between imitation considered as the means of conveying a one-to-one likeness between the object imitated and the idea of the object formed in the mind of the audience, and impression considered as "imaging" or representing passion through artistic movements duplicating the mechanical effects of passion. The former concept involves the apprehension of ideas by the mind subsequent to the operation of the senses, whereas the latter refers to the evocation of sentiment directly through nervous and "spiritual" responses (independent of ideas). The mind, that is, automatically "deduces" the affinity between passion and artistic impression from the similarity of their mechanical effects.

With respect to the distinction between accurate imitation of objects or ideas and representation through impressions, painting and sculpture achieve their effects through the former, music through the latter, and poetry through both. Hence painting imitates the external signs of passion while music reflects passion's internal movements; but poetry does both.

Daniel Webb

Assuming that musical effects result from impressions which are necessarily pleasing, Webb concludes, like Avison and Beattie, that certain passions which are entirely painful cannot be represented by music, although the ideas of such subjects might be depicted in painting: "I am confirmed in this opinion by observing, that shame, which is a sorrowful reflection on our own unworthiness, and therefore intirely painful, hath no unisons in music. But pity, which is a sorrow flowing from sympathy, and tempered with love, hath a tincture of pleasure" (pp. 28–29). Webb bases this argument on empirical observations concerning the pleasurable elements of the various passions, and deduces music's possible subject matter from its effects.[16] In doing so, he confuses natural sentiments of passion with aesthetic feelings, overlooking the extent to which the "raw material" of natural passion is transformed by the artificial medium of music; hatred, for example, may not be pleasurable as an actual state of mind, but it does not follow that responses to its representation through "impressions" cannot be. A pleasurable effect, that is, does not necessarily imply a pleasurable subject matter.

If Webb's argument concerning the incompatibility of shame, hatred, or "hopeless grief" with the movements of music and verse were confined to effects on the audience, it would be less culpable, though still troublesome, than when extended to subject matter (to the minds of poetic characters and the passionate state of musical "subjects"). In the third act of Verdi's *Aïda*, for example, Radames exclaims, "Io son disonorato! Per te tradii la patria!" Certainly we "pity" Radames, and share his shame; but from his point of view, the prevailing passion is shame. Moreover, the plight of Radames and Aïda becomes "hopeless" at this point, but the audience's "grief," whether termed excessive and therefore painful or not, does not lessen the affective nature of the opera.

Webb argues that Locke is mistaken in assigning the source of desire wholly to uneasiness, and that Aristotle also errs in founding it in pleasure, because "in truth, it is a compound of both: of uneasiness through the want of an absent good; of pleasure from the hope of obtaining that good" (p. 32). Many passions arise from mixed causes; they are "composed of mid-tints, running more or less into light and shade, pleasure or pain, according to the nature, motive, or degree of the passion. For instance, if grief arises from the suffering of others, it becomes pity, and is pleasing by its nature. If grief, proceeding from our own sufferings, be hopeless, and therefore excessive, it becomes misery or despair, and is painful from its degree" (p. 33). Webb is apparently

referring to the audience's grief (although the distinction also applies to the state of mind of poetic characters); in these terms, Radames's situation is a source of pleasurable pity for the audience. However, the illustration from *Paradise Lost*, which follows immediately, refers to the grief of poetic characters, implying a necessarily identical relationship between the passions of characters and audience. "Let grief be tempered with hope, it hath a tincture of pleasure: 'All these and more came flocking, but with looks / Down-cast and damp, yet such wherein appear'd / Obscure, some glimpse of joy / t'have found their chief / Not in despair' " (pp. 33–34). Can Radames's shame and "excessive" (because hopeless) grief produce pleasurable effects? Although Webb might argue for an affirmative answer on the basis of empirical evidence, it is not unfair to conclude that his consideration of pity, shame, and grief in relation to music and poetry does not provide an adequate groundwork for a definitive positive or negative conclusion. Because "movements" of passions, in one sense or another, constitute both the matter and effects of music and poetry, the failure to distinguish precisely whether various individual arguments and principles apply to causes (passionate qualities of the work) or effects (passionate feelings as aesthetic responses) or both is a source of much confusion in his definition of the natural connection between causes and effects.

We have seen that Webb distinguishes between ideas and impressions in defining artistic subject matter. This distinction is the basis of two separate concepts of imitation in his essay. It is important to discriminate the two senses of imitation from one another because, in Webb's theory, the pleasure which derives from what might be termed "descriptive imitation" differs fundamentally from that effected through "expressive imitation." Descriptive imitation signifies conveying an exact idea of an external object or idea; pleasure results from the direct comparison of the image with the known object so that feelings of beauty depend on a conscious recognition of art. The "motions" of passion, however, cannot be reduced to sensible images; the expressive imitation of these motions by the movements of sound and verse depends on a subjective, "instantaneous" recognition of the correspondence. Pleasurable effects are greatest if there is no conscious awareness of art: "If the poet is successful in touching the springs of passion, our spirits obey the impression, and run into the same movements with those which accompany the sentiment; thus, while we are under the united influence of the natural motion of the passion, and the artificial

movement of the verse, we lose sight of the imitation in the simplicity of the union, and energy of the effect" (p. 150).

Whether imitation is descriptive or expressive depends on the subject matter involved: "we express the agitations and affections of our mind; we describe the circumstances and qualities of external objects" (p. 138). From his analysis of poetic and musical effects and subjects, it is clear that poetry may express or describe successfully, and that music's greatest power is expressive. Music may represent particular ideas or objects, but such imitations are, for Webb, inferior.

Webb recognizes that when music represents visible objects, its effects are essentially unlike those of painting. Painting appeals to the senses; since music excites affections resembling those subsequent to the apprehension of objects by sight, it might be supposed that musicians "paint visible objects." He argues that this is not the case; music circumvents the need for images by applying directly to the "soul." [17] Webb thus distinguishes between the visual beauty and emotive "energy" of an object; herein lies what is perhaps the greatest single strength of Webb's essay, for this distinction establishes a potentially useful basis for comparisons of aesthetic effects in the various arts. Painting presents images of the former, music is concerned with the latter, and the provinces of poetry include both aspects, since the conventional meanings of words allow ideation, and the movements of verse "image" the mechanical motions of passion.

Chapter Four

Thomas Twining's Dissertations on Poetry and Music as Imitative Arts

Thomas Twining's "Two Dissertations, on Poetical, and Musical, Imitation," prefixed to his translation (1789) of Aristotle's *Poetics,* can justly be ranked among the most perceptive essays in eighteenth-century British aesthetics. The two essays constitute a close analysis of the various senses in which poetry and music can be described as imitative arts. In combination with his notes to and translation of Aristotle, the essays establish Aristotle's reputation, which had varied with the accounts of his interpreters, on a basis commensurate with what Aristotle had actually said. However, Twining's achievement is not simply the clarification of Aristotelian texts and concepts; the two essays contain considerable sound, original thought. For example, the terms he employs for essential conditions of poetic imitation, *immediateness* and *obviousness,* are of permanent critical usefulness. Similarly, his discussion of the nature and effects of instrumental music remains one of the most thoughtful accounts of the subject.[1]

The full significance of Twining's accomplishment becomes clear, however, only if we are aware of the historical context of the two essays, since his major objective is to correct mistaken or inexact applications of the term *imitation* by various contemporary writers. Twining's comment concerning the value of "philological disquisitions" in annotating the *Poetics* applies equally well to his task in the two essays: "when people fancy they understand what they do not, it is doing some good to show them that they do not." [2]

In the preface to his translation of the *Poetics,* Twining writes that "the time is come, when we no longer read the antients with our judgments shackled by determined admiration; when even from the editor and the commentator, it is no longer required as an indispensable duty, that he should see nothing in his author but perfection." [3] By the end of the eighteenth century, Aristotelian "rules" in particular had fallen into some disrepute, and as critics became more concerned with

questions of genius, taste, peculiarities of style, and the basis of general artistic quality in human nature, discussions of the imitative nature of art became less popular. We have seen, for example, that Jones discounts imitation as an important principle in explaining artistic effects and that Beattie would strike music off the list of imitative arts. By 1762, Henry Home, Lord Kames, states that "of all the fine arts, painting and sculpture only, are in their nature imitative." [4] Using *copy* and *imitate* synonymously, he argues that language does not copy nature except insofar as certain words imitate sound or motion through a resemblance between their "softness or harshness" and the sounds they describe.

On the other hand, Richard Hurd, writing in 1751, maintains that "all Poetry, to speak with Aristotle . . . is, properly, imitation. . . . In this view every wondrous original, which ages have gazed at, as the offspring of creative fancy; and of which poets themselves, to do honour to their inventions, have feigned, as of the immortal panoply of their heroes, that it came down from heaven, is itself but a copy, a transcript from some brighter page of this vast volume of the universe." Moreover, the function of "genius" is to select the "fairest forms of things, and to present them in due place and circumstance, and in the richest colouring of expression, to the imagination. This primary or original copying, which in the ideas of Philosophy is Imitation, is, in the language of Criticism, called Invention." [5]

The difference between Hurd's and Jones's use of mimesis indicates the extremes in attitude toward Aristotelian "rules" in general and toward mimesis as a legitimate critical concern in particular. *Imitation* has numerous meanings in the eighteenth century, but regardless of particular applications in individual works, it is a crucial term. Twining seeks to answer those who apply the concept without understanding it, those who castigate it without understanding it, those who extend it to the point of meaninglessness, and those who improperly restrict it.

Despite frequent discussions of Aristotelian "rules" in the eighteenth century, neoclassical critics are not as conversant with Aristotle as one might expect. Much of their acquaintance is derived from Aristotle's French and Italian commentators. Moreover, Aristotelian method is overshadowed by rhetorical tradition;[6] eighteenth-century critics often fail to acknowledge the fundamental differences between Roman rhetoric and Aristotelian poetics.[7]

A prominent factor in the misinterpretation of Aristotle was the lack of a readily available, adequate text of the *Poetics*. Perhaps the

most widely used texts were the unsatisfactory anonymous translation (1705) from the French of André Dacier, Thomas Rymer's translation of Rapin's *Reflections* (1674), and an anonymous undistinguished translation of the *Poetics* in 1775.[8] It was not until 1788 that more satisfactory texts appeared; Pye's translation is dated 1788 and Twining's, 1789. Together, their translations, particularly Twining's, remained as standard texts for the next century. Ironically, however, general interest in Aristotle was waning at the time when Aristotelian scholarship was advancing.

Although Twining interprets Aristotle more accurately than most eighteenth-century critics, it must be acknowledged that his dissertations manifest a certain misunderstanding of Aristotle's intentions. He does not altogether succeed in freeing himself from mistaken attitudes resulting from earlier commentators of Aristotle. The shortcomings of Twining's interpretation are most apparent in the preface to his two dissertations. He states that "Aristotle . . . everywhere reminds [the poet], that it is his business to represent, not what is, but what should be" (p. xv). For Twining, Aristotle prescribes, to a certain extent, rules for the poet. He thus fails to realize that in Aristotle's conception of art, what is proper or improper is so only in each individual case, even though universal terminology may be applied. The *Poetics* does not properly admit of rules. Twining also states that the poet, according to Aristotle, should "look beyond actual and common nature, to the ideal model of perfection in his own mind" (p. xv). He is not to be numbered among those who attempt to reconcile Plato with Aristotle, but such a position is more nearly Platonic than Aristotelian. These misinterpretations are not of major significance, however, in the context of Twining's two essays; they do not seriously impair the value of his specific arguments concerning poetic and musical imitation.

After commenting that imitation is sometimes used in a "strict and proper sense, and sometimes in a sense more or less extended and improper" (p. 3), Twining states that his dissertation "On Poetry Considered as an Imitative Art" will analyze two problems: "in what senses the word Imitation is, or may be, applied to Poetry" and "in what senses it was so applied by Aristotle" (p. 4). He begins by saying that the only circumstance common to everything termed imitation is resemblance, and for every resemblance, two conditions are essential: the resemblance must be immediate and it must be obvious. By "obvious," Twining means that we must recognize the object imitated; sculpture, for example, represents a figure by a similar figure, and in personal imitation, voice is represented by similar voice. By "immediate," he

means that the resemblance must be found in the imitative work itself, in the materials through which the imitation is conveyed.

Twining then proceeds to analyze four senses in which imitation may be applied to poetic art. The first type of imitation involves words as the materials of poetic imitation. Sounds *merely*, or sounds as sounds, may imitate the sounds or motions of the objects imitated (the sense used by Kames), thus producing a sonorous imitation. Although this type of resemblance is immediate, it is not obvious, for we cannot discover the resemblance until we know the signification of the sounds. Thus Twining concludes that although the term *imitation* can be applied to such phenomena, imitation is not then used in its *strict* sense. Sounds significant can more properly and more importantly be understood to imitate than sounds merely.

This second category, sounds significant (or imitation by description), may be applied not only to "poetic landscape-painting" (p. 9) but to all circumstantial and distinct representation which conveys a strong and clear idea of its object to the mind. Descriptive imitation is divided into three categories which are more or less imitative in proportion to their capability of "raising an ideal image or picture, more or less resembling the reality of things" (p. 9). The perfection of the imitation depends on the distinctness and vividness of the ideas composing the descriptive picture and the closeness of their correspondence to the actual impressions received from nature. Hence descriptions of visible objects are the most distinct and vivid. The objects of other senses are not as amenable to vivid and distinct ideas. However, the next most imitative description is that of sounds, the likeness being achieved not through sonorous imitation but through the significations of words. The third type of imitative description is that "of mental objects; of the emotions, passion, and other internal movements and operations of the mind" (p. 15). These mental objects may be described immediately as they affect the mind or through their external and sensible effects. The end of the immediate description of mental objects is simply clear and distinct representation; the end of description through sensible effects is to arouse in the reader the passion or emotion "of its internal cause" (p. 16). Description through sensible effects principally deserves the name imitation since immediate descriptions are "by their very nature" (imaginary passions which terminate in distinct representation) weaker and seldom "possess that degree of forcible representation that amounts to what we call imitative description" (p. 16).

In the third sense, imitation is applied to poetry "when considered as fiction." The likeness in this sense is not to an aural, visual, or mental

object, but to "stories, action, incidents, and characters, as far as they are feigned or invented by the Poet in imitation . . . of nature, of real life, of truth, in general, as opposed to that individual reality of things which is the province of the historian" (p. 19). Epic and dramatic poems provide the principal examples. Fictive imitation is distinct from descriptive imitation in that the resemblance in descriptive imitation is between the ideas raised and the actual impressions received from the things themselves, whereas in fictive imitation, it is between the ideas raised in the poem and ideas outside the poem which are collected from experience. Hence descriptive imitation is opposed to impression; fictive imitation is opposed to fact. In their effects, descriptive imitation produces illusive perception; fictive imitation produces illusive belief. Furthermore, the two may exist independently of one another. The second and third uses of imitation (descriptive and fictive) are, however, extended or improper senses, as is the first (sounds merely). Each lacks one of the two essential conditions for imitation. Sonorous imitation lacks the condition of obviousness; fictive and descriptive are obvious, but not immediate since the imitation lies in ideas raised as signs rather than in the words themselves. Nevertheless, since obviousness is more important than immediateness (*essential* is apparently a relative term for Twining, since one condition is more essential than the other), *imitation* can more properly be extended to fictive and descriptive than to sonorous imitation.

The one type of poetry which can be considered imitative in the "strict and proper sense" is dramatic or personative poetry in which speech imitates speech. Personative imitation is both immediate and obvious. When we speak as another person, we become mimics not only of the ideas we convey but of the discourse itself. Tragic and comic poets, epic poets, and historians imitate in this manner when "either of these quits his own character, and writes a speech in the character of another person" (p. 22). In passages which do not evince any of these four types of imitation, the poet "stoops to fact, and becomes, for a moment, little more than a metrical historian" (p. 23). Twining points out that although Aristotle did not say that all poetry is imitation, other critics have, and that such a statement is simply an "improper and confused way of saying, that no composition that is not imitative ought to be called Poetry" (p. 24).

The four types of imitation, then, are sonorous, descriptive, fictive, and personative. Of the four, personative is most strictly and properly termed imitation. Before examining Twining's discussion of Aristotle's use of *imitation*, it should prove helpful to look more closely at his use

of the term in the first half of the dissertation. It must be noted that he does not assign a single signification to the word; rather, it has various meanings in the text. Moreover, it admits of degree. Thus Twining says that resemblance by sound and by personation are both imitation, but that the latter is more strictly and properly termed imitation; and in discussing descriptive imitation, he says that although descriptions of visible and mental objects are both imitative, the former is more imitative by its very nature. Because the nature of imitation in the first two senses (sound and description) depends on the likeness to objects (and here "objects" may be mental, visual, or sounds alone) outside the work, the degree of the poetic imitation depends on the verisimilitude of the image aroused in the reader's mind to the imitated object in the real world: the greater the likeness between the imitated object and the poetic image of it, the greater the imitation. In both these categories, the measure of the imitation depends on something external to the work. In discussing descriptive imitation, Twining says that poetry is more or less imitative insofar as the poet can raise an "ideal image" resembling the real world, a notion which is Platonic rather than Aristotelian; such imitation depends on particulars, and the criteria of degree of imitativeness ultimately have their bases in nature.

In the first two uses, the things imitated are sounds and mental and visual objects; in the last two applications, the bases of imitation are fiction and personation. Twining's use of *fiction* is completely unlike Aristotle's use of *action*. He calls "stories, actions, incidents, and characters" fiction which imitates "nature, real life, truth, in general, as opposed to that individual reality of things which is the province of the historian." Fictive imitation produces illusive belief and is opposed to fact. Although Twining separates the poet from the historian, his position is different from that of Aristotle, for whom poetry expresses the universal in terms of probability and necessity established within the work. Imitation, used in this sense by Twining, is not an imitation of an action, but an imitation of nature, of real life, of natural truth, produced by the fabrication of stories, actions, incidents, and characters which approximate "truth" or "nature." As in sonorous and descriptive imitation, the measure of the worth of fictive imitation lies not within the principles of probability and necessity established in the work, but in the degree to which it conforms to "truth in general." Cognitive pleasure is basic to imitative art in Aristotle; when Twining says that descriptive poetry is more or less imitative in the degree to which it raises an ideal image of the reality of things, and when he equates imitation with fiction, his position is further from Aristotle than from

89

Plato, who discusses imitation in terms of the degree of falseness as one moves further from ideas.[9]

The primary difference in Twining's use of imitation in the last two senses (fictive and personative) lies in the "immediateness" of the imitation. Both are obvious in the same sense (both, that is, raise ideas and so forth which correspond to "truth in general"), but the latter adds imitative discourse effected through dialogue (or dramatic presentation). Designating personation as the quality of imitation which makes it the only "strict and proper" sense in which the term *imitative* should be applied seems unduly restrictive. Personative imitation is a much narrower concept than Aristotelian mimesis, and does not resolve many of the important problems about imitation raised by Twining.

The second half of the dissertation on poetic imitation, which deals with the question of "in what senses Aristotle applied imitation to poetry," indicates that Twining understands the *Poetics* fairly completely and that he approaches it, for the most part, for what it is: a systematic treatment of the science of poetics. He begins by stating that Aristotelian mimesis meant fiction, whether narrative or dramatic. He then says that Aristotle considered "dramatic Poetry as *peculiarly* imitative, above every other species" (p. 25). By emphasizing the *peculiarly* imitative nature of the dramatic manner, Twining resolves what is an apparent inconsistency in Aristotle: that the poet may imitate in his own person but that the narrator should imitate as little as possible in his own person, since he is not then the imitator (chapters 3 and 24). Twining is certainly correct in emphasizing *peculiar*, since Aristotle did consider the dramatic more imitative than the narrative manner.

He is not correct, however, in identifying Aristotle's use of mimesis with his use of fictive imitation. He argues that Aristotle considered the poet an imitator in that he invents a fable. Twining equates *mythos* with fable, and then equates fable with "imitation of an action" (p. 25). For Twining, the fable or series of events must approximate the real world and is probable in terms of "truth in general"; for Aristotle, artistic probability resides in the work, not in nature.

After considering the "apparent inconsistence" in Aristotle, Twining proceeds to a discussion of the reasons why the other two senses of imitation (sonorous and descriptive) are not found in the *Poetics*. The problem arises because critics conduct comparative discussions of imitation, being "naturally led" to compare poetry with arts which are *strictly* imitative, such as painting. Painting and sculpture

are the most strictly imitative arts because the likenesses they produce are immediate and obvious, and it is the analogous aspects of the arts which influence the first two categories of imitation (descriptive and sonorous). Here, degree of imitativeness is measured in terms of producing a likeness to some original found in nature; thus the arts can be discussed as more or less imitative. Aristotle, however, distinguishes among the modes of artistic imitation in terms of means, objects, and manners of imitation; imitation does admit of degree (although degree of imitativeness is not a primary means of distinguishing among the arts), and imitation is possible in nature, but natural imitation is of particulars, which is copying. The question of copying particulars based in nature, which is what is involved in sounds significant and sounds merely, assumes an importance in eighteenth-century comparative discussions which it does not have for Aristotle.

Twining correctly points out, however, that Aristotle did not maintain that all poetry is imitation or that all imitation is poetry. His observation is important because it avoids difficulties which result from failing to define the proper realm of imitation in nature and art. When nature and art are compared as materials or substances, imitation is peculiar to art (a tree is not an imitation of another tree), but imitation is not confined to art or absent in nature (monkeys are, after all, mimics).

In discussing the absence of description in Aristotle's concept of poetic imitation, Twining comments that "when it is said that Aristotle did not include description in his notion of 'imitation,' it is not meant that he did not consider the descriptive parts of narrative Poetry as in any respect imitative. The subject of a description may be either real, or feigned" (p. 18). Since most of the descriptions of "higher Poetry" are of the latter kind, Aristotle considered them fictive imitation, "as falsehood resembling truth, or nature, in general" (p. 28). Again Twining Platonically equates falsehood with imitation and gives the impression that Aristotle believed that the task of the poet is to convey a portrait resembling "nature," "real life," or "truth in general." Twining concludes by saying that with the ancients, "there could be no difficulty in conceiving Poetry to be an Imitative Art, when it was scarce known to them but through the visible medium of arts, strictly and literally, mimetic" (p. 43). In this final usage of imitation, he means personative imitation, which, in the first half of the essay, he called the "one view in which Poetry can be considered as Imitation, in the strict and proper sense of the word" (p. 21).

In the dissertation "On the Word Imitative, as Applied to Music,"

Twining enumerates three effects comprising the "whole power of Music" (p. 44): it may delight the senses simply by appealing to the ear, raise emotions by affecting the passions, or raise ideas through the imagination. Because music must be expressive to be imitative, and because only the latter two effects of music (raising emotions and ideas) are expressive or "moral" (used in the sense of appealing to the mind rather than to the senses), effects which are "merely physical" are "no more imitative than the smell of a rose, or the flavour of a pineapple" (p. 44). Draper objects that "of course, such musical literature is not to be classified with the mere 'flavor of a pineapple,'" and states that "an analysis of this first type . . . might have led [Twining] to the idealistic sense that Aristotle seems to have intended." [10] For both Twining and Aristotle, imitation implies resemblance; if Twining is correct in arguing that musical effects which are "wholly physical" refer to nothing beyond themselves, he is justified in grouping such music with the flavor of a pineapple in respect to imitation. But one can argue that he dismisses this first musical effect too quickly, having failed to consider the various ways in which "physical" effects might be considered imitative. There may be no "merely physical" musical effects (in the sense of self-contained physical pleasure); as Beattie recognizes, apparent physical properties may resemble motions of the soul. And if psychic patterns and musical sound patterns correspond, the latter may be considered imitative.

Music is imitative in raising ideas immediately through "the actual resemblance of its sounds and motions to the sounds and motions of the thing suggested" (pp. 44–45). Such imitation is analogous to what Twining calls sonorous imitation in poetry; in both cases, although the resemblance is found in the materials through which the imitation is conveyed, it lacks the quality of obviousness. The significance of the sounds is not self-evident. Moreover, of the possible imitative powers of music, the raising of ideas through the resemblance of sounds and motions to imitated sounds and motions is the least effectual and is not essential to musical pleasure. Unless used judiciously, "it will destroy that pleasure, by becoming, to every competent judge, offensive, or ridiculous" (p. 46). It is, however, only this power of music to which Harris, Avison, Kames, and Beattie apply the term *imitation*.

In the course of his essay, Twining mentions two other ways in which ideas can be raised by music, neither of which can be called imitative. Ideas may be raised through association; such effects are immediate, but are not imitative: "If so, to raise an idea of any object by casual association, be to imitate, any one thing may imitate any other"

(p. 45n). Music also has a limited, indirect power to raise ideas "through the medium of those emotions which it raises immediately," but this effect is so subjective "that to call it imitation, is surely going beyond the bounds of all reasonable analogy. Music, here, is not imitative, but if I may hazard the expression, merely suggestive" (p. 49n).

Although such effects are not imitative, Twining realizes that they are among the most pleasurable afforded by instrumental music. Music evokes a general emotion or temper, but does not specify ideas; the listener's imagination is allowed free reign to select those ideas which for him accentuate the original emotion, thus producing a unique pleasure for each member of the audience. He states that "the complaint, so common, of the separation of Poetry and Music, and of the total want of meaning and expression in instrumental Music, was never, I believe, the complaint of a man of true musical feeling" (p. 49n). Twining thus recognizes that the pleasure of instrumental music is essentially different from that afforded by music and poetry combined because the former lacks the precise signification of the latter and must be evaluated on fundamentally different principles.

Of the three powers of music (delighting the senses, raising ideas, and raising emotions), Twining agrees with Beattie, Harris, and Avison that raising emotions is the most important, but "this is so far from being regarded by them as imitation, that it is expressly opposed to it" (p. 46). What these critics oppose to imitation under the name of expression (the power of music to move the passions) is the same effect which the ancients call imitation. Twining argues that although there are genuine disagreements between Aristotle and modern critics, the apparently fundamental differences in regard to theories of imitation and expression are, at least partially, differences in terminology that can be readily explained. First, in calling the raising of emotions imitative, Aristotle refers to the resemblance between "dispositions, or tempers" and the rhythm and melody of music; such a resemblance is between effects (that is, specific sounds evoke feelings which are similar to those attending the emotions of real life). The similarity does not inhere in the medium of imitation, for sounds and psychological states cannot bear strict resemblances to one another, but the similarity of effect is readily intuited (the imitation is thus "obvious"). Second, music without words can raise only a "general emotion"; the addition of words supplies a specific object, transforming a general temper into "a particular and determinate passion." Ancient music was seldom heard without the accompaniment of poetry; thus, "when an antient writer speaks of Music, he is, almost always, to be understood to mean vocal Music,"

which "helps greatly to account for the application of the term imitative, by Aristotle, Plato, and other Greek writers, to musical expression" (pp. 48–49).

Twining argues that music, especially dramatic music, may not only be obviously imitative (by imitating the effect of words) but immediately imitative (by imitating words themselves through "tones, accents, inflexions, intervals, and rhythmical movements, similar to those of speech" [p. 51]). Rhythm and melody are analogous to human action; musical rhythm corresponds to rhythmic motions of men and successive melodic tones correspond to the successive tones of human speech. Twining remarks that critics who "resolve all the pathetic expression of Music" into an analogy between speech and melody "are yet much nearer to the truth than those, who altogether overlook, or reject, that principle" (p. 58). He refutes Beattie's argument that a pathetic melody does not bear any resemblance to the voice of a human being affected by pathos by arguing that the effects of such an analogy may be felt even if the analogy is not perceived. Twining perhaps assigns undue significance to the correspondence between music and speech, while ignoring other, potentially more important correspondences; but it must be remembered that his remarks concerning the music/speech correspondence occur in the context of addressing specific problems posed by others, and seek to redress what he regards as an imbalance between those who overlook entirely the correspondence and those who unquestioningly embrace and abuse it.

Twining uses his analogy between the natural tones of speech and those of melody to clarify another problem Beattie poses in *An Essay on Poetry and Music*. Beattie states that if musical sounds are not imitations of natural sounds, "I am at a loss to conceive how it should happen, that a musician, overwhelmed with sorrow, for example, should put together a series of notes, whose expression is contrary to that of another series which he had put together when elevated with joy" (p. 478). Twining argues that a man overwhelmed with sorrow easily puts together, in speaking, tones which convey sentiments unlike those he expresses when overcome with joy; because melodic tones are analogous to the tones of speech, "whoever can account for the one, need not . . . be at the trouble of trying to account separately for the other" (p. 59n).

In concluding his second dissertation Twining remarks that those critics who would exclude music from the imitative arts are justified in doing so when "imitation" is confined to what he considers the least significant powers of music (raising ideas through the immediate

resemblance of musical sound to the sounds and motions of things imitated). The essay indicates, however, that imitation need not be so confined when applied to music. At the same time, theories which try to account for the nature of instrumental music must rely on principles which recognize the unique qualities and effects of instrumental music rather than on principles derived from vague analogies with the other arts. Twining perceives, more clearly than most of his contemporaries, that numerous fundamental distinctions are of more value than casual analogies in classifying poetry, painting, and music as imitative arts. Each of these arts imitates in some sense, but in manners which differ so radically that, unless careful distinctions are made, "we seem to defeat the only useful purpose of all classing and arrangement; and, instead of producing order and method in our ideas, produce only embarrassment and confusion" (p. 61).

Chapter Five

Adam Smith's Analysis of the
Imitative Arts and Instrumental Music

Although Adam Smith's reputation as a political economist and moral philosopher has long been established, his contribution to eighteenth-century aesthetics has been almost entirely overlooked. His essay, "Of the Nature of That Imitation Which Takes Place in What Are Called the Imitative Arts," which first appeared in *Essays on Philosophical Subjects* (London, 1795) five years after his death, deserves greater recognition than it has received. In it, Smith attempts to define the senses in which sculpture, painting, music, and dancing can be appropriately and profitably discussed as "imitative." Like Harris and Twining, he recognizes that differences in media dictate fundamental differences in the range of possible effects. He also sees that the nature of the medium limits the subject matter imitated and presents certain unique problems in handling subjects common to several art forms; hence the various arts do not imitate in precisely the same manner.

Smith's essay is uneven. Though more perceptive than many contemporary essays, his discussion of sculpture and painting is often unsatisfactory. On the other hand, his analysis of vocal and instrumental music clearly ranks among the most significant theoretical essays on the relationship of music to the other arts in eighteenth-century Britain. Unlike the majority of his peers, Smith does not discuss the effects of instrumental music in terms of principles derived from prior analyses of other arts, particularly poetry, and applied through broad analogies to music. Nor does he dismiss instrumental music as an "unmeaning" (and hence in some sense inferior) art because it cannot yield the precise pictorial or verbal "meanings" of painting, poetry, and vocal music. Like Twining, Smith recognizes that the concepts which define and principles that account for the effects of instrumental music must be essentially unlike those applied to vocal music. If painting, sculpture,

poetry, dancing, and vocal music represent subjects which are in some sense external to their imitative materials, instrumental music does not. He argues that its subject matter inheres in the composition and does not refer to anything beyond itself; hence there are no natural corresponding subjects by which instrumental music can be measured as an imitative art. Doubtless it can be objected that there is more to the question of music as an imitative art than Smith perceives, but his analysis of the nature and effects of that art reflects a greater originality and grasp of the complexity of the subject than any of the comparative discussions of the latter half of the eighteenth century, with the possible exception of Twining's second dissertation. Interest in Smith's essay need not be primarily antiquarian; it remains of absolute worth.

The essay is divided into three major parts (on imitation in sculpture and painting, in music, and in dancing). In each section,[1] the central question can be phrased as "to what extent can any given concept of imitation explain the pleasurable effects of each art?" Smith's primary concern is more nearly Aristotelian than Horatian; he is not interested in how preestablished effects can best be achieved but in the unique possible problems faced by artists working with specified media. Like many of his fellow aestheticians who were influenced by investigations in empirical psychology, Smith is also concerned with natural human responses to the various arts, but this interest is of secondary importance in the essay. Since he is aware of the peculiarity of the problems encountered in different art forms, he does not posit a concept of ideal nature, for example, which serves as the measure of imitative effects for all arts. Instead, he suggests a number of senses in which the arts imitate; and when specific effects cannot properly be explained in terms of imitation, he proposes alternative principles.

Early in his essay, Smith establishes those qualities essential for any concept of artistic imitation and those which distinguish artistic from natural imitation. Imitation implies resemblance of some kind. Smith states that "the most perfect imitation of an object of any kind must . . . be another object of the same kind, made as exactly as possible after the same model."[2] It is clear, however, that this law applies to objects and natural imitation, but not necessarily to artistic imitation. *Perfect* is used in the sense of "most exact"; in art, the precise imitation of particular objects or another work ("servile copying") does not result in aesthetic pleasure, and may lead to displeasure: "To build another St. Peter's, or St. Paul's church, of exactly the same dimensions, proportions, and ornaments with the present buildings at Rome, or

London, would be supposed to argue such a miserable barrenness of genius and invention as would disgrace the most expensive magnificence" (p. 134).

Smith's theory depends on further distinctions between pleasure in nature and art. For example, an exact resemblance of corresponding parts in the same object lends a symmetry and sense of wholeness which may produce pleasure in both art and nature. However, Smith sees that, in nature, two identical objects or corresponding parts of an object, considered singly, do not derive beauty or lack of merit from their mutual resemblance, whereas in art, the exact correspondence of two works results in "some diminution" of the merit of one. Artistic pleasure, that is, does not result from a resemblance to objects of the same kind; instead, it is achieved through a resemblance to objects different in kind. This distinction underlies the central idea of the first section of the essay, an idea which serves as the major premise for all of his subsequent arguments: "In Painting, a plain surface of one kind is made to resemble, not only a plain surface of another, but all the three dimensions of a solid substance. In Statuary and Sculpture, a solid substance of one kind, is made to resemble a solid substance of another. The disparity between the object imitating, and the object imitated, is much greater in the one art than in the other; and the pleasure arising from the imitation seems to be greater in proportion as this disparity is greater" (p. 137).

Smith's explanation of the range of subject matter appropriate for painting and sculpture and his analysis of the degrees of pleasure possible in each result from his concept of disparity. Observing that the disparity between a statue and the object it imitates is not great, he argues that the "imitation seldom pleases, unless the original object be in a very high degree either great, or beautiful, or interesting" (pp. 137–38). Painting, however, can produce pleasure by imitating subjects which are "indifferent, or even offensive" because the greater disparity between imitating and imitated object affords a simple, original pleasure in recognizing the merit of the imitation. From Smith's consideration of sculptural media, it follows that similar pleasure is not possible if the same subjects were imitated in sculpture. Consequently, Smith concludes that "there would seem . . . to be more merit in the one species of imitation than in the other" (p. 138).

The difficulty with this explanation is that, carried to its logical conclusion, it reduces much of the pleasure in the imitations of sculpture and painting to an admiration for technical dexterity. Smith argues that certain subjects necessarily please more in painting than in

sculpture because there is a greater disparity between a two-dimensional canvas and its imitated object than between a three-dimensional statue and its subject. The wider range of pleasing subjects in painting results from the nature of the media, but Smith later (p. 148) argues that a single statue may afford as much pleasure as several drawings of the same subject (since a statue may be viewed from more points of view than a painting). It is not clear why a similar argument does not apply to three-dimensional representations of any subject.

There are greater difficulties in Smith's account of the *variety* of pleasure in the two arts. The principal problem is defining the precise range in which resemblance of some kind and disparity between imitated and imitating object combine to produce maximum pleasure. Smith argues that it is not the lack of coloring which prevents certain subjects which please in painting from pleasing in sculpture; instead, coloring in sculpture "destroys almost entirely the pleasure which we receive from the imitation; because it takes away the great source of that pleasure, the disparity between the imitating and the imitated object" (p. 140). A painted statue may resemble a human figure more exactly than one which is unpainted, but we are not pleased by the superior likeness. Instead, he argues, we blame it for lacking life. Such works, that is, destroy the illusion of art, which is apparently necessary for pleasure in his theory, and achieve their effects by deception. Similarly, Smith states that artificial fruits and flowers fail to produce the lasting pleasure possible from paintings of such subjects, since, although the resemblance may be greater, the disparity is not. The effect is one of unpleasing deception. Conversely, an imperfect resemblance in tapestry may be highly pleasing, since the "instruments of imitation are awkward and the disparity between imitating and imitated object is great" (p. 141). Smith's argument, then, is that as the disparity between objects which do not naturally resemble one another increases, so does our pleasure in imitations which overcome the disparity. It would appear that a corollary argument might be that our pleasure is greater the more completely the disparity is overcome, but such is not the case. If the resemblance is too precise, pleasure is replaced by distaste for deception. Hence, in Smith's explanation of pleasure in painting and sculpture, there is a somewhat nebulous range between unintelligible resemblance and precise resemblance in which the most successful works fall.

The range is determined by universal natural causes of pleasure in artistic imitations. The pleasure derived from the two arts is "founded altogether upon our wonder at seeing an object of one kind represent so

well an object of a very different kind, and upon our admiration of the art which surmounts so happily that disparity which Nature had established between them. The nobler works of Statuary and Painting . . . carry, as it were, their own explication along with them, and demonstrate, even to the eye, the way and manner in which they are produced" (p. 146). Taken singly, attributing the source of pleasure to our "wonder" at seeing natural disparity overcome does not adequately account for the pleasurable imitations of the two arts. It does not, for example, take into account pleasures resulting from the non-representational aspects of art. It does partially explain the pleasure derived from any imitation, but implies a pleasure in precise representation which Smith does not fully reconcile with the idea of intentional deception. The division between deception and "disparity overcome" is cloudy. Moreover, arguing that "nobler works" carry their "own explication" does not clarify the difference between works which deceive and those which overcome disparity without deceiving; it could be argued that works which Smith classifies in the former category (such as colored statues) carry their own explication in a more obvious sense than those in the latter.

If Smith's discussion of the imitative nature of sculpture and painting is somewhat facile, his analysis of vocal and instrumental music is not. He introduces the subject with a brief conjectural history of the development of music, particularly in relation to dancing and poetry. This conjectural history is not merely an exercise in ingenuity; it establishes the various fundamental aspects in which these arts imitate. The common denominator of music and dancing is "time" (or measure): "Music consisting in a succession of a certain sort of sounds, and Dancing in a succession of a certain sort of steps, gestures, and motions, regulated according to time or measure, and thereby formed into a sort of whole or system" (p. 149). Smith reasons that the human voice was probably the first musical instrument, employing words that need not have any meaning. Eventually, words with meaning were fashioned into verse and fitted to the appropriate "humour" of the tune. Thus verse lends "meaning" to tune in the same manner in which a pantomime gives meaning to an otherwise "unmeaning" music, although poetry can express a wider range of meaning. Consequently, it is evident that in terms of narrating events or describing situations precisely, Smith regards poetry as most imitative, dancing as second most imitative, and music as least imitative.

Since things which do not naturally resemble are made by art to do so in vocal music, Smith regards that art as essentially imitative. In

addition to the general manner of song imitating reasoned discourse, he defines two other senses in which vocal music imitates: it imitates the particular feelings of an individual in a particular situation, and it imitates in what might be called a dramatic manner (the singer performing as an actor). In the former type, a lover or warrior, for example, expresses sentiments occasioned by a situation described by words. Smith quite correctly observes that the common eighteenth-century objections to the "unnaturalness" of such music are ill-founded, insofar as part of the pleasure of any imitation derives from "unnatural" resemblances. Moreover, he reasons that vocal music's imitation of animated passions has an advantage over other forms of discourse, even in terms of natural resemblance. Smith's explanation is based on psychological evidence. Vocal music, he argues, may repeat (whereas poetry and prose describe) those thoughts or ideas which naturally recur to anyone moved by a dominant passion, thus perfectly imitating the state of mind of such an individual. The broken repetitions of vocal music constitute its unique imitative power.

In vocal music's dramatic imitations (such as opera), expression corresponds to time and measure, making it an integral part of the total performance. Dramatic music is the most fundamentally and exactly imitative of the three types described by Smith; in it, discourse and action directly imitate their counterparts in real life.

In terms of the various concepts of imitation Smith proposes, vocal music, painting, and sculpture can all be classed as essentially imitative arts. In all, objects which do not naturally resemble are made to do so by art. There are varying degrees of disparity between the artistic work and the subject represented, but in all three, subject matter is external to media. He recognizes that with instrumental music this is not the case; none of the three senses in which vocal music imitates can apply to it. The imitative powers which almost all other eighteenth-century critics ascribe to it (imitations of sound and motion) are indistinct and insignificant. Smith claims it is necessary that the imitating object resemble that imitated sufficiently to suggest readily the latter without additional interpretation if the work is to be called imitative; hence instrumental music's effects are like those of a picture which needs an inscription to clarify its subject matter.

In explaining this phenomenon, Smith draws an analogy between musical compositions and states of mind affected by passion, thus offering his explanation of the frequently discussed eighteenth-century question of the special relationship between emotion and music. The speed and logical sequence of ideas which continually pass through the

mind, Smith reasons, vary according to one's mood (ideas are rapid and often unrelated when we are cheerful, or monotonous and repetitious when grave, and so forth). In music, "acute sounds are naturally gay, sprightly and enlivening; grave sounds solemn, awful, and melancholy" (p. 162): thus, if one listens to instrumental music attentively, the succession and relationship of sounds approximate states of mind and naturally give rise to ideas appropriate to various dispositions. In Smith's terms, however, the effect is *not* that of imitation. Instrumental music does not narrate a story or duplicate the emotions of a particular man in a specific situation; rather, "it becomes itself a gay, a sedate, or a melancholy object" (p. 164). The emotional response of the listener is "sympathetic" in the case of vocal music or painting, Smith says, whereas in instrumental music, it is original; its "meaning" is self-contained insofar as its emotional content does not refer to any object beyond its materials of composition. Instrumental music excites various moods, but it does not imitate them because "there are no two things in nature more perfectly disparate than sound and sentiment; and it is impossible by any human power to fashion the one into any thing that bears any real resemblance to the other" (p. 164).

If instrumental music, whether by itself or in support of the imitations of another art, is not imitative in any important sense, what is its subject matter and how does it produce pleasurable effects? Smith's answer is perhaps the most coherent and competent in eighteenth-century comparative discussions of the arts; it certainly does greater justice to the actual powers and sources of pleasure of instrumental music than any which precede his. His explanation clears instrumental music from charges of being merely sensual and unmeaning. It does so because he does not, unlike Jones or Beattie, treat instrumental music simply as the handmaiden of poetry, and because he does not apply, a priori, principles which, however useful they might be in explaining the effects of other arts, do not recognize the unique qualities of instrumental music. He avoids obscure, conjectural accounts, such as Webb's, of the relationship between physiological mechanisms and musical sounds; such analyses, whatever value they may have for students of natural human behavior, say very little about the aesthetics of music when they ignore the fundamental structural devices of musical compositions conceived as independent wholes, each operating on its own internal, constitutive principles. Moreover, he clearly sees that the effects of instrumental music over the passions are not the only powers of music, and that such effects operate in conjunction with others.

Smith begins with the evidence of what composers have done,

proceeding to an inductive knowledge of the organizing principles and unique qualities and effects of instrumental music. Without imitation, he claims, instrumental music has several effects: "by the sweetness of its sounds it awakens agreeably, and calls upon the attention; by their connection and affinity it naturally detains that attention, which follows easily a series of agreeable sounds, which have all a certain relation both to a common, fundamental, or leading note, called the key note; and to a certain succession or combination of notes, called the song or composition" (p. 171). Through its relationship with other notes, each sound prepares the listener for what is to follow; time and measure create regulated divisions so that "we are enabled both to remember better what is gone before, and frequently to foresee somewhat of what is to come after" (p. 171). Our responses to a particular sound depend on recollection of what preceded it and anticipation of what is to follow it; thus our pleasure in an entire work reflects the combined effect of all parts significantly related to each other. Hence Smith concludes that the complexity of instrumental music "presents an object so agreeable, so great, so various, and so interesting, that alone, and without suggesting any other object, either by imitation or otherwise, it can occupy, and as it were fill up, completely the whole capacity of the mind, so as to leave no part of its attention vacant for thinking of any thing else" (p. 172).

Pleasure in instrumental music, then, is not merely sensual; it produces intellectual satisfaction in the same sense that observing and understanding a mathematical or scientific system affords pleasure. In this sense, Smith's assertion that its meaning is complete in itself, whereas those of painting or vocal music are not, is valid, and establishes a useful distinction among the arts. His distinction between the "subject" of instrumental music and those of poetry and painting is equally significant because it indicates that the conventional eighteenth-century senses of imitative pleasure are not relevant for discussions of instrumental music, and also suggests some idea of the basis on which evaluative principles should be founded. The subject of a poem or picture "is always something which is not either in the poem or in the picture" (that is, distinct from words or colors), whereas the subject of instrumental music inheres in the combination of notes.

As a consequence of his definition of *subject*, Smith is able to argue convincingly that musical "expression" (its effect upon the emotions through the mind) is not, as Avison and many other critics claim, directly parallel to expression in painting. In fact, he says, expression cannot be properly considered a distinct aspect of instrumental music. Expression in painting results from like or dislike of the

passions suggested by the actions or demeanors of characters depicted in painting (that is, by the thought of something external to the lines and colors of the work); similar effects in instrumental music result from melody and harmony, which signify nothing beyond themselves. Thus, to say, as Avison does, that music "is composed or made up of three distinct arts or merits, that of melody, that of harmony, and that of expression, is to say, that it is made up of melody and harmony, and of the immediate and necessary effects of melody and harmony" (p. 174).

In the third part of his essay, Smith defines the imitative and nonimitative aspects of dancing, and analyzes the extent to which pleasurable effects result from imitation. He concludes that dancing's imitative powers are equal to those of any art, but like instrumental music, dancing is not essentially imitative. The cadenced steps distinguishing dancing from other forms of motion yield a simple, nonimitative pleasure, but when such steps imitate the "ordinary" or the "more important" actions of men, the dancer overcomes the natural disparity between imitated and imitating object. From Smith's consideration of its means, it follows that the subject matter dancing can represent is more similar to that of drama than to painting or sculpture because dancing is not limited to a single moment of time. It can relate successive actions in addition to describing a particular, static situation. Consequently, he concludes that dancing affects us "more than either Statuary or Painting" (p. 177).

In Smith's analysis, then, dancing, vocal music, painting, and sculpture may all be considered imitative arts in varying degree and with different effects, while instrumental music may not. The latter differs from the other arts fundamentally (1) because its meaning is self-contained and (2) because its subject matter has no independent existence in nature. Consequently, he recognizes that it cannot be defined, nor can its effects be explained in terms of many of the conventional eighteenth-century concepts of imitation or expression. It is primarily for his analysis of the essential differences in intrinsic constitutive principles between vocal and instrumental music that Smith's essay deserves to be remembered as a significant contribution to eighteenth-century British aesthetics.

Chapter Six

Minor Voices

In terms of inherent worth, influence, or comprehensiveness, the works discussed above constitute eighteenth-century Britain's major attempts to discover bases for clarifying fundamental similarities and differences among the arts. There exists, however, a moderately sized body of minor works—separately published essays, reference manuals, letters, periodical literature—addressed to the same problem or to specialized aspects of it.[1] If many of these works have little permanent intrinsic worth, they are important in defining the changing scope, variety, and public appeal of comparative discussions of the arts in the eighteenth century. From a few widely spaced works early in the century, comparative discussions gradually increased in number throughout the first half of the century, reached their maximum volume in the years between 1760 and 1790, and then declined. If the proliferation of letters and popular periodical literature dealing with comparisons among the arts, and the increased diversity of kinds of men who wrote such works are accurate indicators, general public interest in this branch of aesthetics multiplied considerably during the second half of the century.

One objective shared by most authors of comparative discussions, beginning with Dryden, was the improvement of public taste; it is impossible to judge whether that goal was achieved, of course, unless we equate an expanded reading public with a generally more edified public taste. But if the popularization of a discipline can be socially advantageous, it need not be beneficial for the discipline. Some late-century minor works not only fail to advance aesthetic speculation but actually impede its refinement by repeating past mistakes or obscuring matters clarified by earlier theorists. For example, although Lessing, in *Laokoön*, had argued persuasively against drawing facile parallels based on insufficient considerations of media in 1766, and Harris had demonstrated the worth of Lessing's argument in his

comparisons twenty-two years earlier, such parallels continued to be drawn at the end of the century. And it frequently happens that attempts to popularize arguments which are sound in original sources result in loss of coherence of critical usefulness when "points" are wrenched from their systematic contexts. Not all comparative discussions included here have such shortcomings, but, for varying reasons, each contributes less significantly to this branch of aesthetics than works already discussed.

I have made no attempt to analyze or, in the case of letters and periodical essays, to list all minor comparisons of the arts. My purpose is to draw attention to the existence of a body of works whose diverse kinds of problems posed, critical principles invoked, and reasoning methods employed further define the limits and accomplishments of this branch of aesthetics in the eighteenth century. Some works are cited or examined briefly for purposes of illustration; others merit more extended discussion because of their relatively greater historical or intrinsic importance.

Hildebrand Jacob and Anselm Bayly: The Arts as Unequal Sisters

There are at least four relatively extensive minor works concerned with comparisons of the arts: Hildebrand Jacob's *Of the Sister Arts; an Essay* (1734), the anonymous *An Introduction to the Polite Arts and Sciences, Including the Principles of Literature and the Belles Lettres* (1763), John Seally's *The Lady's Encyclopaedia; or, a Concise Analysis of the Belles Lettres, the Fine Arts and the Sciences* (1788), and Anselm Bayly's *The Alliance of Musick, Poetry and Oratory* (1789).[2] The second and third are handbooks offering broad, unoriginal surveys of the arts designed for reference purposes. Of these four works, those of Jacob and Bayly have the greatest historical importance, primarily for their respective treatments of music in relation to the other arts; viewed together, Jacob's *Sister Arts* and Bayly's *Alliance* illustrate the changing status of music in the century's comparative discussions.

The concluding paragraph of *Sister Arts* gives some notion of the many questions to which the essay is addressed: "Thus we have taken a cursory Survey of these Arts [poetry, painting, and music]; said something, in general, of their Relation, and Difference; of their Value, Rise, and Progress; of the Necessity, Conformity, and Practice of the principal Rules by which they were brought to Perfection; whence it is

they have decay'd; and how they may be restor'd." [3] Jacob thus shares an interest in the historical relationship of the arts with such later writers as Jones and (especially) Brown, but the works which *Sister Arts* most nearly resembles, in terms of primary objectives, are Dryden's "Parallel" and Lamotte's *Essay. Sister Arts* is devoted principally to an enumeration of the arts' similarities and differences, and their consequent rules. Jacob's comparison of the arts, like those of Dryden and Lamotte, chiefly consists of drawing parallels; but, unlike those of Dryden and Lamotte, his parallels do not result from the disciplined application of critical concepts or principles to the various arts. Dryden, for example, uses such Ciceronian concepts as *invention* and *expression* as a basis for his parallels. There is no similar comprehensive schematic framework in Jacob's essay; although some of his parallels are logically connected, most tend to be relatively discrete observations. As his comparisons of the arts suffer from a lack of adequate analytical bases, so the entire work is weakened by lack of organization; questions relating to the arts' materials, histories, subject matters, rules, effects, and value are randomly mixed. What may originate as simple expository problems ultimately are fundamentally damaging to *Sister Arts* because they frequently lead to oversimplification, incompleteness, and confusion of critical principles in the primary arguments of the work.

Jacob's essay is largely unoriginal; most of his principal observations had been made, for example, by Dryden, Du Bos, and Lamotte. *Sister Arts* is historically significant because it is the first extensive British work seeking to clarify similarities and differences among the arts which attempts to include music as an equal sister in its comparisons. Although Jacob says that poetry, painting, and music are so closely allied that "it is difficult to discourse upon either of them, particularly on the two First . . . without giving some Insight" into the others (p. 3), it is apparently less difficult than he states, for music plays a disproportionately small role in his discussion. Jacob wishes to accord music equal treatment; he simply fails to find much to say about it as a sister art whose parts, effects (or "meaning"), and subject matter are strictly comparable to those of painting and poetry. And his failure typifies that of many later writers, for as long as music was compared with poetry or painting in terms of criteria appropriate to the media and constitutive principles of poetry or painting but not music, "parallels" necessarily remained unsatisfactory. The same problem exists in parallels of painting and poetry, of course, or whenever comparisons do not sufficiently discriminate among the unique properties of each art; music, however, was particularly troublesome in such parallels because it was

more difficult to see how nature was imitated in music than in painting or poetry, even when *imitation* was defined in ways which made inappropriate its application to one of the other two arts.

The primary difficulty with Jacob's comparisons of the arts can be illustrated by examining the beginning of his statement of their similarities: "Almost all the Parts of Poetry are found in Painting. Harmony, which is the Essence of Music, is, as it were, the Dress or Cloathing of Poetry; and Painting is a kind of dumb Harmony, which charms and sooths us thro' our Eyes, as Music does thro' our Ears" (p. 4). The key phrase, "as it were," demonstrates the imprecision of the parallel; harmony has not been defined, but even if it had, there is no consideration of the unique properties of the three arts which might lend meaning to the term when applied to all three. Hence the comparison is of no use in explaining aesthetic effects or establishing rules of art. The comment that "Lyric Poetry approaches more to Music, than any other Species of it, as Dramatic and Pastoral Poetry do to Painting" is similarly useless since there is no explanation of the basis of the parallel, nor is there consideration of how the various arts imitate to support the assertion that all three proceed from the principle of imitation (p. 5).

The "separate Beauties" of poetry enumerated by Jacob relate to its ability to portray subject matter inaccessible to the other arts, and are similar to the unique advantages mentioned by Du Bos; it can depict "abstracted Thoughts," for example, and is capable of successive effects. Jacob's lists of the unique advantages of each art, particularly of music, include many which are the type Lamotte classifies as "casual and accidental"; for example, painting and music have more "good Judges" than poetry since their languages are "universal," and perfect copies may be made of poetic and musical but not of pictorial originals.

Jacob considers both pleasure and instruction to be the ends of all three arts, but like many later writers who compare the instructional power of the arts, he has difficulty explaining how music instructs. He says that music is a great "Refiner of the Passions, . . . but as it consists only of Sounds, to which no other Ideas are annexed, its Impressions are soon and easily defac'd" (p. 7). Nevertheless, although "Music may give the Mind no Instruction immediately from itself, yet it helps greatly to mend the Heart in general"; like beauty, "it charms and softens us," and serves to "excite and raise us to the Performance of brave and noble Exploits" (p. 8). Jacob does not attempt to analyze the mechanisms connecting sound and passion in order to explain music's instructional

effects; instead, he simply refers to the "opinions" of "the Grecians" to confirm his assertion that music promotes virtue.

Music is not included in Jacob's discussion of objects of artistic imitation, and plays a very minor role in his parallel rules of art. Painting and poetry are alike in imitating "the most beautiful Works of Nature" (p. 17); music is omitted since "imitation" is here restricted to creating visual likenesses of natural objects and historical events. Music figures in only two of Jacob's "rules"; one concerns the proper ordering of parts (p. 19), and the other claims that musical rests and poetic pauses have similar effects.

Poetry and painting in Jacob's comparisons are more closely related to each other than either is to music by their ability to raise visual images through imitation; when later critics began to challenge the basis of this "natural affinity," the status of music in comparisons of the arts changed. This change may be illustrated by comparing Jacob's treatment of music with that of Bayly, whose *Alliance* was published fifty-five years later. The *Alliance* is not altogether typical of later comparisons of the arts because Bayly is a more adamant champion of music's relative worth than most writers, but he is similar to a number of later writers (including Jones, Beattie, Brown, and Robertson) in stressing close natural ties between music and the verbal arts. Bayly's *Alliance* is of interest primarily because it is perhaps more extreme than any other eighteenth-century comparison of the arts in arguing that music provides criteria by which its sister arts should be evaluated.

Bayly bases his fundamental discrimination of real from fanciful artistic affinities on considerations of apprehending senses. He says that those who regard music, poetry, and painting as sister arts do so "with more fancy and ingenuity than judgement and truth" because the arts "fall under the cognizance of different senses; that of the eye, which is the proper judge of colours and proportion in painting, and that of the ear, which is the only nice and true discriminator of sounds, their nature, whether grave or acute, and their measure, whether long or short, in musick, poetry and oratory." [4]

Jacob and Bayly reach dissimilar conclusions about music's worth through comparable and equally culpable processes. We have seen that Jacob's comparisons are unfair to music because it is judged on the basis of criteria derived from prior analyses of the materials and effects of the other arts; Bayly simply reverses the process by setting musical standards for poetry and oratory. Of the sister arts, Bayly says that "musick is the elder, and on whom the other two are dependent.

Musick is the basis on which poetry and oratory can be advantageously erected, and by it can be truly judged of" (p. 2).

Considerations of relationships between nature and art are central factors in determining artistic worth for both Jacob and Bayly, but for different reasons. Jacob judges the arts in terms of their ability to imitate "beautiful nature"; to Bayly, the worth of an art increases in proportion to its "naturalness," and decreases as its "imitativeness" increases. Bayly does not use "naturalness" to signify degree of likeness between imitating and imitated objects; it refers to the degree to which an art is "connate with the soul of man" (p. 3). He states that music is "the first and immediate daughter of nature, while poetry and oratory are only near relations of music, mere imitations of nature, and the daughters of instruction and art" (p. 2). To support this contention, he observes that all children have a natural aptitude for song, and that music is so "purely intellectual" that those who do not derive musical ability from natural genius can seldom please after receiving a musical education. If Jacob's comparisons are weakened by obscuring vital distinctions among the arts, Bayly's discussion is more fundamentally flawed. His argument does more than confuse nature and art; by making art a measure of inferiority in music and poetry (or any other art, each of which derives its existence and worth from artificiality), it destroys the foundations of aesthetic discourse.

Periodical Essays and Letters

Most minor works of the century which were concerned with relationships among the arts took the form of letters or periodical essays, of which the following are characteristic examples: *Lay-Monastery*, nos. 31 and 32 (January 1713), probably by Sir Richard Blackmore; *Free-Thinker*, no. 63 (October 1718); John Gilbert Cooper's "Letter VII," in *Letters Concerning Taste* (1755); *Macaroni and Theatrical Magazine*, no. 361 (1773); John Stedman's "Letters XXIV and XXV," in *Laelius and Hortensia; or, Thoughts on the Nature and Objects of Taste and Genius* (1782); William Jackson's "Letter XVII," in *Thirty Letters on Various Subjects* (1783), and two essays on poetry and music in *The Four Ages, Together with Essays on Various Subjects* (1798); *The Philanthrope*, no. 33 (1797); *The Artist* (1807), no. 9 by James Northcote, nos. 13 and 15 by Prince Hoare, and no. 18 by Henry James Pye.[5] These works illustrate the considerable diversity in both breadth and types of questions asked and methods of solution in comparative

discussions, and the shifts of emphasis which occurred during the century.

Blackmore's two essays in the *Lay-Monastery* closely resemble Dryden's "Parallel" in primary interest and form of theory. Like Dryden, Blackmore draws parallels between poetry and painting: "the parallel between [painting and poetry] not having yet been drawn at length, I will give an imperfect sketch of some features and properties in which they agree";[6] also like Dryden, he treats painting and poetry as means of achieving predetermined effects through historically pre-scribed species. Blackmore's "imperfect sketch" consists of deducing affinities between pictorial and poetic species from similarities of subject matter and ends. Dryden establishes similar likenesses, based on identical considerations, but in the "Parallel" they are largely means— part of the groundwork for drawing parallel rules—rather than the essay's chief objective.

For Blackmore, painting and poetry are essentially similar to one another and distinct from the other arts because only they seek to "imitate nature." He establishes an exact likeness between natural particulars and artistic renderings of such material as the chief criterion for judging the merit of poetry and painting: "the more excellent and perfect [the arts] are, the nearer they approach to an entire resemblance of [nature]" (p. 32). Blackmore draws an analogy between moral and artistic "truth" which should, but ultimately does not, force him to reconsider his unduly restrictive use of "imitation." He says that "as moral truth is the conformity between our thoughts and assertions," so truth in painting and poetry "is founded in the similitude between the picture and the exemplar in the mind of the artist," where it has an "ideal existence." However, he adds that if a work is faithful to the artist's conception, but distorts nature, it "is justly said to be false" (p. 33). Obviously, it is impossible to assign worth to art for conveying successfully any imaginative conception if only those conceptions which do not violate truth to nature have value; despite his remarks concerning the artist's "fancy," Blackmore's conception of artistic "truth" refers only to natural particulars, not to the successful expression of a "fanciful" ideal or probability inherent in any given work.

Blackmore assigns relative value to the various pictorial and poetic species on the basis of the potential affectivity and instructional usefulness of the subject matter they portray. The parallel species of epic and tragic poetry and history painting are the noblest because their subjects are most affecting and best suited "to inspire generous

sentiments, and to convey to the mind moral and divine instruction"
(p. 40).

Blackmore was perhaps the first British writer after Dryden to
draw parallels between pictorial and poetic species primarily based on
similarities of subject matter, but we have seen that he was not the last.
Neither was Lamotte or Jacob; as late as 1782, for example, Stedman
compared pastoral poetry and painting, and enumerated rules of
composition necessary for both.[7] Such comparisons, failing to recognize
that final causes are necessarily influenced by material causes, fre-
quently establish truth to visual nature as the imitative basis of both
arts, and do not discriminate adequately the unique subject matters of
either. Hence it is not surprising that the author of "On the Coalition
between Painting and Poetry" still felt the need, in 1797, to warn
against thinking that all poetic images (particularly those arising from
dispositions of mind which are not expressed by external signs) can be
depicted in painting, since painting presents visible images, but poetry
need not.[8] Moreover, several minor "defenses," especially of poetry, are
primarily based on narrowly restrictive applications of the *ut pictura
poesis* doctrine (using the phrase, that is, to imply that painting and
poetry strive for identical effects through comparable means). For
example, Cooper argues that poetry is superior to painting because it
can depict a wider range of natural subjects and convey visual images of
the same subjects more successfully than painting.[9] He is partially aware
that the unique properties of each art influence their kinds of possible
effects, but the ability to portray natural objects accurately is the chief
measure of superiority in his argument. Many earlier writers argue that
painting and poetry may be mutually assistant in providing subject
matter for one another; it was generally agreed, however, that painting
had more to gain from such mutual borrowings, insofar as the range of
poetry's subject matter is greater. Moreover, a corollary argument
advanced by Stedman and many others is that the subjects of certain
kinds of painting (history painting, for example, which is usually
regarded as the art's noblest mode) sometimes "depend" on poetry for
completeness of meaning and effect, since painting cannot represent
successive actions depicted in poetry; a painting of Hector's funeral, for
example, will be wholly comprehensible only if the viewer is aware of
Homer's description of it and of events leading up to it. An improper
but not uncommon extension of this argument is the conclusion that
painting is a handmaiden, rather than a sister, of poetry, insofar as it is
generally dependent on poetry for its best subject matter, or that
painting's effectiveness increases in proportion to the likeness between

its representations and poetic expressions of the same subject. North-cote wrote "On the Independency of Painting on Poetry" to defend painting from this charge.

He attempts in his essay to refute the "received opinion" that "painting is the follower of, and dependent on, poetry." [10] He says that although painting and poetry "begin their career from the same important point, and each strives to approach the same goal by different paths," they "are equally the children and pupils of Nature, rival imitators of her" (pp. 2–3). Northcote uses the criterion of accurate representation of natural particulars as a means of arguing that painters should not borrow ideas, actions, and expressions from poetry. "There is no better way to prove the defects or excellences" of a descriptive poet than to make pictorial compositions "from the images which he raises" in order to "detect every deviation from nature"; similarly, he says that "historical truths" are necessarily altered for poetic purposes. Painting and sculpture "derive all their highest excellence from being transcripts of ideas formed from a study of general nature, and regulated by a judicious choice" (p. 5); but Northcote recognizes that if truth to nature may be a valid criterion of pictorial worth, it need not apply to poetry. Many "flights of imagination," unconnected with accurate visual images, are "particularly fitted to [the poet's] art" (p. 12), and are legitimate sources of pleasure in poetry, but not in painting. Conse-quently, Northcote concludes that it is foolish to argue that painting should or does depend on poetry for its subjects; presumably because the ends and means of imitating nature differ in the two arts, each has distinct subjects suited to its powers. He mentions three "subjects best suited to the powers of [painting]": those which contain sentiment expressed by external signs and independent of "foreign aid for an explanation"; universally known events unencumbered "by trifling minuteness of description"; and historical events deriving significance from their consequences or from "characters conspicuous for their virtues or their vices" (p. 15). Finally, Northcote adds, "there are certain ideas and impressions" relating to natural history and mechani-cal inventions, "which words are not calculated to give." Ultimately, neither painting nor poetry is inferior to the other, "but equal, and distinct in their powers" (p. 16).

Northcote's essay offers an indirect, partial challenge to the validity of earlier parallels which overlook essential differences among the arts; it is indirect insofar as it occurs in the context of the specific question of whether painters ought to borrow subject matter from poetry, and partial in that Northcote does not develop distinctions

implicit in his discussion or use them to develop a definition of imitation which might discriminate the visual effects of painting from the nonvisual effects of poetry. There are other minor works, however, which directly question the validity of drawing parallels among the arts in general or of making the *ut pictura poesis* doctrine the basis of pictorial and poetic parallels.

Jackson's brief, amusing letter "On the Analogy of the Arts" questions whether there is not "something very fanciful in the analogy which some people have discovered between the arts." [11] He shows that music is "like" a standish, grate, or shirt, concluding that "there are scarce any two things in the world but may be *made* to resemble each other" (p. 121). Jackson's letter reflects a caution which is encountered more frequently in late than in early eighteenth-century comparisons, but which is, one must add, by no means universally present at the end of the century, despite the efforts of such men as Harris, Lessing, Reynolds, and Twining.

A more specific attack on earlier parallels is contained in Hoare's "Letter from a Speculator on the Connection Generally Supposed to Subsist between Poetry and Painting." [12] Hoare states that his "Letter" attempts to show that comparisons based on the *ut pictura poesis* principle are improper because the whole of one art is compared with part of another. His analysis is both highly interesting and, ultimately, deceptively inept. The essay is, in fact, more an attack on definitions of painting than on comparisons based on the *ut pictura poesis* principle. Initially, the "Letter" gives the impression that all comparisons of the arts are under attack; this is not the case, however, since Hoare concedes that one branch of painting is exactly parallel to poetry in its "powers, combinations and intentions." His objection is not that parallels based on the *ut pictura poesis* principle overlook the fact that differences in media dictate differences in effects and subject matter, or that they establish criteria appropriate to one art but not to the other; instead, his criticism is that the arts cannot be compared as long as poetry is defined in evaluative terms (as a superior form of writing) and painting in generic terms (and not as a superior branch of the graphic arts). Were this "inconsistency" removed, Hoare would have no objection to comparing the two arts as superior forms of expression. Ironically, although he begins by denouncing the *ut pictura poesis* principle, the "Letter" ultimately condones its most flagrant abuses in comparisons of the arts.

Hoare says that although he was tempted to begin by flatly

denying his motto (*ut pictura poesis erit*), he will attempt to define painting's powers by comparing it with poetry. In misinterpreting and generalizing from Horace's phrase, Dufresnoy laid "the foundation of modern belief in a doctrine teeming with difficulties, absurdities, and disputes"; moreover, misunderstandings of painting result "from this very source, viz. its having been made the invariable object of comparison with poetry." In order to correct these misunderstandings, Hoare attempts to show that past comparisons have been "of the whole of one art, to a part of another," for, although "I am very willing to grant that one branch or a province of painting" exactly coincides with poetry, there are others "which neither make pretensions to poetry, nor have the least connection with it" (pp. 13–16).

The precise nature of Hoare's objection to comparisons of poetry with painting in general is made clear when he defines poetry. He adopts Blair's definition of poetry as " 'the language of passion or of enlivened imagination, formed most commonly with regular numbers' " (p. 16). Certain kinds of painting, such as representations of heraldic objects or accurate resemblances of combs or pets, do not have the heightened character of poetic expression; neither do certain kinds of writing, such as "doggrel rhymes," but the latter are not defined as poetry, whereas the former are considered paintings. Hence, Hoare concludes, "there is either a total dissimilarity between the two arts" or a need for a clearer "subordinate arrangement of our vocabulary of arts"; the difficulty is that painting "is used as a *generic* term, and poetry as a *special* one" (p. 20). Since that difficulty can be removed by inventing a term denoting "the language of passion or of enlivened imagination" in painting, it is clear that Hoare has no fundamental objection to the use of the *ut pictura poesis* principle in comparisons of the arts.

The 1807 volume of *The Artist* conveniently illustrates the variety of kinds of analysis present in comparative discussions of the arts. In addition to Northcote's essay and Hoare's "Letter," it contains Hoare's "Views of the Liberal Arts" [13] and Pye's "On the Influence of the Imitative Arts on Manners and Morals," [14] both of which are broader in scope than the two former works. They seek to evaluate the relative worth of the arts, but do so in the context of essentially dissimilar initial questions; hence the methods and principles used in their comparisons and evaluations differ fundamentally. Hoare classifies and evaluates the arts on the basis of various principles of "representing" nature, whereas Pye compares and judges the arts in terms of their effects on "manners

and morals." Although both men are concerned with all phases of art, primary emphasis falls on considerations of formal and efficient causes in Hoare and final causes in Pye.

Hoare's essay, like Twining's "Two Dissertations," seeks to correct confusion resulting from calling the arts "imitative" when the various possible meanings of *mimesis* are not properly defined. He says that of the "two distinct qualities" (ends) of art (providing instruction and pleasure), it is always more difficult to determine whether the latter has been achieved; it is universally admitted that all art "is to exhibit a representation of nature in some manner or other" in order to evoke pleasurable responses. Because there is no great "misunderstanding of what is equally by all denominated *art*," the difficulty in judging pleasurable effects lies in determining what is meant by *nature* (p. 4).

Works of art, particularly paintings, are often criticized, Hoare states, because they do not imitate external nature; such critics, he adds, fail to realize that "there is a pleasure arising . . . from refined or select imitations of nature" which is "probably superior to that [derived] from the ordinary and far more obvious imitation" (pp. 4–5). Hoare's primary argument is that the various classes of each art "represent" different aspects of nature through several principles of representation. By defining distinct principles of representation and classifying artistic species in relation to them, he attempts to provide a valid basis for comparing and evaluating the effects of individual works and classes of works.

Acknowledging that "precise unquestionable boundaries" cannot be established, Hoare lists three distinct classes, based on subject matter represented and principles of representation, into which every art can be divided. They are: the imitation of nature, in which familiar objects are accurately represented; the selection of nature, in which objects are selected "under some particular influence, or with some particular view or design"; and the abstraction of nature, in which abstract ideas or images are represented. Works falling in the first class have the most admirers since their artificial resemblances invariably excite "a kind of animal joy"; such works include wax work and colored sculpture in the arts of design, imitations of the natural sounds of birds and animals in music, and distortions of form imitating natural human defects in acting (or what he calls "mimickry"). The second class also has many admirers "because there will always be very many, who have a delight in applying the general accumulated knowledge of mankind . . . to such purposes as are grateful to their peculiar bent of humours." Hoare adds that the knowledge and training necessary for artists working in this

class predispose the artist's mind toward virtue, assuring that "the greatest number of works of a select nature assume an instructive or moral air." Such works include "the whole list of second rate poets" and a comparably extensive range in painting; Hoare offers no musical examples. In the third, "supreme" class, works exhibit "the power of generalizing all that we have learned of individual nature," thereby touching "the essential springs and feelings of existence." He claims that few works fall into this class and offers no specific examples.[15]

The primary objective of Pye's "On the Influence of the Imitative Arts on Manners and Morals" is similar to those earlier works which compare the instructional powers of the arts. It is unique among comparative discussions of the arts, however, in its treatment of romances and novels, and differs from many in deducing the moral influence of the various arts directly from considerations of the separate imitative powers of each. Pye's essay falls into two sections, the first dealing with manners and the second with morals. He includes painting, sculpture, music, and poetry as imitative arts, and attempts to show that these arts exert great influence in refining manners by tracing the progress of the arts in Greece, Rome, and modern Europe.

The influence of the imitative arts on morals Pye deduces from prior examinations of "the peculiar power and excellence of each" rather than from historical evidence. He quotes Richard Payne Knight in distinguishing the imitative powers of sculpture from those of painting: sculpture is a " 'more impartial representer of beauty of form' " than painting because the former cannot employ " 'tricks of light and shade,' " and, since its imitations are distinct, sculpture " 'can leave nothing to the imagination' " and cannot create the artificiality of appearance possible in painting. Painting's subsequent advantages are great, Pye contends, since every visible form or action can be imitated in painting. He draws a similar distinction between the imitative powers of music and poetry; poetry's power to imitate sounds is inferior to that of music, "but the moral powers of poetic imitation are universal," inasmuch as poetry can portray manners, actions, and passions (pp. 5–7).

Pye's evaluations of the various arts' moral influence are far from satisfactory. On the basis of his examination of their imitative powers, he simply says that "the effect of Sculpture on morals is very trifling; that of Painting is greater, but not permanent" (p. 7). Although he offers no immediate explanation, it later becomes evident that Pye measures a work's moral influence by the strength of the impression it makes on the imagination (or the degree to which a work stimulates or commands the

attention of the imagination). Since his prior analysis of sculpture contends that its imitations leave nothing to the imagination, it is not surprising that he says its moral influence is "trifling." It is not clear, however, why painting's effects are impermanent, for his analysis of painting's imitative power does not lay the groundwork for such a conclusion. Presumably there are psychological causes accounting for the impermanence of all pictorial effects, but Pye provides no such explanation. Similarly, he says that music can have no moral effect "as an imitative art," although "it certainly possesses other powers that have." Music lacks moral influence as an imitative art because its mimetic powers are restricted to reproducing amoral natural sounds; in explaining its power as an affective art, Pye merely observes that he feels "enough from simple and pathetic melodies not to doubt" music's effects on those more "tremblingly alive to musical influence" (p. 7).

In his discussion of poetry's moral influence, Pye distinguishes between descriptive and imitative poetry (which includes drama, epic poetry, romances, novels, or any composition portraying "manners, actions, and passions"). Of the imitative species, he claims that romances and novels take "the firmest hold on the imagination, and [have] by far the greatest influence on the morals" of contemporary readers, even though drama is the "most perfect of the imitative arts," and once had a greater influence. Pye's explanation is that romances and novels make a "stronger impression" on the imagination because they receive "superior attention." Athenian audiences, that is, paid greater attention to dramatic productions than modern audiences, whereas "the ancient Romance and modern Novel" are given "uninterrupted attention." Romances and novels differ in moral influence, however, insofar as "the Romance held up an example, which set exact imitation at defiance, but the Novel presents scenes that we seem all likely to be engaged in"; by providing "deceptive pictures" (rather than the exaggeratedly virtuous or chivalric portraits of romances), the novel may have "a pernicious influence on morals" (pp. 8–10).

A plurality of sources is used by Pye for evidence in comparing and evaluating the arts' effects on morals and manners: analyses of the arts' imitative powers based on distinctions of media, explicit and implicit psychological explanations of artistic effects, and the history of the arts. If "On the Influence of the Imitative Arts" resembles a number of previously discussed works in attempting to judge the instructional powers of the arts and their species through considerations of media and psychological causes, it is also related to a class of works remaining to be

examined. Although historical questions play a minor role in it, the presence of evidence drawn from art history links Pye's essay with an important group of late eighteenth-century hybrid essays—works which combine art history and comparative discussions of the arts.

Chapter Seven

Comparative Discussions and Scholarly Histories of Art

The eighteenth century, particularly during the second half, produced a number of works in which comparisons among the arts were made in conjunction with histories of the arts or attempted solutions to historical problems. John Brown's *A Dissertation on the Rise, Union, and Power, the Progressions, Separations, and Corruptions, of Poetry and Music* (1763), Thomas Robertson's *An Inquiry into the Fine Arts* (1784), and Robert Anthony Bromley's *A Philosophical and Critical History of the Fine Arts* (1793–95) are characteristic examples of such specialized adaptations of comparative discussions. Works such as these are difficult to classify because they contribute, in varying degrees, both to aesthetic theory and to art history. Like the works discussed in the preceding chapters, all are importantly concerned with comparisons and directly address questions relating to the interrelationships of the arts; but unlike those works, they are also significantly directed to other questions. They ought to be viewed as hybrids which do not belong exclusively or strictly to the study of comparative discussions or to the study of histories of art, but which can lend increased and important dimensions to either discipline.

The significance and use made of comparisons of the arts in these works vary. In Brown's *Dissertation,* for example, tracing poetry and music to the same natural causes provides the framework for the author's survey of the progress of the arts through history, and analyzing the power of poetry and music combined serves as the basis for the main argument of the work. Historical and aesthetic observations are more fully integrated in Brown's *Dissertation* than in Bromley's *Philosophical History,* for instance. In the latter, comparisons of the arts serve to justify writing the kind of history of painting the author wishes to write; that is, Bromley, by finding painting better suited to moral

instruction than the other arts, provides a rationale for focusing his history on those aspects of the pictorial arts which he judges to be their unique strength. Like Bromley's comparison of the arts, Robertson's introductory discourse "Concerning the Principle of the Fine Arts" stands as a more separable section of his work than is the case with Brown's comparisons. The reasons for this relative separability in the *Philosophical History* and the *Inquiry*, however, are not the same. The original plan of the *Inquiry* was to investigate all of the fine arts; the introductory discourse establishes principles for classifying and judging the arts, and outlines arguments concerning the interrelations of the arts which were to be explained more fully in subsequent volumes. Later comparisons did not materialize, however, since only the first volume (on music) was completed; consequently, the *Inquiry*'s primary value for the history of aesthetics lies in the germinal introductory discourse.

The questions of art history which such works address differ widely in scope, and, of course, partially determine the different uses of comparisons made by each author. Brown's plan is comprehensive; he attempts to illustrate the natural unity and unnatural separation of poetry and music throughout history. William Mitford's "Of the Connexion of Poetry with Music," in *An Essay on the Harmony of Language* (1774), and Joseph Spence's *Polymetis* (1747), works which also combine aesthetics with history, address more limited problems. Mitford attempts to explain the alliance of Greek music and poetry on the basis of natural connections between cadence and versification; Spence seeks to illustrate the relationships among Roman poetry, painting, and sculpture from their remains.[1] Robertson's *Inquiry* is probably the most ambitious in conception of these works; the 461-page volume treats in detail only one of the nine arts he proposes to examine.

I shall make no attempt to survey all eighteenth-century works which combine comparisons of the arts with art history. The following discussion focuses on Brown's *Dissertation*, Robertson's *Inquiry*, and Bromley's *Philosophical History* because these works provide examples of the different uses of comparisons in works involving both aesthetics and history, and give some indication of the variety of critical methods, principles, and specific arguments employed in this branch of philosophical/historical criticism. I am concerned with the historical observations in each of these works only when they relate significantly to the author's comparisons of the arts.

John Brown: The Subordination
of Art History to Polemics

Dr. John Brown is best known today for *An Estimate of the Manners and Principles of the Times* (1757), but his *Dissertation*[2] was widely read and commented upon in the eighteenth century. It apparently seemed no less peculiar to its eighteenth-century audience than it does to twentieth-century readers. In *Some Observations on Dr. Brown's Dissertation on the Rise, Union etc. of Poetry and Music* (1764), an anonymous critic compares Brown's history of the arts to the weather forecasting of an almanac: by establishing a few principles, one cannot deduce systematically the progress of the arts, whose development is complex and unpredictable. This criticism is not wholly unwarranted, for Brown's history of the arts is written largely to confirm the theoretical arguments advanced early in the *Dissertation*. Moreover, part of Brown's "history" is conjectural; in the early part of the *Dissertation*, he posits a primitive society whose initially joined arts progress, separate, and are corrupted through societal changes. Principles underlying the interrelationships of the arts are deduced from the hypothetical conditions and history of this primitive society. This society, its conjectural history, and principles concerning the value and power of the arts derived from consideration of man in this natural state function as a paradigm for later historical sketches of the arts in various countries. Brown assumes that certain traits can be predicated of all men in a state of nature, and that civilization evolves in fixed patterns and has the same general effect on man and the arts regardless of environmental variations. In sum, Brown deduces all aesthetic principles from his consideration of a hypothetical primitive society, and translates these principles into laws by universalizing both this society and the process of artistic evolution in it. Consequently, the early chapters of the *Dissertation* are more important for the history of aesthetic theory than Brown's subsequent analyses of the arts in specific countries.

The primary objective of the *Dissertation* is polemical. As Schueller aptly remarks, Brown "championed the reunion of poetry and music" with "all the fervor of a reformer." [3] He does so by analyzing the natural causes of the birth, unity, and eventual separation of poetry and music, and by suggesting ways in which existing genres can be altered to reunite the two arts, thereby restoring their maximum power. Unlike Dryden, Lamotte, and Robertson, Brown is not centrally concerned with how effects can best be achieved in preestablished modes; but like

Beattie and Jones, he bases his analysis of the arts on principles derived from empirical psychology. As Beattie and Jones attempt to explain aesthetic effects in terms of natural human behavior, Brown seeks to explain the origins and essential unity of the creative impulse in poetry and music in terms of natural causes. Consequently, considerations of the role of the artist play a more significant role in Brown's system than in any of those previously discussed.

The psychological basis of Brown's explanation of the origin of the arts is announced early in the *Dissertation*; he says that "whatever is founded in such Passions and Principles of Action, as are common to the whole Race of Man" can best be investigated by viewing man in an uncultivated state ("before Education and Art have cast their Veil over the human Mind"), for the workings of the mind are then instantaneously apparent (p. 26). Brown asserts that agreeable and disagreeable passions (love, hope, joy/hate, fear, sorrow) are naturally expressed through action, voice, and articulate sounds, the latter power of expression distinguishing man from animals and deriving from his unique "Fancy" and ability to associate ideas. Poetry and music have the same origin (the desire to express passion) and are naturally allied through their foundations in order and proportion (man's innate "love of a measured Melody" produces song, dance, and verse [p. 27]).[4] Within this general framework, peculiar or specialized modes of poetic and musical expression are determined by environmental circumstances which cause certain passions to predominate.

Instruction is the final cause of poetry and music in Brown's discussion. If these two arts originate in the desire to express passion, passion is ordered by art to serve social functions: melody, dance, and song "make up the ruling Pastime, adorn the Feasts, compose the Religion, fix the Manners, strengthen the Policy, and even form the future Paradise of savage Man" (p. 28). Hence the primary value of art does not lie in its ability to provide pleasure through its affective power, but in its ability to enlist passion in support of moral and social objectives. Art is naturally pleasing for Brown, but pleasure is not its principal end.

Thirty-six consequences of the introduction of civilization and the "use of Letters" in primitive society are enumerated by Brown (pp. 36–46). The first thirteen deal with the progress of the arts while united, the next twenty with the separation of the arts, and the last three with their corruption. The first thirteen illustrate the value Brown places on the moral and social ends of art. These ends, he implies, are best achieved when the arts are united—an assumption which accounts for

his remark that instrumental music "would be little attended to, and of no Esteem" in early stages of society. Poetry and music naturally join to serve their noblest ends at public festivals; since instrumental music by itself does not have vocal music's power to celebrate historical events or inculcate moral, political, or religious principles, it is disregarded. Moreover, Brown says that poetry and music are naturally allied in the character of the performer; insofar as the ends of the arts are social, chiefs or legislators become performers, and gods are conceived as singers and dancers. The introduction of "measured Periods" strengthens the natural union of poetry and music; as cadence is a natural part of melody, so poetic verse strengthens the force of music by matching its rhythm to that of music.

The remainder of the first thirteen "consequences" attempt to define modes of poetry and music in early civilized states and to explain music's power in terms of natural human behavior. The various modes adduced by Brown are defined in terms of their final causes, and each emphasizes the instructional function of the arts: early histories and laws would be written in verse, religious rites would be performed and oracles delivered through music and poetry united, and songs would have religious, moral, and political intentions. Hence music would constitute a large portion of formal education. He recognizes, like Harris and Avison, music's affective power based on the special relationship between certain sounds and certain passions. His explanation of this phenomenon is the standard and simplest eighteenth-century solution, and is based on the association of ideas. The power of simple melody is augmented by "appropriating certain Sounds to certain Subjects," which are associated with certain passions; hence music becomes "a Kind of natural and expressive Language of the Passions" which assumes a "universal Power over the minds and Actions" of men.

The twenty consequences dealing with the separations of poetry and music (which Brown uses in the extended sense of melody, dance, and song) detail the origin and progress of specialized genres (odes, epics, tragedies, hymns) and the introduction of self-conscious artificiality (the use of a chorus, adherence to unities of time and place, and so forth). During this intermediate stage of development, music and poetry are held in high regard, continue to serve their original purposes, and achieve a state of relative perfection, but the seeds of corruption are sown, since the progressive compartmentalization of functions, for Brown, leads inevitably to a disregard of the original altruistic ends of art. It is not clear at this point in his account whether the separation of

the arts results from societal change or from the natural progress of the arts. The two have a reciprocal action; he first says that separations occur through "the Progress of Polity and Arts" (p. 40), and later says that "as a Change of Manners must influence . . . Music, so . . . a change in . . . Music must influence Manners" (p. 45).

It appears from Brown's consideration of the corruption of poetry and music that although the progress of art and society affect each other reciprocally, the original cause of change is societal. Music is corrupted "in a Society of more libertine and relaxed Principles"; musicians, "being educated in a corrupt State," would "debase their Art to vile and immoral Purposes, as the means of gaining . . . Applause" (p. 45). He thus concludes that the complex character of the bard/musician would separate,[5] and the man of genius would spurn the role of artist, for self-aggrandizement would supplant the inculcation of "every thing laudable and great" as the end of art.

After tracing the progress, separation, and corruption of poetry and music in various civilizations, Brown turns to the question of how the arts can be reunited to serve their original ends—religious, political, and moral instruction "under a strict Subordination to Truth" (p. 228). Like most earlier eighteenth-century writers who compare the affective power of music and poetry, he argues that musical expression is general or vague, whereas poetic expression is "particular, and unalterably appropriated" to its subject (p. 223). Hence it is poetry's task to specify the general passion raised by music. This argument forms the basis of Brown's plan for the reunion of the arts; since poetry and music cannot be reunited in their original character (because the legislator/bard's character "naturally separate[s] in an early Period of Civilization" [p. 222]), and since poetic expression is less adaptable than musical expression, it is chiefly the poet's responsibility to reunite the arts. It would be easier, that is, for the poet to select or adapt music to accompany his poetry than for the musician to adapt poetic selections to his music.

The ode or hymn is best suited for reunification with music because "this Species is more universally allied with Melody [in its foundation] than any other" (p. 225). Earlier Brown says that the ode consists of the immediate expression of passion; it is most directly allied to melody through its subject, which is "the sudden Shocks and Emotions of the Soul; which are found to be the powerful Bands of Nature, by which Melody and Song are most closely bound together" (pp. 101–02). In short, Brown considers lyric poetry more naturally allied to music than narrative or dramatic poetry because the original

cause of both music and the lyric is the spontaneous desire to express passionate states of mind directly (rather than to portray emotion indirectly by narrating or representing the causes of passion). The original ends of the ode and melody reunited can be accomplished through "a pathetic and correspondent Simplicity of Composition in Both."

In one of the more interesting footnotes in the *Dissertation* (pp. 226–27), Brown attempts to explain, in terms of psychological causes, why simple melody is more affective than that which is "complex and artificial." He says that the natural sounds of passion are unmusical and simpler in their composition and succession than melodic tones; hence musical expression of passion must be imperfect with respect to imitation. However, imagination imposes its impressions on reason, which judges perfection in imitation, so that melody retains its affective power unless the imitation departs radically from the simple natural sounds of passion, in which case reason rebels and affective power is lost. This argument leads him to attempt an explanation of "a mysterious Circumstance, which lies yet unaccounted for, at the very Foundation of musical Expression": the "fact" that music's imperfect imitations are more affecting than the perfect voice of passion in nature. Brown's somewhat badly organized explanation of this phenomenon is that pleasure inherent in musical sound and in the secondary circumstances of artistic performances predisposes the listener to sympathetic responses. Musical sound has a "mechanical Power over the human Frame" which awakens it to a high degree of "Sensibility and Sympathy," so that "a sweet Voice, like a fine Countenance," creates "Prejudice in Favour of its Possessor"; conversely, "the Voice and Figure of a distressed or joyous Object" in nature may be so "horrid or uncouth" as to lessen the hearer's sympathy. His argument is somewhat similar to Hume's explanation of pleasure in tragedy (that aesthetic pleasure may convert potentially unpleasant emotions into emotion which reenforces aesthetic pleasure as long as events on stage are not sufficiently horrifying to destroy the original aesthetic satisfaction).[6] However, Brown's explanation lacks the sophistication of Hume's; although he says that the artistic heightening of natural sound must not proceed "so far as . . . to destroy Probability," Brown does not adequately define the limits or degrees of probability in musical sound.

Because Brown recognizes the impracticality of urging a return to the original forms, uses, and conditions of poetry and music in order to reunite the two arts,[7] he confines his specific suggestions to "the four principal Kinds, in which Poetry and Music are now united," so that

they "may be either improved in their Form, or more effectually directed to their proper Ends" (p. 228). Of the four kinds (common song, anthem, opera, and narrative or epic ode), Brown considers the last to be potentially "the highest and most interesting Union of Poetry and Music" (p. 238), but in all cases the objective of reunion is to "give a proper and salutary Direction to that Overflow of Wealth, which must either adorn or overwhelm" society (p. 242).

Comparisons of the arts are usually employed by Brown to further his mission of reform throughout the work. He is more interested in promoting social, moral, and religious change than in aesthetic theory; despite this fact, the entire *Dissertation* is built on the framework of philosophical criticism. All of Brown's capsule histories and arguments for reform depend on his prior analyses of the essential similarities of poetry and music with respect to origins in human nature, principles of construction, and affective powers. Consequently, any writer wishing to attack Brown's *Dissertation* can make his strongest case not by challenging the "factual" histories but, as the author of *Some Observations on Dr. Brown's Dissertation* partially recognizes, by calling into question the work's fundamental theoretical principles and assumptions.

Thomas Robertson: The Importance of Classification

Robertson's *Inquiry* is similar to Brown's *Dissertation* insofar as Robertson's investigation of the theory and history of the individual arts was to be based, like Brown's history of poetry and music, on an initial comparison of certain aspects of the arts under discussion.[8] In nearly all other respects, the two works are dissimilar. For example, Robertson is less concerned with the separations and corruption of the arts, arguments for reform,[9] and psychological causes of artistic expression, and more interested in classifications of the arts, arts other than poetry and music, and theoretical questions relating to principles accounting for aesthetic pleasure. Robertson's work is less polemical than Brown's, and might have had considerably greater significance in the history of eighteenth-century aesthetics. The fact that only the first volume was completed lessens the work's value for aesthetics not only because additional projected comparisons did not materialize but also because the principal theoretical argument of the introductory discourse was left incomplete.

The introductory discourse "Concerning the Principle of the Fine

Arts, and the Plan for Treating of Them" has two primary objectives: (1) to provide a partial explanation of a universal principle accounting for pleasure in all of the fine arts, mainly by discussing concepts which Robertson judges to be inadequate; and (2) to establish a system of classification for the fine arts. Before addressing the question of what causes underlie aesthetic pleasure, Robertson distinguishes fine from necessary arts and makes his contribution to the frequently discussed question of which is prior in birth and development. Robertson's distinction between fine and necessary arts is conventional and is based on ends; like Batteux and many other mid- and late-century writers, he defines the fine arts as those relating to pleasure (and not instruction), whereas necessary arts relate to physical needs. However, his answer to the question of whether fine or necessary arts are first chronologically is unconventional; he raises the issue primarily to discount its significance. He says that although human nature is so constituted that man pursues objects of pleasure more eagerly than objects of necessity in primitive societies, "we read in many books" that the necessary arts "are the first in order; as if there were an imbecility in man, confining him to the steps of a progress" (p. 2). Robertson rightly distinguishes essentially artificial from natural phenomena; if natural objects evolve in certain patterns, there is no reason to assume that the products of human ingenuity follow similar courses. The fault, he says, lies in reasoning by analogy (an animal develops from an embryo, but the arts need not). "It is vain to inquire into the order of the Arts of Necessity and of Pleasure" because "they appeared both upon the same day, the moment men existed" (p. 3). Disagreeing with most earlier writers, Robertson adds, however, that the fine arts probably developed more quickly in the earliest stages of society, until increasing demands for food forced man to forego leisure hours formerly devoted to pleasurable arts.

Robertson's discussion of "the Principle of the Fine Arts" is primarily concerned with the relationship between art and nature. He poses two alternative possibilities in asking why the arts please: "Is it, because they possess . . . inherent and independent powers in themselves . . . or, because they are the imitations of other things, that are pleasing in nature; and thus derive their virtue from sources which cannot be called their own?" (p. 5). Robertson believes that by showing that the arts are more than "merely imitative," he can dispel prejudices against them and increase their "dignity." His attack on the usefulness of mimesis in explaining artistic effects is strikingly similar to Jones's argument in "On the Arts Commonly Called Imitative." Like Jones, Robertson attributes to Aristotle the concept of imitation which he

attacks; in fact, both men attack the non-Aristotelian concept of the Roman rhetoricians—the accurate depiction of natural objects and the mirroring of conditions or manners. "It has been unequivocally meant," Robertson says, "that the Fine Arts really follow and copy Nature; reflecting her, almost as a mirror does the object that is placed before it. When Aristotle said, the Fine Arts were imitative . . . there was an inaccuracy in his very thinking" (p. 6). Robertson's attack like Jones's may be useful for his immediate purposes, but it makes no significant contribution to the continuing debate over the mimetic nature of the arts, because Robertson, unlike Twining, fails to comprehend the various and useful ways in which earlier critics had used mimesis. Indeed, his analysis of the concept of mimesis is even less significant than Jones's insofar as he fails to provide a full definition of an alternative principle for explaining artistic effects. He gives some indication of what such a principle might be in his system, but does not develop it. Moreover, his argument lacks even the dubious virtues of the relative timeliness and vigor of Jones's essay. Progressively fewer critics used imitation in the sense which Robertson attacks; and if Jones's polemical enthusiasm, while not redeeming his critical shortcomings, at least gives interest to his argument, the same cannot be said of the first part of Robertson's introductory discourse.

Robertson in his initial attack on imitation relies primarily on empiricism rather than on analyses of the materials or structural principles of the arts. We observe that certain literary characters, subjects of paintings, and buildings have no original in nature; hence, he concludes, it is the function of the artist's fancy to alter nature. Moreover, nature is often completely excluded from art because the latter "banishes wholly what is unclean and shocking in Nature." Indeed, the arts contain something "quite independent of Nature" provided by the artist's "enthusiasm," a faculty which contrasts with the more mechanical capacity to imitate. To complete his refutation of the concept of mimesis, Robertson says that "even the *la belle Nature*, which the writers of France have set up as the object" of imitation is too limiting, and implies that the Italian term "the *bello ideale;* that beauty, which is independent and uncopied; created by the idea of the Fine Artist" best accords with observable evidence. In some arts (such as architecture), beauty increases in proportion to departure from nature. Robertson chooses to reserve "to its proper place an attempt to define what the true principle" of the arts is (p. 13), but it appears from the introductory discourse and from his later discussion of the history of modern music (especially pp. 441–51) that the "true principle" would

be similar to the *bello ideale*. In discussing drama, for example, he remarks that the audience "call[s] out, indeed, that [the representation is] perfect Nature, and we are imposing upon ourselves all the while: it is Nature perfectly beautified, that we see" (p. 444). The distinction between *la belle nature* or *la nature embellie* (nature beautified by the artist) and the *bello ideale* is not clarified adequately in the *Inquiry*; presumably, the latter is more nearly the entire creation of the artist than the former. But the issue is confused by such remarks as "the highest merit to which the Fine Artist can rise, is, by adorning Nature, to interest mankind" (p. 13), since the "true principle" here seems to be *la belle nature*. Robertson's treatment of the matter is hardly trenchant, and it is difficult to believe that the problem would have been resolved successfully in later volumes, since his conception of the issue appears rooted in ambiguity.

The second half of the introductory discourse contains Robertson's system for classifying the arts, and a discussion of his manner of treating the subject matter of his projected work. Although he recognizes the complexity of the problem of classifying the arts, his system is largely inadequate because the basis on which it is built is too simplistic to make numerous significant distinctions among the arts, and because the fine arts are never sufficiently defined. Robertson says that Batteux's "odd" classification of eloquence with architecture "warns us, that this point is not of that indifferent kind, as to be settled at random" (p. 14). Batteux's grouping of eloquence and architecture is based on ends; both have usefulness and pleasure as their object.[10] Robertson, however, bases his system on the faculties of apprehension to which the various arts are addressed; such a system necessarily encompasses considerations of the materials of the arts, but, in Robertson's case, does not involve comparisons of ends or subject matters.

Robertson divides the arts into those which relate to the ear, the eye, and the mind, recognizing that these categories overlap. The first includes music and speech, in which "the doctrines of tune and of time in Music" correspond "exactly with those of accent and of rythmus in Speech" (p. 15). The second, involving light, color, figure, and proportion, consists of architecture, painting, sculpture, gardening, and dance. Eloquence and poetry comprise the last, which treats of the "effect which ideas, images, and sentiments have upon the soul" (p. 16).

The kinds of shortcomings present in Robertson's comparisons of the arts may be sufficiently illustrated by examining briefly two of many problems arising from his classifications. In his classification of music and speech as aural arts, "speech" signifies "spoken language"; to

distinguish it from "Eloquence and Poetry on the one hand, and from Grammar . . . on the other," the theory of speech "treats of words, as sounds; forms and arranges them in various ways, to make various impressions upon the hearer; and gives the principles of prose and verse" (pp. 15–16). It is not clear (1) why speech is classed as an aural rather than mental art, since it deals with mental impressions; (2) what distinguishes speech from eloquence and poetry (whose "theory" concerns the effect of "ideas, images, and sentiments" upon the mind), since speech contains the "principles of prose and verse," and since speech, eloquence, and poetry all arrange words to serve apparently similar ends; or (3) why speech is classed as a fine art at all. In terms of Robertson's earlier general distinction between fine (pleasurable) and necessary (useful) arts, speech ought not to be classed as a fine art; it signifies "spoken language" whose primary end is the useful one of communication.

An equally serious and somewhat similar problem arises at the end of his classification of the arts which refer to the body. The arts, he says, may refer to senses other than the ear and eye; if we examine them, "there may happen to be discovered a greater number of senses, and of external objects acting upon them, than we are aware of" (p. 16). This remark reveals the most fundamentally damaging weakness of Robertson's system. There is nothing in his account which distinguishes artistic from natural processes or the effects of artistic from those of natural objects. Various senses may be affected by more "external objects" than one might suppose, but Robertson gives no indication that he is aware that the effects of an art work and those of an object in nature necessarily differ because the former are achieved through matter differing from natural matter. Max Schasler comments that the classification of the arts is the critical test of the scientific worth of an aesthetic system because all theoretical questions depend on it for solution;[11] if so, Robertson's ambitious *Inquiry* fails fundamentally, for the system of classification on which it is founded is fatally deficient.

Robert Anthony Bromley: The Subordination of Aesthetics to Art History

Comparisons of the arts and scholarly history are less intimately connected in Bromley's *History*[12] than in Brown's *Dissertation* or Robertson's plan for the *Inquiry*. Bromley's comparison of the arts, in contrast to Brown's and Robertson's, does not serve primarily as a basis

for later theoretical arguments and historical propositions. Bromley limits his history of the arts to painting, sculpture, and architecture, but deals with painting and poetry in his comparison of the arts. He is more interested in the history of painting than in that of sculpture or architecture; more specifically, he is chiefly concerned with certain kinds of painting which he judges to be superior because of their ability to provide various types of moral instruction. Most eighteenth-century writers argue that poetry's power of instruction is greater than that of painting, but Bromley considers painting the noblest of the arts precisely because of its ability to instruct. Hence his comparison of painting and poetry should be seen in the context of offering a rebuttal of a widely accepted estimate of poetry's superior instructional strength, thereby justifying the publication of a history focusing on pictorial modes suited to moral and religious edification.

Bromley's comparison of the arts is frustrating reading for anyone interested in aesthetic theory because it consistently gives promise of critical insight, but is ultimately disappointing. Many of his distinctions are important and potentially useful, but his overriding concern for proving painting's superiority prevents him from realizing the implications of most of them. His recognition of essential differences between simultaneous and progressive effects, for example, enables him to isolate some of painting's unique powers, but there are conclusions about poetry's unique powers implicit in his distinction which ought to lead to qualifications of assertions of painting's natural superiority. Bromley nearly always ignores data and the implications following from applications of basically sound critical principles when such material might impede the pace of his tribute to painting. His affirmations of painting's worth might have been acceptable if qualified and if based on a recognition and refutation of possible alternative conclusions, but they are not; and what might have been a meaningful contribution to the science of aesthetics is, instead, an encomium.

Most of the principal doctrines used in Bromley's comparisons do not originate with him; Dryden, Du Bos, Richardson, Lamotte, and Jacob, for example, advance similar or identical theses relating to painting's instructional power. Many of his arguments supporting major contentions, however, are original. Although Bromley's and Du Bos's theories concerning painting's inherent strength are similar, the work which his comparison of the arts most nearly resembles, in terms of principal conclusions about painting, is Lamotte's *An Essay upon Poetry and Painting*. Bromley's *History* and Lamotte's *Essay* provide an example of works whose nearly identical doctrinal statements may lead

the historian to obscure vital differences between the two if the implications of such statements are not viewed in the context of specific arguments and broad objectives. Both men argue for the superiority of painting's instructional power on the basis of prior considerations of the arts' media and subject matter, and of psychological causes of artistic effects. But similar conclusions are reached for very different reasons, and do not lead to identical evaluations of ultimate artistic worth in the two works. For example, the two men do not mean precisely the same thing by *instruction;* they use similar evidence in support of different arguments; and Lamotte's investigation seeks to define the relative affective and instructional powers of both painting and poetry.

In order to avoid confusion in examining Bromley's specific arguments, it should prove helpful to clarify a minor awkwardness resulting from his classification of painting as a mode of writing, and from his assignation of the term *poetic painting* to one of the pictorial modes. Bromley says that in his comparison of the arts, located in the second chapter of part 1, he will show "the advantages of painting, in an improved state, over all other modes of writing" (p. 8). In the first chapter, he calls painting "the original writing of nature" because its first function was to convey messages, and because its origins lie in man's innate imitative talent. Man learned to communicate through crude pictorial representations before inventing letters which signify ideas, but through the perfection of words, other kinds of writing supplanted painting's simple communicative function. However, in its "improved state," painting retained its superior instructional power, although the kind of instruction provided changed. Bromley uses "poetic painting" to refer to works whose effects depend largely on the painter's imaginative embellishments (pp. 63–85); probability in "historic painting" is defined in relation to historical accuracy, whereas it is determined by a combination of fiction with common sense and historical verisimilitude in "poetic painting." The term *poetic* refers to qualities relating to pleasure rather than instruction in painting (although pleasurable "poetic" qualities reenforce instruction); similarly, implicit in Bromley's comparison of the arts is the assumption that poetry's proper end is pleasure, since "fiction is the soul of poetry," and since painting's means give it greater power when both arts deal with the same subject matter.

Bromley's comparisons deal with the instructional scope, force, dignity, and universality of the two arts. In each category, judgments of painting's superiority are derived from analyses of the arts' materials and supported by psychological explanations of effects. Of his compari-

sons, that respecting universality is perhaps the most confusing, even though its basis is not complex. The initial argument supporting painting's superiority is one which had been advanced by Dryden, Du Bos, Lamotte, and many others: painting employs a "universal language, intelligible to all in every country, and in every period of time," whereas poetry "can speak only to those who have been taught its language," and even to those it is often involved in obscurity. Bromley adds that even if the language of poetry were clear, "since the ideas it conveys depend not for their preservation on any actual forms or images brought home to the mind, but merely on sounds or arbitrary marks, it must be transient in its effects" (p. 21). His argument is similar to Du Bos's assertion that the natural signs of painting operate directly in forming images and are stronger in effect than those of poetry because words, as artificial signs depending on education, first elicit ideas of which they are signs and are then translated into visual images for the mind by the imagination, but he converts what is a statement of the relatively greater immediacy and strength of painting's affective power in Du Bos into an absolute judgment of the permanency of painting's effects. In doing so, Bromley omits mention of the imaginative faculty which converts poetic signs into images; painting's visual media may insure a more nearly universal audience, but poetry's effects are not transient because poetry fails to evoke mental images. It is not clear, however, whether Bromley intends "transient" to refer to effects on a given reader, or to works considered as objects, or to both. When applied to works as objects, it is less objectionable, implying that a painting will remain intelligible because basic human passions remain unchanged, whereas changes in language may obscure a poem's original meaning. His remark that pictorial language "speaks to multitudes at once, and to successive generations; and when once impressed on the mind, retains an abidance there, which time can rarely efface" seems to indicate that his judgment about permanence and transience is meant to apply both to individual effects and to works as objects.

On the basis of universality of language, Bromley argues that there are certain subjects, such as natural scenes, beauties of perspective, and those concerning the useful arts, "in which words can give no assistance; subjects, which form some of the first delights to the rational mind, and often no inconsiderable instruction" (p. 22). This assertion is nearly identical to Lamotte's contention that painting is superior to poetry in utility because it can portray images pertaining to geography, mathematics, and other "useful" subjects. The accessibility of such subjects to painting constitutes Lamotte's principal reason for assigning

134

greater instructional merit to painting than to poetry; for Bromley, it is an incidental advantage resulting from a greater cause.

In completing his case for painting's superior universality, Bromley confuses the art of painting with ideation. He says that "if we consult what we read, we should" conclude "that words at no time inform us perfectly, without reference to the painter's art." No one reads without converting "words into an image, and fancies the scene . . . to exist before him. . . . If writing fails to raise such an image within us, it is then poor and indifferent" (p. 23). If we ignore the contradiction between this argument and his earlier statement that poetry's ideas do not depend on "images brought home to the mind," there remains the problem of arguing for painting's superiority on the basis of imaginative responses to poetry. Bromley establishes a visual ideal for an essentially nonvisual art, and then equates this end with the art of painting; hence painting and forming mental images are the same thing, so that if the poet successfully achieves the pictorial ideal, the credit belongs to the art of painting. Obviously, neither the art nor the language of painting is synonymous with ideation, but, unfortunately, Bromley chooses to end his comparison of the arts with a poorly timed rhetorical question: "Shall we hesitate then to pronounce, that of all the languages in the world that of the pencil is most copious and universal?"

Bromley's arguments for painting's superiority in both instructional scope and force are based on a distinction between simultaneous and progressive effects in the arts. Since language describes its subject progressively and the canvas reveals its subject instantly, the various effects of poetry are cumulative, whereas those of painting are simultaneous. Similar observations are made by many earlier writers, including Du Bos and Lamotte. Du Bos uses this distinction as part of his contention that the force of painting's affective power is greater because it has greater immediacy; Lamotte agrees, on the same basis, that painting is quicker and more universal in achieving effects, but he considers poetry's affective power greater. Although he uses this distinction in defining some of painting's unique powers, Lamotte, unlike Bromley, does not afford it prominence in arguing for painting's superior instructional power, since that power, in Lamotte, is based on its ability to depict useful subjects alien to poetry. Moreover, Lamotte uses this distinction to define many of *poetry's* advantages; since poetry can portray successive actions, for example, it is capable of greater variety both in the subjects it portrays and the emotions it evokes. Although Bromley attaches fundamental importance to the distinction between progressive and simultaneous effects in discussions of both the

scope and force of instruction, it is a more viable basis for his argument concerning painting's superior force. In his discussion of "the scope of instruction," after stating that the "best composition of language can but display its subject in progressive detail," whereas "with one glance of the eye the mind seizes the whole" in painting (p. 8), Bromley offers a psychological explanation of why painting's scope is greater than poetry's. Pictorial effects, he says, are "caught at once upon the canvas" and "abide upon the senses," but poetic effects rise "only in succession" so that every "succeeding gratification treads out in some degree the impression of that which is gone by" (p. 11). The primary difficulty with his argument is that there is no necessary connection between his basic distinction and the conclusion that painting's scope is greater, for he ignores any consideration of poetry's unique "scope" resulting from cumulative effects. He is somewhat aware of the possibility that certain kinds of passion (such as pathos [p. 12]) or subtle variations of passion may be better suited to poetry, but he does not resolve the problem. Instead he substitutes simple assertion for argumentative proof; he states, for example, that the canvas offers no "disadvantage to those parts of the story, which language would bring forward with its best colouring" and no "loss of those secondary circumstances" which poetry portrays "with all the variety and exactness of expression" (p. 9), but offers no convincing evidence. Unlike Lamotte, Bromley avoids mention of passions which are not expressed through visual signs (and, consequently, are not proper subject matter for painting), nor does he consider certain abstract ideas which can be expressed through poetic, but not pictorial, media; the question of superior scope is more complex than Bromley realizes or perhaps is willing to admit.

The simultaneous rather than progressive effects of painting also account for its greater instructional force because "where more causes are combined and concentered together, the stronger and more copious will be the effect. . . . The fire which gathers in an instant from many quarters will be more intense than that which lingers in its progress" (p. 13). The remainder of Bromley's argument is based on the assumption that the eye conveys stronger impressions to the mind than the ear. Instruction derives from "the stronger and more marked affections," all of which are within painting's range, when "admirable objects" unite "in a whole"; we are more strongly impressed when a speech is delivered orally than when read in private because the eye impresses all circumstances of the scene on the mind. By analogy, the "images do not indeed speak [in painting], but they are alive to the sight," and have a peculiar eloquence; "in the speaking and the silent figure the medium is

the same" (the eye) (p. 14). Since Bromley believes the eye conveys stronger impressions and raises more immediate effects than the other senses, he concludes that painting's instructional force is greater than poetry's.

Bromley's discussion of dignity is more original both in terms of critical principles and specific arguments than those concerned with scope, force, and universality, but it is nearly as confusing as that dealing with universality. He uses *dignity* to refer to the artist's heightening of edifying subject matter; the case for painting's superior instructional dignity is made in the context of the two general categories of *action* and *style*. Bromley says that action in artistic subject matter "lifts every scene to its best moment" and confers dignity; action in painting is superior to that in the arts of language "because it is the full and real exhibition of Nature, to which the artificial exhibition of her by words only holds a secondary place." To illustrate that action is possible in painting, Bromley again draws an analogy (based on an observation made by Quintilian) between painting and pantomime; as a silent and immobile mimic may express passion, so may figures on canvas. The test is "if the passion be preserved and given in its own energy; and if so, the effect is obtained," and painting claims, "in common with real life, that action which lifts every scene, and unaided by which the finest writing in the world loses many gradations of dignity" (pp. 16–17). The analogy is not a good one, since passion and action are confused, and even Bromley might acknowledge that poetry can better imitate action than painting. He apparently refers to heightened single moments, however, deriving his judgment of painting's superiority from the implicit argument that poetry is further removed from nature than painting. There is nothing in Bromley's discussion which differentiates art from nature; moreover, degree of dignity depends on similarities between imitating and imitated object inherent in the materials of art. Painting imitates "real nature" because figure imitates figure, whereas poetry describes nature through nonvisual ("artificial") means. For Bromley, painting's relatively greater "naturalness" results from organs of perception; we perceive passion and action in nature and in painting, but not in poetry, with the eye.

If dignity of action depends on truth to nature for Bromley, dignity of style does not. Stylistic dignity consists of depicting the subject "in the best possible view," including heightening through incorporating material which is not "connected in strictness" with natural subject matter. Bromley says that nature never presents material so as "to give a perfect display to the whole," but "the painter breaks

through those disadvantages and fetters" (p. 17). He states that these powers are "beyond any capacities of writing," adding that every painting is "either divine or poor," whereas we endure mediocrity in writing, "although it be dressed in no graces of diction," because "we do not necessarily look there for a dignity of style" (pp. 18–19). His assertion of painting's superior dignity is wholly unproved, for poetry is equally able to achieve the qualities (unity of parts, contrast, embellishment of nature, and so forth) he attributes to stylistic dignity in painting; restricting stylistic dignity to "diction" in poetry merely weakens his argument because the phrase must have comparable meanings when applied to the two arts if it is to serve as a basis for comparing and evaluating them.

Bromley's and Brown's comparisons of the arts illustrate possible extremes in combinations of aesthetics with scholarly art history. We have seen that Bromley's comparisons are clearly designed to glorify the art of painting by praising its instructional power, thereby adding luster to any history of painting, but particularly to one focusing on modes with high moral purposes. His defensiveness is not surprising, in light of the fact that painting is frequently viewed as a weak sister of poetry in eighteenth-century comparisons of the arts written by literary men; nonetheless, when comparisons of the arts are cast in the role of apologist for a particular art, their potential value for aesthetic discourse suffers. In Brown's *Dissertation*, the process is reversed; his individual histories serve to verify theoretical propositions about the natural, essential unity and unnatural disjunction of the arts. Brown's comparisons are perhaps no more disinterested than Bromley's, insofar as they function within the context of arguments for artistic reforms. Robertson's comparisons occupy a middle ground between those of Brown and Bromley. They attempt to provide definitions, distinctions, classifications, and critical principles on which the remainder of the *Inquiry* could be based; their purpose, however incompletely achieved, is that of clarification rather than disputation. In the *Inquiry*, aesthetics is not markedly subordinated to history, as in Bromley's *History*, nor history to philosophical speculation, as in Brown's *Dissertation*. Comparisons of the arts and scholarly history can be and were integrated in various other ways; these three works are especially useful for comparative purposes, however, because they exemplify the ends and center of the spectrum of possible priority and independence of "philosophical criticism" and art history in works combining the two.

Chapter Eight

Variety and Change
in Comparative Discussions

The works analyzed in the preceding chapters have been treated as self-contained, reasoned discourses within a specialized branch of aesthetics; insofar as this study is a history, it must therefore be one without a thesis. Works have not been viewed as attempts to arrive at a single aesthetic truth known in retrospect by students of the eighteenth century but not necessarily by eighteenth-century theorists, or as manifestations of a general scheme of dialectical contraries (such as "expressive" versus "mimetic" theories) predicated of the entire age by the literary historian. Instead, I have attempted to reconstruct those problems which critics set for themselves, and to indicate the reasoning methods and critical principles which each deemed uniquely appropriate for answering those questions. Each essay is "given meaning," so to speak, as an entity within this context; hence the merit of an essay is determined by appraising what it achieves in employing certain principles and methods in solving specific problems. If the essays of Twining and Smith are superior to those of Lamotte and Jacob, for example, it is not because they are more strongly in revolt against the "constraints of reason" and "neoclassical rules" or because they pave the way for the millennium of romanticism, but because they accomplish more of lasting worth in answering questions similar to those posed by the earlier treatises. A work may be faulted for incoherence or inconsistent logic, for methodological inadequacies, for violations or failures to see the implications of its own principles, or because its principles are simply inadequate for solving the problems it addresses or are based on deficient conceptions of the nature of the artistic phenomena with which the work deals, but its worth cannot be properly assessed if it is viewed as a series of discrete opinions and doctrines.

To say that these works have been analyzed in the context of the specific questions and methods which lend meaning to their doctrines

does not imply, of course, that their authors never share problems or use similar methods in their solution. Nor does it mean that lines of development within comparative discussions of the arts cannot be traced by comparing what the various theorists attempted and the means through which solutions were effected. But it does mean that such comparisons ought to follow separate analyses of each theorist's peculiar efforts; to regard them a priori as differing answers to the same questions or as various permutations of a common world view invites distortions and those facile analogies whose facility is their chief merit.

I now intend to review the kinds of problems posed and the principles and methods employed in their solution, and to designate, by comparing these aspects, some of the major conceptual and procedural shifts of emphasis in eighteenth-century comparisons of the arts.

Each work included is centrally concerned with the general task of finding bases for distinguishing fundamental similarities and differences among the arts or with specialized aspects of this problem. Although their works share a similar locus of subject matter, no two authors conceive their basic objectives in an identical manner or cast their arguments in precisely the same form. The discovery of universal bases of the arts may derive from analyses of works of art, prior critical theories, human nature, or qualities of mind (that of the artist, apprehending agent, or both). If fundamental likenesses and differences among the arts are to be clarified, the nature and value of each art must in some way be defined. The source to which each writer turns for first principles for defining, classifying, and comparing the arts depends on the kinds of questions he asks, his unique conception of the problems involved, and his purpose in asking the question in the first place. A history of aesthetic theory is largely one of writers' choices (among possible principles, doctrines, methods, and questions); to whatever extent those choices can be made intelligible, answers can be provided as to why writers produce the kinds of theories they do.

Works published during the first forty years of the time span I have covered (those of Dryden, Blackmore, Lamotte, and Jacob) are broadly similar in method, and share a common critical vocabulary. All draw parallels among the formal components of the arts, adduce parallel rules, and agree that poetry and painting are the most closely related arts, but differ in the uses made of similar parallels and in assignations of ultimate artistic worth. Common terms assume different meanings, and identical doctrines lead to different conclusions in these works; hence they are more diverse than surface similarities of statement indicate. It is a common technical orientation or rhetorical

methodology which serves as the common denominator of these works and distinguishes them most fundamentally from the works of such later men as Harris, Beattie, or Jones.

Dryden, in the "Parallel," appeals to the practices of past artists and to literary and pictorial theories based on historically approved artistic habits to deduce fundamental rules of painting and poetry. His immediate purpose in translating Dufresnoy's poem is to provide rules (for both audiences and painters) through which the general level of taste could be improved. If poetry can be shown to be basically similar to painting in value and in the way it achieves its effects, then parallel rules for poetry might be expected to serve the same function. Hence Dryden stresses those parallels which yield general precepts defining the natures and governing the subject matter and effects of the two arts.

The major terms of Dryden's discourse, like those of Dufresnoy, are derived from the tradition of Roman rhetoric—invention, disposition, and expression. And the final judge of artistic merit is the cultivated man of taste, both as a connoisseur familiar with artistic practices and precepts and as a seeker of truth or moral instruction. Dryden's method is rhetorical in that poetic and pictorial kinds are viewed as conventional means of producing predetermined effects. The "Parallel" is technical criticism insofar as it concentrates on questions of artistry, construction, and established styles and species rather than on general qualities or values which distinguish one artist from another regardless of medium or genre.

Literary and pictorial genres are distinguished in terms of the demands of subject matter and different audiences. Painting and poetry are fundamentally alike in that both seek to provide pleasure (and the latter, moral instruction) in artificial media and preestablished genres through imitation. The imitative ideal is that of "ideal" truth and natural probability, varying from genre to genre in accordance with the subject matter imitated. In the "Parallel," the rules of painting and poetry are deduced ultimately from authority and practice, which in turn are based on a knowledge of unchanging nature. Although no rules can be given for invention, art becomes an impersonal standard to which the artist must subordinate himself to be successful. For Dryden, art is superior to nature insofar as it improves upon natural phenomena, and dependent on nature as a source of subject matter and on the audience's natural pleasure in discovering the "truth" of "lively" imitations of nature.

Blackmore's *Lay-Monastery* essays and Lamotte's *Essay upon Poetry and Painting* are self-avowed "supplements" insofar as they

attempt to draw new parallels between poetry and painting or elaborate upon those drawn by earlier theorists. Neither writer offers a fully comprehensive system of parallels, although Lamotte's essay is more extensive and of greater historical and intrinsic interest. Like Dryden, Blackmore and Lamotte treat painting and poetry as means of achieving predetermined effects through historically prescribed species. Again, like Dryden, Blackmore and Lamotte locate the essential affinity of poetry and painting in the imitative nature of the two arts, but the three writers mean different things by *imitation* and draw dissimilar conclusions about artistic ends and the relationship of nature and art from considerations of artistic imitation.

The primary objective of Blackmore's two essays is to establish parallels between poetic and pictorial species based on the arts' similarities of subject matters and ends. These parallels are nearly identical to some of Dryden's, which are based on the same considerations; corresponding parallels in Dryden's work, however, serve as part of a larger argument rather than as the essay's chief end. Although he discusses artistic truth in terms of the resemblance between the work and the artist's unique conception of his subject matter, Blackmore ultimately restricts imitation to the mirroring of natural particulars and judges artistic worth by the degree to which a work accurately depicts particular nature. His concept of mimesis more nearly resembles that of Lamotte than that of Dryden. He distinguishes among the species of each art on the basis of the affective and instructional power of their respective subject matters, but, unlike Dryden and Lamotte, does not compare the relative instructional or affective power of the two *arts*.

Although the works of Lamotte and Dryden are addressed to similar problems and employ similar methods, many of the terms common to the two essays assume somewhat different meanings and are used in distinctions of radically different significance. Like Dryden, Lamotte seeks to establish exact parallels between poetic and pictorial rules, but he does so in order to define the limit of licences common to both arts. For Dryden, the basis of the effects of both arts is the imitation of the "best nature" because such representations produce maximum pleasure and enlightenment; for Lamotte, imitation does not refer to ideal types but to the portrayal of actual conditions, customs, or natural objects and to copying literary models. Hence the truth of a work is historically verifiable; it refers, as it does in Blackmore, to the precise correspondence of imitating and imitated objects and to whether depicted events actually took place. Given this principle, the specific rules Lamotte adduces necessarily differ from Dryden's.

Historical accuracy overrides the demands of specific audiences. Both arts instruct and please, but Lamotte assumes, as Dryden does not, that violations of decorum necessarily destroy any potential pleasure in a right-minded audience. This assumption results in one of the most damaging weaknesses of Lamotte's *Essay*; it is not possible to reconcile his assertion that the artist is obligated to those general rules of his art which are founded on unchanging nature with his requirement that artists must imitate historical and moral truth, because it is clear that those "truths" exist in a context of Christian morality and western values.

What is perhaps the greatest difference in doctrinal statement between the two essays results directly from variations in their authors' conceptions of the problem of instruction in art. For Dryden, poetry has a greater potential for instructing, because it can imitate a greater range of subjects than painting, but Lamotte restricts instruction to conveying accurate visual images of "useful" subjects. Since painting and poetry are arts of sensible images for Lamotte, and since the images of painting are less obscure, more immediate, and hence more accurate, he argues that painting has a greater capacity for instruction.

There are additional differences of emphasis and method which further distinguish Lamotte's essay from Dryden's and define Lamotte's position in the history of comparative discussions of the arts. Differences between painting and poetry, for example, are emphasized to a greater degree in Lamotte than in Dryden. And if Lamotte's method remains essentially rhetorical, like that of Dryden, the *Essay* nonetheless has been influenced by Du Bos's interest in explaining artistic effects in terms of natural causes. Even though such considerations play a distinctly minor role in his essay, Lamotte is aware of the potential usefulness and possible results of prior analyses of psychological causes in aesthetic theory. Fully developed "causal" forms of inquiry did not appear in British comparative discussions before the middle of the century.

Jacob's *Of the Sister Arts* resembles the works of Dryden, Blackmore, and Lamotte in its principal interests. It deals mostly with parallels among the parts, genres, and rules of the various arts. Jacob's parallels lack originality, the greater part having been drawn by such earlier theorists as Dryden, Du Bos, and Lamotte, and, unlike those of Dryden and Lamotte, are not based on a systematic framework of critical principles. Jacob is more interested in the historical relationships of the arts than the three earlier writers, but the chief historical significance of his essay resides in the attempt to include music as the

equal of painting and poetry in the parallels. He argues that all three arts strive for pleasure and instruction through imitation; his difficulty in defining the manner in which music imitates and instructs prefigures that encountered in later writers who include music in parallels. Parallels among any of the arts suffer when the arts are compared or judged on the basis of principles or criteria appropriate to the unique properties of one but not of others, but music presented greater difficulties than poetry and painting to many theorists who based comparisons on restrictive concepts of imitation, because it is more difficult to see wherein "nature" is significantly imitated in music than in poetry or painting.

Mid-century comparisons of the arts, considered collectively, manifest a far greater pluralism, in terms of reasoning methods and critical terms employed, kinds of questions asked, and sources consulted for critical principles, than the comparative discussions published earlier in the century. Unlike the essays of Dryden, Blackmore, Lamotte, and Jacob, Harris's "A Discourse on Music, Painting and Poetry," *The Polite Arts*, and Avison's *An Essay on Musical Expression* do not share a common form of theory or essentially similar principles, although Harris's "Discourse" and *The Polite Arts* are superficially alike in doctrinal statement and the use of terms derived from Plato. Nor should these works be viewed as predominantly transitional links which combine traits of both earlier rhetorical and later causal forms of theory, although such a description more nearly fits Avison's work than the other two. All three introduce problems, concepts, or arguments differing fundamentally from those found in earlier British comparative discussions, two (Harris's "Discourse" and Avison's *Essay*) play especially significant roles in shaping later discourse in this branch of aesthetics, and one (Harris's "Discourse") deserves to be remembered in the history of aesthetics for its intrinsic value as well as for its influence on later theorists.

Harris's "Discourse" differs radically from the essays of Lamotte and Dryden both in the problems it raises and the reasoning methods it employs to solve them. Certainly Harris is also concerned with imitation as a basis of artistic effects and with the proper subject matter of the arts, but any significant similarity ends with that of general subject matter. Harris does not conclude that the arts strive for similar effects by imitating subjects through pictorial images, nor are the arts regarded as conventional modes of discourse whose rules may be deduced from "nature methodized." Instead, he discriminates among the arts in terms of their different media, evaluating them in terms of their ability to

imitate accurately and with respect to the inherent worth of the subject matter to which each art is restricted by its media. Differences of media also dictate differences in possible effects; if visual accuracy is a relevant measure of artistic worth in the pictorial arts, it is not in poetry and music, because their media are not visual ones of color and figure. The natural media of music and poetry are sound and motion, but poetry also utilizes the artificial medium of words (given "meaning by compact"). Whatever the status of poetry in relation to painting and music when viewed in its natural medium, its advantages in respect to range of subject matter become apparent in its artificial medium.

For Harris, the ultimate superiority of poetry derives from the intrinsic moral worth of those subjects which painting and music cannot imitate. Poetry enables man to contemplate the true internal moral order (innate ideas which exist in all rational minds). Although Harris and Lamotte both judge the highest art to be that which is most instructive and affecting, their meanings are entirely dissimilar. For Harris, the most affecting and instructive matter is an immutable moral world existing independently of physical nature and sensible images. Thus the value or truth of a poetic imitation does not refer to historical and pictorial accuracy or to a concept of ideal nature synthesized in the mind of the poet, but to preexistent ideas of perfection, the apprehension of which enables man to achieve his "real Self."

The significance of Harris's "Discourse" for eighteenth-century comparative discussions can scarcely be exaggerated, for his investigation of the natural powers and limitations of artistic media (and their consequent subject matter) forces a reexamination of those theories which assume a similarity of purpose, subject matter, or effects among arts which use various media. At the very least, it necessitates consideration of a complex of questions of enduring critical worth differing essentially from those raised by rhetorically oriented parallels. Harris's "Discourse" has not received the attention it deserves. Lessing has been acclaimed for refuting in his *Laokoön* in 1766 parallels which overlook the arts' differences in media and constitutive principles; Harris sounded essentially the same warnings twenty-two years earlier.

Although Harris's "Discourse" and *The Polite Arts* are similar in terms of their general areas of interest and doctrinal statements, they differ with respect to critical principles and methods. The primary problem of *The Polite Arts* consists in defining a concept of "ideal imitation" common to all the "polite" arts. Among eighteenth-century British comparisons, *The Polite Arts* is unique in adapting "Platonic" terms and concepts to a non-Platonic system of values and reasoning

methods. In *The Polite Arts*, artistic worth is assigned to the communication of pleasurable qualities rather than to the moral or instructional merit of subject matter. And ideal form, which constitutes the source of pleasure when properly represented in art, is not given independent status as a world of permanent, immaterial, informing ideas. Instead, it exists in the mind of the artist, who actively collects and synthesizes the scattered beauties of material nature. A similar synthesizing principle determines the standard of taste by which individual works are judged; the audience "collects" and synthesizes the single beauties of past works into a concept of ideal beauty. *The Polite Arts* resembles Reynolds's *Discourses*, published later in the century, both in its concept of ideal form and in its method of defining terms and establishing values through generalizing from particulars to ideas.

The polite arts are defined as those which have pleasure as their object; thus problems of instruction in art, which play a significant role in all previously discussed essays, are made irrelevant in *The Polite Arts*. The central problem is how the arts can best please. In answering that question, the author turns briefly to a prior analysis of human nature. Man is limited to perceptions of the sensory world, but is not satisfied with it as an ultimate source of pleasure; although nature cannot be transcended, its single products can be improved upon while still remaining natural. The representation of this ideal nature is the end of all the polite arts.

The controlling principle of the essay is that through imitating ideal beauty all arts achieve their greatest effects; considerations of the artist, work, and audience are determined by and secondary to the knowledge of what is to be imitated. Art is defined primarily as subject matter. Questions relating to differences of media and artistic species are made relevant only insofar as various media and species imitate different aspects of ideal nature. Effects vary from art to art and species to species, but all are based on the common principle of the apprehension of ideal nature in ideal art forms. Thus a major conceptual and procedural difference between Harris's "Discourse" and *The Polite Arts* is apparent: Harris begins with an investigation of those differences in media which necessitate the discrimination of subject matter, whereas *The Polite Arts* proceeds from the definition of common subject matter to a consideration of the means through which it is imitated. The difference is important since it leads to quite different definitions of the nature and value of the several arts. Moreover, in *The Polite Arts*, the poetic species are distinguished in rhetorical fashion; they are conceived as kinds conventionally restricted to preestablished effects and subjects.

The author is aware that different means permit different effects in music and poetry, but he assumes an identity of effects in poetry and painting, thus positing similar standards of evaluation for visual and verbal arts.

I have said that mid-century comparative discussions, considered collectively, are pluralistic with respect to forms of theory. *The Polite Arts* is an example of an individual mid-century work which evinces methodological eclecticism. It manifests no single, consistently applied methodology; its discussion of how the arts please is causal, its process of defining terms and values is dialectical, and its analysis of species is rhetorical.

The significance of Avison's *An Essay on Musical Expression* in the history of eighteenth-century comparative discussions is not unlike that of Dryden's "Parallel." Both initiate discussion, Dryden by drawing parallels between painting and poetry, and Avison by performing the same task with painting and music. These essays are also similar insofar as both are concerned with likenesses rather than differences among the arts and make comparisons in order to improve public taste. However, the forms of theory and critical principles employed by the two men bear little resemblance.

Both Harris and Avison argue that music's effects are non-mimetic. But Harris does not supply an alternative concept accounting for musical effects; Avison does, by defining music as "expressive" rather than imitative. Even though Avison does not provide a satisfactory definition of musical expression, his discussion of it is germinal; numerous later theorists, similarly perplexed in trying to analyze music as an imitative art, refer to Avison's *Essay* in describing the expressive or affective power of music. However, as later theorists were quick to recognize, the critical usefulness of the term *expression* need not be limited to discussions of music; if music's effects can be explained profitably in terms of expression, cannot the term be used as a basis for defining qualities or effects common to all the arts? Avison focuses attention on music's affective power and then compares it with that of painting; in doing so, his *Essay* deemphasizes technical or formal concerns in favor of considerations of qualities common to all arts regardless of species, thus playing an important role in one of the major shifts of emphasis in the century's comparative discussions.

In describing music's affective power in relation to melody, harmony, and expression, Avison relies for first principles on a brief analysis of the manner in which musical properties operate on man's imagination and passions. He is less concerned with how artistic effects

can be achieved in historically defined species than Dryden, and more interested in explaining artistic effects in terms of natural human behavior; hence the *Essay* is more nearly aligned with later causal forms of theory than with earlier rhetorical forms. It remains, however, more importantly concerned with technical matters than most later causal theories; Avison's analogies between music and painting are far-ranging in scope and serve an equally broad spectrum of purposes. But few of his analogies are of much intrinsic merit; despite the homage paid it by later music critics and comparative theorists, the *Essay* is far less insightful than the work of Avison's contemporary and friend, James Harris.

The essays of Beattie, Webb, and Jones resemble one another and differ from the works previously discussed both in kinds of problems posed and reasoning methods employed. Insofar as their basic concern is with qualities and effects common to all the arts rather than with technical questions of construction, they may be described as examples of "qualitative" criticism. The form or method of argument is "causal" in the sense that they attempt to explain artistic qualities and effects in terms of natural causes derived from prior analyses of psychology and natural human behavior.

All three men pose questions relating to the universal bases of aesthetic responses, to those objective causes which account for effects for all men. Such questions direct attention to the psychological mechanisms governing aesthetic feelings. Interest thus focuses primarily not on subject matter, but (1) on the mind apprehending works and (2) on the mind which gives artistic form to the properties of the physical world. This second area of interest represents one of the major contextual shifts in the century's comparative discussions, for the artist assumes a more significant role in these aesthetic theories than in earlier ones. The conduct, qualities, and powers of the artist's mind are not subsumed under general considerations of art but investigated as causes of aesthetic effects. In these theories, art remains of value mainly for its effects on the audience, but the artist is afforded a more prominent position.

A change of greater significance involves the source of fundamental principles on which rules for creating and evaluating all of the arts are based. The nature of the change is clear when we consider what happens to the status of rules based merely on past practices in theories which seek explanations of effects in universal psychological phenomena (Beattie and Jones) or natural nervous responses (Webb). If such inquiries often grew from the desire to justify artists (such as

Scottish poets and musicians) whose works were judged in some way inferior by the precepts established by ancient models and critics, or to explain the undeniable effectiveness of works (especially certain Shakespearean plays) whose peculiar qualities could not be explained by such standards, the resulting issues are much more far-reaching. The question at stake is basic to aesthetic discourse: should rules derive from a knowledge of past artistic practices and critical systems or from direct study of the habits and properties of the mind? The change should not be regarded as a complete or abrupt relocation of first principles; it is gradual, and most of the century's theorists make use of both approaches (many of the earlier writers included here certainly do). Nonetheless, there is an important change of emphasis evident in such writers as Beattie, Jones, and Webb, a shift, as Marsh states, from "one side to the other of the most general and inclusive conceptual opposition in ancient criticism—from 'art' to 'nature' " ("Neoclassical Poetics," p. 561). This change has the effect of elevating the student of mental behavior to at least equal rank with the artist and general "man of letters" as a qualified aesthetic theorist or arbiter of taste; hence it is not surprising that a much larger percentage of the aesthetic treatises of the last half of the century were composed by amateur or professional philosophers.

A further development in basic principles through which comparisons were effected concerns the conception of the audience which serves as the ultimate judge of art. Again the change is one of shifting emphasis rather than a complete reversal of principles, but it is significant because it affects the formulation of fundamental rules for art. Theories which explain effects through psychological or physiological natural causes posit a basic human nature whose universal laws account for all aesthetic responses. Different environmental factors affect common humanity as secondary causes which explain variations in works and responses. Specific audience demands and the artist's training need not be ignored, but the characteristic responses of men in general are given greater emphasis than the demands of men with socially determined needs, gifts, and circumstances. Consequently, rules can be justified in terms of natural man's reactions instead of those of the cultivated man of taste.

It is not surprising that an increased interest in natural causes served as an impetus for and justification of fresh comparisons among the arts. When men like Beattie divide rules into those which are based on human nature and those which "have no better foundation than the practice of some great performer" (*An Essay on Poetry and Music,*

p. 349), the result is a deemphasis of the demands of artistic species in favor of causes determining responses to all artistic productions. Moreover, interest in general aesthetic qualities, such as the picturesque or the sublime, which are not restricted to a single art or species, undoubtedly encouraged interest in comparisons.

Although Beattie, Webb, and Jones share a causal form of theory, the questions they raise vary. Beattie's primary task is to deduce rules of music and poetry from natural laws based on psychological principles. Since the function of true poetry and music is to produce pleasure by raising the passions, specific technical rules are based on an answer to the prior question of how and why pleasing passions are raised. That answer lies in the investigation of mental traits which connect artistic material with aesthetic feelings. Poetic and musical effects result from responses of the sympathetic imagination and from mental associations of ideas (of which there are several types, ordered by natural laws). Moreover, all effects are governed by man's innate love of moral and natural truth.

Jones's essay resembles Beattie's in founding its explanation of poetic and musical effects on principles of empirical psychology (and, additionally, in the natural causes accounting for the origins of the arts) and in referring aesthetic communication to the sympathetic faculty. But Jones differs from Beattie in denying the imitative power of poetry (although that difference is partly semantic, since they define imitation differently) and in attempting to define a natural artistic act (nature acting through the artist). In the latter effort, Jones's theory equates art with nature by obscuring the differences in man's response to natural and artificial expressions of passion, thus (1) ignoring fundamental questions of media and (2) confusing the work as object with the work as representation.

Although he also explains musical and poetic effects in terms of natural causes, Webb differs from both Beattie and Jones in defining the mechanism connecting artistic materials with pleasurable sentiments in physiological terms. For Webb, "movements" impressed on the nerves and animal "spirits" are analogous to movements produced by artistic impressions. Passions and the properties of art convey like movements to the nerves and spirits (the seat of pleasure); this principle of corresponding motions governing physiological responses, rather than those of sympathy or association of ideas, explains the natural influence of art on the passions.

In accounting for the various kinds of pleasure possible in art, Webb multiplies the modes of passionate motion to accord with

possible combinations of artistic properties, and distinguishes between those effects which depend simply on sense impressions and those which involve the apprehension of ideas by the mind subsequent to sense impressions (expressive and descriptive imitation). The great advantage of poetry over painting or music is, according to Webb, its ability to achieve both effects simultaneously; verse movements "imitate" the mechanical motions of the passions while word meanings allow ideation, thus affording the listener the pleasure of comparing imitated and imitating object and apprehending the beauty of poetic imagery.

Regardless of basic types of questions asked and reasoning methods employed, all of the theorists included here are in some way concerned with imitation as a basic concept for defining art. The term obviously signifies many different things and varies in importance from theory to theory. For example, it is of central importance in *The Polite Arts*; the essential function and value of all the arts consist in imitating ideal beauty synthesized from nature. For Jones, on the other hand, imitation cannot explain the significant powers of any of the arts. He defines imitation as copying particular objects and manners and defines art as the natural expression of passion; since his definition of imitation precludes the possibility of expressing passion, he concludes that such a principle cannot be relevant for explaining artistic effects. Harris delineates several senses in which the various arts imitate according to their respective media; the highest forms of poetry imitate innate ideas of a perfect moral order, whereas the important effects of music do not result from imitation. Avison follows Harris's lead in denying the mimetic basis of music's primary effects, choosing to define music as an "expressive" art. And Lamotte considers painting and poetry essentially imitative, but restricts the concept to visual accuracy. In view of the disagreements over the value of imitation as a means of producing aesthetic effects, it is not surprising that two of the major late-century writers approach the problem of finding a universal basis of the arts with the question of precisely how the various arts imitate.

Twining answers the question in regard to poetry and music (1) by defining the conditions necessary for any kind of artistic imitation and (2) by analyzing the various aspects of poetic and musical works which determine distinct types of imitation. His "essential conditions" of imitation allow for differences resulting from media and for a wide range of possible effects within a given medium, and discriminate artistic from natural imitation. The possible types of imitation outlined derive from Twining's inductive grasp of the constitutive principles and

materials of poetry and music. Resemblance is common to all imitation; for artistic imitation, the resemblance must be immediate and obvious (in the materials of the work and recognizable).

Twining defines four types of poetic imitation—sonorous, descriptive, fictive, and personative. In all four, effects can be analyzed in imitative terms, although only the last is strictly and properly imitative.

A musical composition, on the other hand, may produce one of three possible effects; it may delight the senses, raise ideas, or raise emotions. To be imitative, music must be expressive (that is, it must appeal to the mind); hence the first effect is not imitative. Music raises ideas imitatively by representing natural sounds and motions through musical sounds and motions, but such effects are not obvious. It also raises ideas nonimitatively through association and indirectly through emotions raised immediately. The third power (raising emotions) is the most important and is that which earlier theorists call expressive. Twining argues that such effects can properly be termed imitative; the resemblance may be obvious (by imitating the *effects* of words which the mind intuits to be similar to the effects of psychological states) and immediate (by shaping the properties of music to approximate those of speech). The greatest contribution of Twining's essay on music is his recognition that if the same concepts are used to define all the arts, their meanings must be carefully defined in accordance with the means, ends, and objects of each art.

Smith, like Twining, attempts to define the senses in which the arts (in this case, sculpture, painting, dancing, and music) can appropriately be called imitative. He also recognizes that differences in media lead to differences in analytical principles, determine the scope of subject matter imitated, and present unique problems in representing common subjects. An important difference between their theories involves the kinds of basic questions asked. Twining confines his dissertations to defining and discriminating the imitative natures of poetry and music; he *indicates* the kinds of effects possible, but is not centrally concerned with explaining why the arts please. Smith is more fundamentally interested in explanations of pleasure; universal causes are derived from an analysis of man's natural responses to artistic phenomena of any kind. When those causes are combined with a consideration of the media of each art, the resulting principles serve to explain the degrees and kinds of pleasure possible.

Imitation implies resemblance, but the most exact resemblance in art does not produce aesthetic pleasure. The basic principle underlying Smith's explanation of pleasure in the imitative arts is that the greater

the disparity between imitating and imitated object, the greater the pleasure (assuming, of course, a recognizable resemblance). The disparity between a two-dimensional canvas and its object is greater than that between a statue and its object; consequently, some subjects which naturally please in painting do not in sculpture. Both arts are imitative in presenting objects which do not naturally resemble one another, and they do so without deceiving the audience into mistaking art for nature. Hence Smith's primary task in explaining the highest pleasure in the two arts becomes that of determining the categories in which resemblance and disparity successfully coincide.

Smith's greatest achievement is his conception of the essential differences in nature of instrumental and vocal music. By examining their means, objects, and ends, he recognizes that principles used to explain the effects of instrumental music must be fundamentally unlike those applied to vocal music or the other arts. However much theorists in the period differ in defining *imitation*, most agree that the important effects of instrumental music are not, in any sense of the term, imitative. If the end of instrumental music is regarded as affective expression of some sort, the explanation of such effects usually depends on the assumption of a special relationship between certain musical sounds and specific passions. But if the subject matter of instrumental music is passion, it cannot be defined in the same manner, or as clearly in individual compositions, as the subject matters of other arts. Moreover, such music does not have "meaning" in the sense that pictorial and verbal arts do. Of the various arts analyzed comparatively, instrumental music is the most troublesome; discussions of music often concentrate on vocal music since it more clearly parallels poetry.

Smith attempts to define instrumental music's "meaning" and subject matter and to explain its effects through principles which isolate its unique properties, rather than by borrowing principles from analyses of other arts and applying them analogically to music. For Smith, vocal music is essentially imitative; things (song and discourse) which do not naturally resemble each other do so through art. Like sculpture and painting, its subject is external to its media. Instrumental music differs fundamentally; its subject inheres in the materials of composition, referring to no corresponding objects or actions in nature. It cannot therefore be evaluated as imitative. Its subject is a certain combination of notes, significantly related and ordered. Such compositions may approximate states of mind, but provide pleasure without suggesting any other object. This pleasure is intellectual rather than sensual, and its meaning complete in itself. Hence its "expression" (emotional content)

is in no way analogous to that of such arts as painting. In painting, expression depends on moral judgments concerning the actions or characters represented; in instrumental music, the sources of expression, melody and harmony, signify nothing beyond themselves and thus do not allow moral judgment. The distinction is significant for comparative discussions because it necessitates differences in the conceptual terms through which effects are evaluated. If expression can be discussed as a distinct category apart from the materials of the other arts, it cannot be in instrumental music, since it follows automatically from melody and harmony.

The issues raised by Smith's essay are of considerable importance because they involve questions about the source of first principles for evaluating the arts. And it is impossible to see that significance unless the essay is first regarded as a systematic solution to specific problems conceived and analyzed in a particular manner, rather than as a collection of discrete opinions or as another manifestation of the "neoclassical" desire for perfect harmony in all spheres of the universe.

Comparative discussions of the arts, along with aesthetic speculation in general, gradually increased in popularity during the eighteenth century in Britain. In terms of total numbers of works produced, this branch of aesthetics achieved its most rapid growth between 1760 and 1790, which saw the proliferation of essays, letters, and popular periodical essays dealing with comparisons among the arts, written by men from many different walks of life. The second half of the century also saw the rise to popularity of an important kind of adaptation of comparative discussions—the combination of comparisons with scholarly histories of the arts. Brown's *Dissertation*, Robertson's *Inquiry*, and Bromley's *History* illustrate the various ways in which "philosophical criticism" and art history were combined in the eighteenth century. These hybrid works and the many late-century minor comparative discussions manifest a diversity and speculative contentiousness probably unforeseen by Dryden when he at the end of his "Parallel" a century earlier invited others "to add more" to his comparisons of the arts.

Another change in the course of the century, which might also have surprised Dryden, was a gradual shift of emphasis in the relative importance of painting and music in comparative discussions. During the first third of the century, comparative discussions addressed similarities and differences between painting and poetry; in the years following Jacob's inclusion of music (1734), music played an increasingly prominent role in these works. By the last quarter of the century,

comparative discussions tended to focus on poetry and music, some-
times to the exclusion of painting. This change in subject matter is not
surprising, given the shifts of emphasis in principles and methods in the
eighteenth century, and the conceptions of the ends and subject matter
of painting which obtained throughout the period. Painting was to
strive for more or less accurate representation of visual particulars; no
one argued that the province of painting (or sculpture) might include
anything other than natural concretes, even though certain of the
decorative arts flourished, during the eighteenth century and before,
without directly imitating such particulars. Comparisons with poetry
were therefore limited, insofar as poetry's subject matter clearly
included more than natural concretes. The increasing interest in causal
forms of theory, when combined with the rise of qualitative criticism,
undoubtedly contributed to the increasing prominence of music in these
works. Music's affective powers were universally recognized, and it was
seen that some of the effects of poetry and music are similar and might
be explained in terms of the same or related psychological principles.
The fact that music proved the most troublesome of the arts in
comparative discussions undoubtedly contributed to the frequency of
music's inclusion late in the century, disagreement promoting continued
debate. There is a sense of finality in the comparisons of the imitative
nature of painting and the "pictorial" aspects of poetry which is absent
in the discussions of poetry and music; similarities of subject matter in
music and poetry were less clear, and explanations of analogous effects
more difficult and necessarily more tentative, given the embryonic state
of psychological speculation. But regardless of differences of emphasis
in specific theories, poetry, painting, and music were the dominant arts
in these discussions. Sculpture, when included, was frequently discussed
in the same terms as painting, very few comparative theorists were
concerned with architecture, and almost no one with gardening.[1]

I have indicated in this review that the history of the century's
comparative discussions is characterized by considerable variety in the
kinds of questions asked, critical principles invoked, and reasoning
methods employed. This variety can easily be and has often been
overlooked if one concentrates attention on the commonplace terms
and distinctions characteristic of "neoclassicism" without recognizing
the different uses (and hence significations) of such concepts and
devices in individual theories. The period is one of vitality and change
rather than stasis; within the continuum of critical language, there are
several important general shifts involving the source of primary
principles, the elevation of the artist to a more prominent position, and

a generalizing of the audience. The works included in this study constitute the major effort of eighteenth-century British authors to discover universal bases of the arts. They vary considerably in intrinsic merit, ranging from what now may be regarded chiefly as historical curiosities (the essays of Lamotte and Jacob, for instance) to works of considerable absolute worth (notably, those of Harris, Twining, and Smith). But if it is unreasonable to claim that all, or even most, of these theorists are major ones in the history of aesthetics, there is something to be learned from studying all of them. As long as men remain interested in the problems of reasoned discourse, there is value in seeing precisely how the problems within this branch of aesthetics were conceived and solved by men of varying ability and serious intellectual intentions in a previous century.

Notes

Introduction

[1] Theories, that is, could be either "technical" or "qualitative." For discussions of the history of neoclassical criticism and technical and qualitative criticism, see R. S. Crane, "English Neoclassical Criticism: An Outline Sketch," *Critics and Criticism*, ed. R. S. Crane (Chicago: Univ. of Chicago Press, 1952), pp. 373–88, and his "On Writing the History of Criticism in England, 1650–1800," *The Idea of the Humanities* (Chicago: Univ. of Chicago Press, 1967), 2: 157–75; rpt. from *UTQ* 22 (July 1953): 376–91; see also R[obert] M[arsh], "Neoclassical Poetics," *Encyclopedia of Poetry and Poetics* (Princeton: Princeton Univ. Press, 1965), pp. 559–64. Technical criticism focuses on questions of artistry or construction relating to preestablished species; qualitative criticism is concerned more with those effects or qualities which distinguish individual works or artists from others or are possible in all arts or all species of a given art.

[2] For an example of the consequences which ensue when theories are reduced to statement and then forced to conform to a single meaning, see William K. Wimsatt, Jr., and Cleanth Brooks, *Literary Criticism: A Short History* (New York: Knopf, 1957), esp. pp. 271–75. One conclusion Wimsatt draws is that painting became the "technical norm" of poetry. Apparently one is asked to believe that all or most theorists comprising the "neo-classical mind" shared the assumptions that poetry should strive for the sensory (visual) impressions of painting (*ut pictura poesis* in its most restrictive sense) and that the arts attempt a "direct imitation of nature." Neither assumption is valid; the meaning of *ut pictura poesis* and the usefulness of imitation (with all its various meanings) as a critical term for discussing the arts were topics of considerable controversy in the eighteenth century. The mere fact that there was controversy (aside from the fact that *various* conclusions resulted) indicates that that cabalistic being, the "neo-classical mind," was indecisive.

There are equally odd conclusions about eighteenth-century theorists' comparisons of poetry with music: "Comparative theorists of the day considered poetry to be the highest art, because it could say things. Painting was second. Music, third. . . . The norm of imitation was . . . preferred to norms of sensory pleasure, of the geometric or formal, or even of direct emotive expression" (p. 275). It is not clear which eighteenth-century theory of imitation is viewed as the "norm of imitation" which is opposed and preferred to "emotive expression." Many eighteenth-century theorists did argue that poetry is more effective as an imitative medium than instrumental music, but that does not imply that music cannot "say things." The affective qualities of music were universally recognized; their bases were to be sought in causes for which *some* theories of imitation seemed inadequate.

[3] "On Writing the History of Criticism," p. 164.

[4] In John W. Draper, "Aristotelian 'Mimesis' in Eighteenth Century England,"

PMLA 36 (Sept. 1921), for example, Sir William Jones and James Harris are lumped together because they do not consider music "imitative." Such a comparison is of little use. The methods employed by Jones and Harris are quite different, nor were they addressing the same problem. Jones is concerned with investigating the universal principles through which art achieves its effects in the minds of men, and defines imitation in a manner which allows him to argue that none of the arts is imitative; Harris distinguishes the various arts in terms of different media and argues that although music may be imitative, it achieves its greatest effects from other sources.

[5] For discussions of the shortcomings of this type of intellectual history, see Crane, "On Writing the History of Criticism"; Marsh, "The 'Fallacy' of Universal Intention," *MP* 55 (May 1958): 263–75, and his *Four Dialectical Theories of Poetry: An Aspect of Neoclassical Criticism* (Chicago: Univ. of Chicago Press, 1965), chap. 1; and Walter J. Hipple, Jr., *The Beautiful, the Sublime, and the Picturesque in Eighteenth-Century British Aesthetic Theory* (Carbondale: Southern Illinois Univ. Press, 1957), pp. 4–6.

[6] For examples of works of this type, see J. W. H. Atkins, *English Literary Criticism: 17th and 18th Centuries* (London: Methuen, 1951); Wimsatt and Brooks, *Literary Criticism*; and Aiso Bosker, *Literary Criticism in the Age of Johnson* (Groningen: Wolters, 1930). For reviews of Atkins and Wimsatt, see Crane, "On Writing the History of Criticism," and Marsh, "The 'Fallacy' of Universal Intention," respectively.

Bosker, viewing eighteenth-century criticism as a struggle between "believers in the doctrine of reason" and those who revolted against it (contraries which he also terms "neoclassical" and "romantic"), classifies Thomas Twining as a member of the latter group, one who was "obviously a critic with romantic leanings" (p. 233), was influenced by Bishop Hurd, and "waives all belief in authority" (p. 234) because Twining states that "the time is come when we no longer read the antients with our judgments shackled" with admiration. Having decided that Twining was "in revolt against reason" and failing to ask the basic question of what Twining's primary task is in his two dissertations, Bosker misinterprets him. We do not read the ancients with determined admiration, Twining argues, precisely because we have misread them, and his task is to try to correct some of those misreadings, including those of men like Hurd, who extended the concept of artistic imitation to the point of meaninglessness.

[7] The inclusion of Charles Avison's *An Essay on Musical Expression* is an obvious exception, but this work cannot be ignored because its influence on later comparative discussions of the arts can scarcely be overestimated.

[8] See, for example, Atkins, *English Literary Criticism*, p. 345: "Beyond thus discriminating between the functions of the arts—description being that of painting, action that of poetry—English critics did not go. It was left for Lessing to point to the significance of the facts, namely that the difference of function was necessarily determined by the difference of medium." James Harris, Adam Smith, and Thomas Twining, among others, went "beyond discriminating the functions of the arts" and were certainly aware of the "significance of the facts" Atkins refers to.

[9] In referring to forms of theory, the terms *rhetorical* and *causal* are used in the sense outlined by Marsh, *Four Dialectical Theories*. In rhetorical theories (like that of Dryden), principles and areas of interest derive from Roman and Greek rhetorical treatises and from literary studies which treat artistic works in terms of problems of "producing and controlling (by 'art' and 'nature') the kinds and qualities of subject matter, arrangement, and style determined a priori to be necessary or appropriate to the audience or the established norms of the art." Species, deduced from considerations of the audience's special demands and the artist's unique gifts and education, are seen as

conventional modes of producing predetermined effects. Works are treated not as ends, but as means of "achieving special socially determined ends" (pp. 6–7).

In "causal" theories (such as those of Beattie and Webb), the primary problem is how artistic effects and qualities can be explained in terms of natural causes, rather than how they can best be achieved in preestablished forms. Principles for such explanations derive from prior analyses of psychology and natural human behavior.

Marsh identifies two additional forms of theory: "dialectical," in which poetry is discussed as the "apprehension, expression, or creation of some kind of supreme or transcendent reality and order," and "problematic," in which the major concern is distinguishing, "inductively and in literal terms, the special problems of human art, or 'making,' in its various kinds from those of social action and scientific or philosophical knowledge, and [isolating] the different principles governing the performance of basic kinds of literary tasks."

Chapter 1

¹ In addition to his preface and the prose translation of Dufresnoy, Dryden published Roger de Piles's notes (1668), "Observations on 'The Art of Painting' of Charles Alphonse Dufresnoy," translated from French into English. De Piles, a friend of Dufresnoy, translated Dufresnoy's poem into French after the author's death, adding extensive notes which "are wholly conformable to his opinions" and of which Dufresnoy "would not have disapproved" (*The Works of John Dryden*, ed. Sir Walter Scott [London, 1808], 17: 336).

² Lawrence Lipking, *The Ordering of the Arts in Eighteenth-Century England* (Princeton: Princeton Univ. Press, 1970), p. 39.

³ See Władysław Folkierski, "*Ut pictura poesis* ou l'etrange fortune du *De arte graphica* de Du Fresnoy en Angleterre," *Revue de litterature comparee* 27 (Oct.–Dec. 1953): 385–402, and William K. Wimsatt, Jr., "Samuel Johnson and Dryden's *Du Fresnoy*," *SP* 48 (Jan. 1951): 26–39. Pope composed a poem, "To Mr. Jervas, with Fresnoy's Art of Painting," which he sent to his painter friend with a copy of Dryden's translation.

⁴ *Essays of John Dryden*, ed. W. P. Ker (Oxford: Oxford Univ. Press, 1926), 2: 115. All citations from the "Parallel" are from this edition and will hereafter be noted in the text by volume and page numbers.

⁵ Perhaps it is more accurate to say "on Dufresnoy's poem as seen through de Piles" because Dryden leans heavily on de Piles's commentary. Lipking mentions that Dryden "has translated de Piles rather than Du Fresnoy" (*Ordering of the Arts*, p. 47).

⁶ There are many treatises on the art of painting preceding and contemporary with Dufresnoy's poem. For a brief account of some of the "antecedents" of *De arte graphica*, see William Guild Howard, "Ut Pictura Poesis," *PMLA* 17 (1909): 40–123, esp. his comparison of Dufresnoy with Marco Girolamo Vida and Lodovico Dolce. For a history of the changing fortune of Horace's phrase, *ut pictura poesis*, in criticism from antiquity through the eighteenth century, see Jean Hagstrum, *The Sister Arts* (Chicago: Univ. of Chicago Press, 1958).

⁷ Dryden's translation, "The Art of Painting," *The Works of John Dryden*, 17: 341. All citations from Dryden's translation of Dufresnoy are from the Scott edition and will hereafter be noted in the text by volume and page numbers.

⁸ *Ars poetica* 361, in *Satires, Epistles and Ars poetica*, trans. H. Rushton Fairclough,

Loeb Classical Library, 1st ed., rev. (London: Heinemann, 1929). Horace uses the phrase simply as an illustration: some poems please only once, while others can bear repeated readings. Similarly, some paintings are most impressive at close range while others need full light.

9 Attributed to him by Plutarch *Moralia* 346 f.

10 Bellori's concept of ideal form is not strictly Platonic, however. It is combined with concepts similar to those of Cicero, Seneca, Leon Battista Alberti, Raphael, and others. Ideas of beauty can be deduced by studying and synthesizing the scattered beauties of nature (as in the tale of Zeuxis); sensory experience, that is, may form the basis of art.

11 Hagstrum, *The Sister Arts*, pp. 184–85, asks, "Is Bellori's Neoplatonism adopted by Dryden? It seems not. . . . Dryden seems to accept the doctrine of ideal form but is made uncomfortable when it appears in the dress of Platonic or Plotinian metaphysics. He was too skeptical to see much of an analogy between the artistic process and the creation of the cosmos, between artistic and religious inspiration. A conception of ideal form he most certainly possessed; but he derived it, like Cicero, Seneca, and the Italian humanists, from the generalizing mind operating upon empirical reality." It is true that Dryden does not draw an analogy between the artistic process and the creative act of God, but our preceding discussion of Bellori indicates that his neo-Platonism is tempered by the concept of ideal form resulting from the synthesis of particular natural beauties. There is no fundamental quarrel between a concept of ideal form derived from Cicero and Seneca and Bellori's conclusion that painters choose "the most elegant natural beauties, perfectionate ['generalize' would have the same meaning] the idea" (2: 122), and thereby elevate art above the individual productions of nature. Certainly Dryden does not reject the concept of ideal nature, but he introduces Bellori's concept in order to show that the idea of perfect nature has critical value only in relation to some literary genres and cannot be made the basis for rules of imitation in all.

12 This idea is implicit in Philostratus's comparison between poetry and painting in the passage Dryden translates early in his essay.

13 Hagstrum, *The Sister Arts*, p. 176, rightly notes that Dryden thus "gives dogmatic and not very persuasive expression to an idea only implicit in the writing of Horace." Dryden quotes Horace's phrase, *operum colores*, to equate color and verbal expression. Horace, however, is not establishing a parallel between the formal components of the arts. The phrase occurs in the context of Horace's argument that some styles are appropriate to certain themes and not to others. "If I fail to keep and do not understand these well-marked shifts and shades of poetic forms, why am I hailed as poet?" (*Ars poetica* 86–87).

14 Later eighteenth-century theorists use *expression* in quite different and less restricted senses, often as a quality inherent in what Dryden terms *invention*.

15 Besides Dryden, Lamotte mentions Junius, Félibien, Roger de Piles, and "Mr. D. B." (Jean Baptiste Du Bos).

16 *An Essay upon Poetry and Painting* (London, 1730), p. 14. All citations from this work are from the first edition and will hereafter be noted in the text by page number.

17 See Richard McKeon, "Literary Criticism and the Concept of Imitation in Antiquity," *Critics and Criticism*, ed. R. S. Crane (Chicago: Univ. of Chicago Press, 1952), pp. 147–75, esp. pp. 171–74; rpt. with minor alterations from *MP* 34 (Aug. 1936): 1–35.

18 This argument is found in Du Bos's *Critical Reflections on Poetry, Painting, and Music*, trans. Thomas Nugent (London, 1748), 1: 69. Du Bos's work first appeared eleven years before Lamotte's *Essay*.

[19] The other two "accidental" advantages of poetry are (1) that the glory of the poet is more lasting since literary works can be printed in quantity and are not liable to the accidents that can destroy paintings and (2) that poets have ancient models to follow, but painters do not (pp. 32–35).

[20] Dryden observes that painting can show in one moment that which takes much longer to depict in poetry (2: 131); Du Bos analyzes the effect in terms of natural causes (1: 322–23). Lamotte quotes Richardson, agreeing that painting "pours" ideas into the mind, while poetry "drops" them successively (*Essay on the Theory of Painting*, p. 6). Painting is quicker in effects and more extensive since its language is universal; moreover, appreciation of a poem written in one's own tongue requires greater prior knowledge than is necessary to apprehend the beauty of a painting (pp. 37–38).

Chapter 2

[1] First published in *Three Treatises* (London, 1744). All citations from the first treatise, "Concerning Art, a Dialogue," and from the second, "A Discourse on Music, Painting and Poetry," are from the first edition and will hereafter be noted in the text by page number.

[2] For a discussion of Harris's dialectical method, see Marsh, *Four Dialectical Theories of Poetry*, chap. 5.

[3] Marsh, *Four Dialectical Theories of Poetry*, p. 160, rightly notes that Harris's use of "energies," rather than a term like *activities*, is confusing because it suggests "efficient power."

[4] *Critical Responsiveness: A Study of the Psychological Current in Later Eighteenth-Century Criticism*, Univ. of California Publications in English 20 (Berkeley: Univ. of California Press, 1949): 56. If Harris's phraseology suggests that of the *Poetics*, his meaning does not.

[5] *English Literary Criticism*, p. 345. Eighteenth-century British theorists are not guilty of the simple-minded partitioning of functions here attributed to them. There is no universally held doctrine that argues that painting is limited to description and poetry to action. Dryden, Lamotte, and Harris, for example, discuss *actions* that are appropriate subjects for painting, and the numerous writers who are in some way concerned with *ut pictura poesis* are certainly interested in "descriptive" poetry.

[6] Moreover, John Miller's four-volume 1761 translation of Batteux's *Cours de belle lettres, ou principes de la littérature*, which incorporates *Les Beaux Arts*, claims to be the first English version of Batteux.

[7] There is additional irony in the Dedication in that the physician to whom it is addressed, William Chesselden, gained notoriety by publishing a *Treatise on the High Operation for the Stone* (1723), which was attacked for plagiarizing the work of John Douglas, a rival surgeon and teacher.

[8] There are two nearly identical editions (1746 and 1747) of *Les Beaux Arts* antedating the publication of *The Polite Arts*, which follows the 1746 edition. For a detailed list of the author/translator's borrowings from, additions to, and substitutions for material in *Les Beaux Arts*, see my article, "Literary Thievery: *The Polite Arts* and Batteux's *Les Beaux Arts réduits à un même principe*" (July 1974).

[9] There is not sufficient evidence to determine conclusively the identity of the author/translator of *The Polite Arts*; for a discussion of two possible candidates, see my "Literary Thievery."

[10] " 'Imitation' and 'Expression' in British Music Criticism in the Eighteenth Century," *Musical Quarterly* 34 (Oct. 1948): 545.

[11] Schueller, " 'Imitation' and 'Expression,' " pp. 545 and 557, for example, compares their statements that the arts are imitative and Harris's comment that music best imitates sounds of grief or anguish with the anonymous author's remark that music can imitate by inarticulate sounds and that music without words expresses complaint or joy. That Batteux's *Les Beaux Arts* and Harris's *Three Treatises* invite comparison was recognized two centuries ago by publishers of Batteux's work. The first volume of a four-volume edition of *Principe de littérature* (Götingue and Leide, 1755) contains " 'Les beaux arts réduits à un même principe' avec deux petits traités, l'un sur l'art, et l'autre sur la musique, la pienture et la poesie." The two treatises are translations of the first two of Harris's *Three Treatises*.

All citations from *The Polite Arts* are from the first edition and will be noted in the text by page number.

[12] *Enthusiasm* simply refers to the artist's heightened ability to form ideas of perfect nature from scattered beauties and to present them forcibly. It does not imply that artistic subject matter can be found in anything other than nature as experienced by the senses.

[13] Three chapters (7, 23, and 24) are devoted to the arts of eloquence and architecture; the first is a translation from Batteux, whereas the last two are apparently original. Consideration of these arts is largely irrelevant for the principal problems to which *The Polite Arts* is addressed because their origins are in usefulness rather than pleasure, but the analysis of the two in chapter 7 (and the brief mention of the two in chapter 2) are of interest as a means of illustrating the peculiar qualities of the "polite" arts. His contention is that eloquence and architecture were originally produced by necessity, but perfected by taste. They thus occupy a middle ground between the polite arts, which are solely designed for pleasure and justified by taste, and the "mechanic arts," which relate only to necessity. Eloquence and architecture differ essentially from the polite arts in that the latter *imitate* nature whereas the former *employ* nature, and they are distinct from the mechanic arts because they also "polish" nature for social pleasure while the mechanic arts employ nature "as she is" (pp. 5–7).

The fundamental rule applying to eloquence and architecture is that since they are designed primarily for use, those elements in them which function principally to elicit pleasure ought to be given the "Character of Necessity itself." As painting cannot plead its precise likeness to an original in nature as a justification for the failure to elicit pleasure, architecture cannot use ornamental beauty as an excuse for a building which has no use. Furthermore, the ornamental beauties of eloquence and architecture are to be proportioned to their social use (the edifice of a king may be more ornamental than that of a common man). Since eloquence is intended to communicate, its realm is not the probable but the true. Prose and eloquence are interchangeable terms, differing from poetry in the following manner: "Poetry is an Imitation of beautiful Nature expressed by Discourse in Measure: and Prose or Eloquence, is Nature itself expressed by free Discourse." The poet expresses the probable agreeably; the orator tells the truth persuasively. "Poetical Fictions," such as romances and "Didactick or Instructive kinds of Poetry," violate the author's definitions and are regarded as "Caprices made on purpose to be out of Rule" (pp. 33–40).

The last two chapters of *The Polite Arts* (pp. 133–60) present various rules concerning the proper use of eloquence and architecture, the relation between use and ornament, and the training and necessary qualities of the orator and architect. Although

these rules appear to be the author's (rather than Batteux's), they derive from Batteux's definitions of the two arts. They are presented rather perfunctorily and are of little interest here because they are not significantly related to the work's pictorial, musical, and poetic theories.

[14] The distinction is substantially the same as Harris's concept of ideas and affections. The notion that tones are consecrated to sentiments in a "special manner" is also similar to Harris's assertion that sounds are directly related to the various affections. Nor is there any fundamental disagreement between the two authors in regard to the source of pleasure in music; both argue that music derives its efficacy from raising "affections" or "sentiments."

[15] (London, 1752). All citations, noted in the text by page number, are from the third edition (London, 1775), which, like the second edition (London, 1753), contains John Jortin's "A Letter to the Author, Concerning the Music of the Ancients" and Avison's "A Reply to the Author of Remarks on the Essay on Musical Expression," written in answer to William Hayes's attack on the *Essay*.

[16] "Correspondences Between Music and the Sister Arts, According to 18th Century Aesthetic Theory," *JAAC* 11 (June 1953): 337.

[17] See, for example, Schueller, "The Use and Decorum of Music as Described in British Literature, 1700–1780," *JHI* 13 (Jan. 1952): 73–93; and Lipking, *The Ordering of the Arts*, chap. 8.

[18] "A Reply to the Author of Remarks on the Essay on Musical Expression," *Essay*, p. 176.

[19] For a discussion of British music criticism prior to Avison, see Lipking, *The Ordering of the Arts*, chap. 8.

[20] Avison also argues that although musical force may mislead or induce excessive passion, musical sound is so constituted that the passions which it can evoke are limited to those which are generically benevolent or social. He says that the mind is susceptible of agreeable passions while listening to music because melody and harmony naturally induce pleasure, but painful, malevolent passions cannot be evoked by music. This argument appears to be original with him and was frequently debated by later aestheticians.

[21] Avison acknowledges his debt to Harris in discussing musical imitation, and, like Harris, confines his analysis to the mimetic power of music when joined with poetry. He accepts all of Harris's principal conclusions (there is a minor disagreement about whether music is better suited to imitate sounds or motions); one questions how flattering to Harris Avison's wholesale acceptance of his arguments is because Avison's application of Harris's conclusions does not incorporate the incisiveness of Harris's "Discourse." Avison simply lacks Harris's analytic talent.

Chapter 3

[1] In " 'Imitation' and 'Expression,' " p. 561, Schueller states that "Beattie and Daniel Webb in the 18th century indicated that music expresses . . . passions through motion by calling up associations." This is true of Beattie, but not of Webb; the distinction between Webb's physiological "motions" and Beattie's mental associations is important because their definitions of the mechanism connecting causes with effects influence the kind of aesthetic theory each man produces.

[2] Beattie, a Scotsman, was professor of moral philosophy and logic at Marischal College, Aberdeen, and a friend of Gerard and Campbell. The *Essay on Truth* attacks Hume's "sceptical and atheistical doctrines" (preface to 1776 ed., p. xii).

³ Advertisement, 1776 edition. All citations from *An Essay on Poetry and Music* are from the first edition and will hereafter be noted in the text by page number.

⁴ For general background discussions of sympathy in eighteenth-century critical theory, see Walter J. Bate, "The Sympathetic Imagination in Eighteenth-Century English Criticism," *ELH* 12 (June 1945): 144–64; and Walter J. Ong, "Psyche and the Geometers: Aspects of the Associationist Critical Theory," *MP* 48 (Aug. 1951): 16–27.

⁵ Beattie footnotes this idea to Adam Smith, *The Theory of Moral Sentiments* (London, 1759). Beattie's discussion of sympathy is largely unoriginal; it is likely that Smith's essay is the source of many of Beattie's ideas, particularly his concept of sympathy as an active moral force. Scott Elledge, *Eighteenth-Century Critical Essays* (Ithaca: Cornell Univ. Press, 1961), 2: 1179, suggests that the most notable part of Beattie's chapter is his conclusion that poets ought principally to raise emotions which strengthen the mind, thereby inducing moral virtue.

⁶ *Dissertations Moral and Critical* (Dublin, 1783), 1: 89–90. All citations are from this edition and will hereafter be noted in the text by volume and page numbers.

⁷ Beattie uses the example of the enduring popularity of Homer's art as a justification for basing rules on a "philosophical" investigation of human nature, particularly on the various assumptions he makes about the connections between aesthetic emotions and pleasing moral instruction. Hector and Achilles have been admired as patterns of "heroic excellence and virtue" for thousands of years, which proves that "the faculties whereby we distinguish truth and virtue are . . . really parts of our original nature, and . . . little obnoxious to caprice of fashion" (pp. 411–12).

⁸ "Fancy" and "imagination" are here used synonymously by Beattie. See his *Dissertations Moral and Critical,* 1: 87.

⁹ "*Ut Musica Poesis:* The Parallel of Music and Poetry in Eighteenth Century Criticism," (Ph.D. diss., Princeton University, 1945), pp. 91 and 93.

¹⁰ Beattie inserts a long discussion of the causes of pleasure in witnessing painful events in "tragical imitations." Although he does not footnote Du Bos, Fontenelle, or any other sources, none of Beattie's explanations is original. Despite his dislike of Hume, he is apparently willing to incorporate ideas from "Of Tragedy" to further his own arguments.

¹¹ "On the Arts Commonly Called Imitative," *Poems, Consisting Chiefly of Translations from the Asiatick Languages* (Oxford, 1772), p. 202. All citations are from the first edition and will hereafter be noted in the text by page number.

¹² Draper, "Aristotelian 'Mimesis' in Eighteenth Century England," p. 392, states that "Sir William Jones, also, could find no 'imitation' in music; but his *Treatise of the Art of Music* seems to allow imitation." Sir William Jones, however, is firm in denying the pleasurable value of imitation in music. The Sir William Jones who wrote "On the Arts Commonly Called Imitative" and the William Jones of Nayland who wrote *A Treatise on the Art of Music* are two different men. See Draper's own bibliography, *Eighteenth Century English Aesthetics: A Bibliography* (Heidelberg: Carl Winters Universitätsbuchhandlung, 1931).

¹³ (London, 1769). All citations are from the first edition and will hereafter be noted in the text by page number. Webb's *Observations* enjoyed considerable popularity both in England and on the Continent, particularly in Germany, during the eighteenth century. A German translation by J. J. Eochenburg was published in 1771 at Leipzig.

¹⁴ No eighteenth-century theorist, including Webb, traces aesthetic effects entirely to physiological causes, although such causes occupy significant positions in the works of other theorists in the period, including Burke, Sir Uvedale Price, and Richard Payne Knight. In analyzing aesthetic sentiments, Burke is perhaps the only eighteenth-century

theorist who assigns to physiological mechanisms as important a role as Webb. For analyses of the contributions of Burke, Price, and Knight to British aesthetics, see Hipple, *The Beautiful, the Sublime, and the Picturesque.*

[15] These four classes are repeated from Webb's *Remarks on the Beauties of Poetry* (London, 1762). In his *Observations,* Webb cites Quintilian, Cicero, Aristotle, and Athanasius Kircher as sources (there are other, less important ones), but perhaps his favorite "sources" are his own essays, the *Remarks* and *Inquiry into the Beauties of Painting* (London, 1760).

[16] Webb uses his classification of the passions which are and are not possible subjects for musical expression as the foundation for his contribution to the common eighteenth-century concern with finding an explanation of the educative and moral value of music. If musical movements can have no connection with passions which are painful by nature or through excess, and if they continually oppose disruptive impressions, Webb concludes that they were intended to improve man's moral sense.

The interest of many eighteenth-century critics (from Harris and Avison through Jones, Beattie, and Twining) in the unique "natural relation" between music and moral character probably results from the need they felt to try to account for the statements of philosophers, particularly in Plato's *Republic* and Aristotle's *Politics,* assigning various significant educative worth to the different modes of Greek music.

[17] In offering his explanation, Webb refers to Rousseau's article on "imitation" in the *Dictionnaire de musique* (Paris, 1768); his solution is essentially the same as Rousseau's statement that "l'art du musicien consiste à substituer à l'image insensible de l'object celle des mouvemens que sa présence excite dans le coeur du contemplateur. . . . Il ne représentera pas directement ces choses, mais il excitera dans l'ame les mèmes mouvemens quo'on éprouve en les voyant." Cf. Webb's statement that "To paint by movements would be enchantment indeed; but the wonder ceases when we are made to understand, that music hath no other means of representing a visible object, than by producing in the soul the same movements which we should naturally feel were that object present" (pp. 34–35).

Chapter 4

[1] Unlike many of the "literary men" who attempt comparative discussions of the arts, Twining is eminently qualified as a music critic. After mentioning Twining's "intelligence, taste, and erudition," eighteenth-century Britain's foremost music historian, Charles Burney, in his *General History of Music from the Earliest Ages to the Present Period,* 1 (London, 1776): 19, praises Twining as "a gentleman whose least merit is being perfectly acquainted with every branch of theoretical and practical music."

[2] Twining to Burney (Oct. 19, 1786), *Recreations and Studies of a Country Clergyman of the Eighteenth Century,* ed. Richard Twining (London, 1882), p. 140.

[3] *Aristotle's Treatise on Poetry, Translated; with Notes on the Translation, and on the Original; and Two Dissertations, on Poetical, and Musical, Imitation* (London, 1789), p. xii. All citations are from the first edition and will hereafter be noted in the text by page number.

[4] *Elements of Criticism* (Edinburgh, 1762), 2: 234.

[5] "A Discourse on Poetical Imitation," *Works* (London, 1811), 2: 111.

[6] See Crane, "English Neoclassical Criticism: An Outline Sketch," esp. p. 375.

[7] Hurd, for example, attempts to reconcile Aristotle with Horace and Cicero.

Differences between Aristotle and Plato are also frequently obscured; Beattie and Kames, among many others, treat Aristotelian "plot" as if it were identical with the Roman "fabula."

8 See Elder Olson's introduction to *Aristotle's "Poetics" and English Literature* (Chicago: Univ. of Chicago Press, 1965), p. 20. Henry James Pye calls the latter translation "as much beneath criticism as it is above comprehension." Twining comments, in his preface, that the English version of Dacier is "a mere translation of Dacier's translation, notes, and preface; though professing, in the title-page, to be translated from the original Greek, and accompanied, indeed, by some marginal *improvements* from the Greek text, most of which, if admitted into the version, would make it still worse than it is" (p. v).

9 See McKeon, "Literary Criticism and the Concept of Imitation in Antiquity."

10 "Aristotelian 'Mimesis' in Eighteenth Century England," p. 396.

Chapter 5

1 An appendix "Of the Affinity between Music, Dancing, and Poetry," is included. The editors of the first edition, Joseph Black and James Hutton, introduce it by saying that "the following Observations were found among Mr. Smith's Manuscripts, without any intimation whether they were intended as part of this, or of a different Essay" (p. 179). There is, however, a cross reference which indicates that the appendix was intended as a supplement to this essay. Mainly concerned with distinguishing dancing from ordinary steps and musical from natural sounds, the appendix, though of some intrinsic interest, is not directly involved in Smith's principal arguments.

2 "Of the Nature of That Imitation Which Takes Place in What Are Called the Imitative Arts," *Essays on Philosophical Subjects* (London, 1795), p. 133. All citations are from the first edition and will hereafter be noted in the text by page number.

Chapter 6

1 There were even a few poems, such as one by a "Mr. Nourse," entitled "Ut Pictura Poesis" (1741) in Robert Dodsley's *A Collection of Poems* (London, 1758), 5: 93–95, and William Cooke's "An Ode on Poetry, Painting and Sculpture" (London, 1754), concerned with comparisons among the arts. However, such works are panegyrics rather than contributions to aesthetic theory.

2 In a review of John W. Draper's *Eighteenth Century English Aesthetics; a Bibliography*, R. D. Havens (*MLN* 47 [Feb. 1932]: 118–20) suggests two additions to the comparative discussions listed by Draper: (1) Anonymous, *The Alliance of Musick, Poetry, and Oratory* (1789), and (2) D. Walcot, *Observations on the Correspondence between Poetry and Music* (1769). The latter is also listed by the *CBEL*. These appear to be mistaken "additions"; the former is probably Anselm Bayly's work, and the "D. W." who wrote the 1769 *Observations* is Daniel Webb, not "D. Walcot." Both Bayly and Webb are listed by Draper.

3 *Of the Sister Arts; an Essay* (London, 1734), p. 37. All citations are from the first edition. Jacob, an amateur poet and playwright, was the third baronet of Bromley, Kent. Not surprisingly, *Of the Sister Arts* takes the form of the dilettante's random reflections rather than the expert's systematic exposition of first principles.

[4] *The Alliance of Musick, Poetry and Oratory* (London, 1789), pp. 1–2. All citations are from the first edition. Only the chapter serving as an introduction to the section on music is of interest in the history of comparative discussions of the arts.

[5] Although published after the turn of the century, these four essays were written by men who were very much a part of eighteenth-century England's artistic and intellectual life (and whose major work was done then). Moreover, all four essays attempt to clarify, defend, or develop stands taken by earlier writers rather than to break with tradition. Hoare was a prolific playwright, painter, and disciple of Reynolds; Northcote was also a painter, author, and friend of Reynolds. Pye was poet laureate and a highly competent classical scholar.

[6] *Lay-Monastery*, no. 31 (Jan. 25, 1713), in *The Gleaner: A Series of Periodical Essays*, ed. Nathan Drake (London, 1811), 1: 32. All citations are from *The Gleaner*. Drake attributes nos. 31 and 32 of the *Lay-Monastery* to Blackmore; I know of no reason to doubt this attribution.

[7] Letter XXIV ("To Hortensia"), *Laelius and Hortensia; or, Thoughts on the Nature and Objects of Taste and Genius* (Edinburgh, 1782), pp. 224–33.

[8] *The Philanthrope*, no. 33 (1797), in *The Gleaner*, 1: 243–51.

[9] Letter VII, *Letters Concerning Taste . . . to Which are Added Essays on Similar and Other Subjects*, 3d ed. (London, 1757), pp. 41–48.

A similar argument is found in Stedman's Letter XXV ("To Laelius"), in *Laelius and Hortensia*, pp. 234–42, although Stedman is somewhat more inclined to recognize differences in media.

[10] "On the Independency of Painting on Poetry," in *The Artist*, no. 9 (May 9, 1807): 1. All citations are from this edition.

[11] Letter XVII, in *Thirty Letters on Various Subjects*, 2d ed. (London, 1784), 1: 118.

[12] In *The Artist*, no. 15, pt. 3 (June 20, 1807): 13–20. All citations are from this edition.

[13] In *The Artist*, no. 13 (June 6, 1807): 1–11. All citations are from this edition. "Views of the Liberal Arts" is a shortened form of the title.

[14] In *The Artist*, no. 18 (July 11, 1807): 1–12. All citations are from this edition.

[15] Hoare's essay, especially his discussion of the "abstraction of nature," is heavily indebted to Reynolds's *Discourses on Art*.

Chapter 7

[1] An additional work, John Robert Scott's *Dissertation on the Progress of the Fine Arts* (London, 1800), has something of the same interest as Brown's *Dissertation;* both men trace the progress of the arts from early stages of success to the less successful present, and make suggestions for restoring the arts' past grandeur, but Scott is less concerned with aesthetic questions relating to the interrelations of the arts.

[2] (London, 1763), 1st ed. All citations are from this edition. Brown's life was extremely varied. He was a minister, poet, playwright, educational projector (he proposed to the Russian empress a scheme for educating Russian youth), and committed suicide at age 51 after years of mental disorders. In 1761, Brown was presented the living of St. Nicholas in Newcastle, and became acquainted with its organist, Charles Avison. Brown is said to have helped Avison compose *An Essay on Musical Expression*.

[3] "Literature and Music as Sister Arts: An Aspect of Aesthetic Theory in Eighteenth-Century Britain," *PQ* 26 (July 1947): 201.

4 Brown adds that musical instruments naturally arose as imitations of the human voice or other natural sounds (pp. 27–28). Draper, "Aristotelian 'Mimesis' in Eighteenth Century England," p. 394, claims that Brown thus "tried to defend instrumental music." Although it might appear at this point that Brown is laying the groundwork for a defense of instrumental music, he is not. He admires the power of music most when it is joined with poetry because it is then a more effective means of instruction. Vocal music is of far greater importance to him than instrumental music; he finds the latter's chief value in its power to reenforce the instructional power of song and verse.

5 McKenzie, *Critical Responsiveness*, p. 38, comments: "But if the manners are very corrupt there will be a total separation between the bard and legislator. This is a very early suggestion of the thesis maintained so frequently in the present century that when artists feel a marked contradiction between their aims and the aims of the group politically and economically dominant, there will be either a retreat into art for art's sake or a literature of protest." This is not an accurate reading of Brown's argument. Brown says that the single complex character of the bard/artist separates; the result may be something that resembles art for art's sake, but it is perhaps better expressed as an art of appeasement or "art for the sake of unworthy applause." The source of difficulty is not the conflict between artists' aims and those of men who are politically or economically dominant; the artist corrupts his own art by prostituting its original ends. If society, having educated the artist, is indirectly responsible, the artist in Brown's account is not one who retreats to maintain the purity of his art. There is no indication that Brown's artist recognizes or cares about societal or artistic corruption, for he is corrupt in seeking the approval of a debased society; indeed, it is "the Man of Genius and Worth" who shuns the arts.

6 "Of Tragedy," *Four Dissertations* (London, 1757).

7 Such a suggestion is impractical because all societies automatically evolve beyond those conditions which give rise to and temporarily support the earliest forms and functions of art. Hence Brown seeks to restore only those artistic practices which he believes are compatible with the manners of any relatively complex society.

8 Robertson was a Scottish Presbyterian minister and member of the Royal Society of Edinburgh. In addition to the *Inquiry*, he published *The History of Mary Queen of Scots; Including an Examination of the Writings Which Were Ascribed to Her* (Edinburgh, 1793), and an essay on *Hamlet* in *Transactions of the Royal Society of Edinburgh* 2 (1788): 251.

9 Indeed, Robertson remarks: "How often have unthinking men talked of recalling Ancient Music, where Poetry was united to Song? . . . It belongs not to the new world: is perfectly heterogeneous to every thing modern" (*An Inquiry into the Fine Arts* [London, 1784], p. 446). All citations are from the first edition and will hereafter be noted in the text by page number.

Robertson rejects proposals such as Brown's not only because civilization has evolved but partially because he believes that the affective power of "unmeaningful" instrumental music has potential moral, religious, and social usefulness. Even though the modes of ancient music are more effectively designed for instructional purposes, and modern music is more frequently used for amusement than instruction, both may serve socially beneficial ends.

10 *Les Beaux Arts*, pp. 5–7.

11 *Das System der Künste* (Leipzig, 1885), p. 47.

12 All citations from *A Philosophical and Critical History of the Fine Arts* are from volume 1 (London, 1793) of the first edition and will hereafter be noted in the text by

page number. Like Brown's *Dissertation*, Bromley's *History* caused a somewhat surprising stir when it was published. When the first volume appeared, certain of Bromley's enemies (including Henry Fuseli and John Singleton Copley) succeeded in persuading the Royal Academy to pass a resolution declaring any subsequent volumes of his *History* improper to be admitted to the library of the Royal Academy. Bromley was a prominent London minister whose other publications consist of sermons preached on various special occasions.

Chapter 8

[1] The works of Humphry Repton provide a late eighteenth-century defense of gardening as the noblest fine art. For an account of Repton's work and his controversies with Sir Uvedale Price and Richard Payne Knight, see Hipple, *The Beautiful, the Sublime, and the Picturesque.*

Index

Alberti, Leon Battista, 160

Aristotle: and Lamotte, 27; and Harris, 33–35, 40, 161; and *The Polite Arts*, 45; and Beattie, 62, 67, 166; and Jones, 71–72, 75; and Webb, 81, 165; in eighteenth-century criticism, 84–86; and Twining, 84–94 passim; texts and commentaries in eighteenth century, 85–86; and Smith, 97; and Robertson, 128–29; mentioned, 15, 22, 49, 165–66. *See also* Imitation

Art histories and comparative discussions of the arts: and Pye, 118–19; in eighteenth century, 120–21, 138; and Robertson, 120, 121, 127–31, 138; and Bromley, 120, 121, 131–38; and Brown, 120, 121, 122–27, 138; mentioned, 14

Atkins, J. W. H., 40–41, 158, 161

Avison, Charles: and Harris, 38, 52, 53, 54, 58, 144, 147, 148, 163; on music and painting, 52, 53–59, 147–48; and Dryden, 52, 54–55, 56, 147; historical importance of, 52–53, 59, 144, 147, 158; and causal theory, 53, 54, 147–48; on expression, 53–59 passim, 103–104, 147–48; on imitation, 53, 55, 58, 92, 147, 151, 163; and rhetorical theory, 54, 148; and Beattie, 54, 68; and Jones, 54, 74; and Webb, 54, 81; on poetry, architecture, and eloquence, 58, 163; and Twining, 92, 93; and Smith, 103–104; and Brown, 124, 167; and *The Polite Arts*, 144; on music's benevolence, 163; mentioned, 165

Bate, Walter J., 164

Batteux, Charles: and *The Polite Arts*, 41–42, 162–63; and Robertson, 128, 130; Miller's translation of, 161; and Harris, 162; mentioned, 161

Bayly, Anselm: historical importance of, 106, 109; and Jacob, 106, 109–10; and Beattie, 109; and Jones, 109; and Brown, 109; and Robertson, 109; on music, poetry, and painting, 109–10; on imitation, 110; mentioned, 166

Beattie, James: and causal theory, 13, 60–61, 62–63, 66, 67, 148–50, 159; and Avison, 54, 68; and Dryden, 60–61, 62; and Lamotte, 60–61, 62; on poetry and music, 61–70, 150; on imitation, 61, 67, 68–69, 85, 92; on sympathy, 61–69 passim, 164; and Jones, 61, 70, 71, 72, 73, 76, 148–50; and Webb, 61, 77, 79, 81, 148–50, 163; on association, 61–70 passim, 163; and Aristotle, 62, 67, 166; on imagination, 64, 66, 67, 68, 164; on instruction, 66; on ideal nature, 67; and Harris, 68; on expression, 68; and Twining, 85, 92, 93, 94; and Smith, 102, 164; and Bayly, 109; and Brown, 123; and Hume, 163, 164; and Du Bos, 164; mentioned, 48, 141, 165

Bellori, Giovanni: and Dryden, 18–19, 160; on ideal form, 19, 160; on imitation, 19; and Plato, 160; mentioned, 13, 15

Blackmore, Sir Richard: and rhetorical theory, 111, 140–41, 142; on imitation, 111, 142; and Dryden, 111, 112, 142; on poetry and painting, 111–12, 142; and Lamotte, 141–42; mentioned, 110, 144

Blair, Hugh, 115

Bos, Jean Baptiste du. *See* Du Bos, Jean Baptiste

Bosker, Aiso, 158

Bromley, Robert Anthony: and Brown, 120, 131, 138; on painting, 120–21, 132, 133–38; on instruction, 120–21, 132–38 passim; and Robertson, 121, 131, 138; and Du Bos, 132, 134, 135; on poetry, 132, 133–38; and Dryden, 132, 134;

James S. Malek is chairman of and associate professor in the department of English at the University of Idaho. He received his M.A. (1966) and Ph.D. (1968) degrees from the University of Chicago. He has published extensively in scholarly journals.

The manuscript was edited by Marguerite C. Wallace. The book was designed by Julie Paul. The typeface for the text is Caledonia designed by W. A. Dwiggins about 1938; and the display face is Deepdene designed by F. W. Goudy about 1929.

The text is printed on Nashoba Antique paper and the book is bound in Columbia Mills' Llamique cloth over binders boards. Manufactured in the United States of America.